D0794097

Doris Chase
Artist in Motion

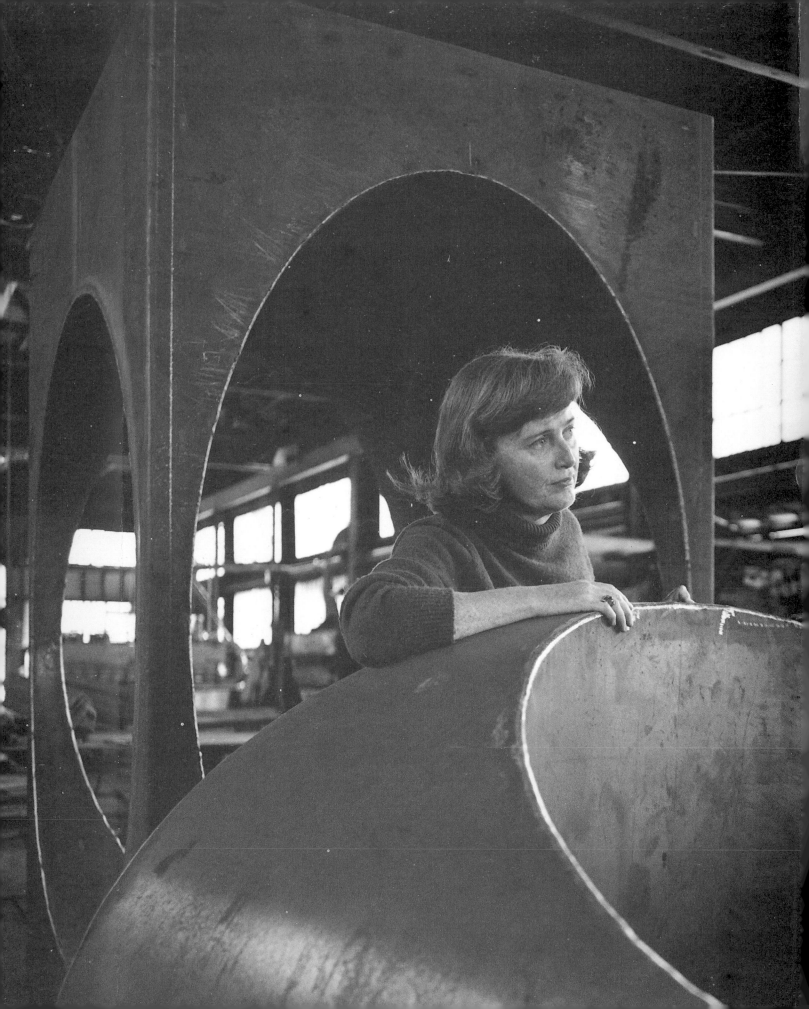

Doris Chase
Artist in Motion

**From Painting and Sculpture
to Video Art**

by Patricia Failing

Foreword by Ann-Sargent Wooster

A Samuel and Althea Stroum Book

University of Washington Press

Seattle and London

This book is published with the assistance of a grant from the Stroum Book Fund, established through the generosity of Samuel and Althea Stroum.

Copyright © 1991 by the University of Washington Press
Designed by Ed Marquand, Marquand Books, Inc.
Printed in Hong Kong

All rights reserved. No portion of this publication may be reproduced or transmitted in any form or by any means, electronic or mechanical, including photocopying, recording, or any information storage or retrieval system, without permission in writing from the publisher.

Library of Congress Cataloguing in Publication Data
Failing, Patricia.
 Doris Chase, artist in motion: from painting and sculpture to video art /
 by Patricia Failing; foreword by Ann-Sargent Wooster.
 p. cm.
 "A Samuel and Althea Stroum book."
 Includes bibliographical references and index.
 ISBN 0–295–97112–6
 1. Chase, Doris, 1923– . 2. Artists—United States—Biography. 3. Video art—United
States. I. Title.
N6537.C4638F35 1991
700′.92—dc20 91-7629
[B] CIP

The paper used in this publication meets the minimum requirements of American National Standard for Information Sciences—Permanence of Paper for Printed Library Materials, ANSI Z39.48-194.

A 35-minute videotape surveying many of the videotapes discussed in this book has been prepared to accompany *Doris Chase, Artist in Motion.* For information, please write to the Multimedia Department, University of Washington Press, P.O. Box 50096, Seattle, Washington 98145-5096.

Jacket: Video stills from *Circles II, Circles with Jonathan, Moon Gates,* and *Rocking Orange.*
Frontispiece: Doris Chase, 1969. Mary Randlett photograph.

Cal
N6537
C4638
F35
1991

Contents

Illustrations

Foreword

by Ann-Sargent Wooster

The word *pioneer* brings to mind the hardy women who went West to build a new life from scratch, turning the necessities of survival into a richly embroidered life. The word pioneer also suggests the frontiers of science and technology, from Madame Curie to the first women astronauts. It evokes nineteenth-century women artists like Berthe Morisot, who battled society's disapproval of professionalism for women artists and became one of the founding members of the Impressionists.

Doris Chase's life has aspects of all these kinds of pioneers. As one of the earliest and most successful video artists, she built a career in this difficult medium in the decades that witnessed its birth. Chase's artistic endeavors serve as a model for a new kind of career in the arts. She has shown how to make technology an art form. More important, she continues to evolve as an artist, keeping pace with a fast-changing field where technological innovations redraw and expand the methods of image production at an ever accelerating rate. Chase has also had the courage to develop her styles and mediums to satisfy her own internal vision, moving from sculpture to videodance, and then abandoning videodance at the height of its success for a new kind of video theater and a new kind of electronic stage. Initially she collaborated with writers and performers. More recently she has written and produced plays about the inner world of older women, giving voice to her own experiences and, in the process, enfranchising a neglected segment of the population.

Chase will be remembered for her role as a first-generation video artist. But she also provides a role model for women artists generally. Before the last two decades, women seldom achieved both professional and personal success. Recent advances for women artists tend to obscure the previous rarity of professional success and the even rarer achievement of combining a career with family life. The re-emergence of feminism in the late sixties and early seventies suggested that getting a high-caliber masculine job was women's primary goal. In art terms, this kind of gender emancipation meant getting good galleries, critical acclaim, inclusion in major museums, and public commissions. Now, twenty years later, women executives and artists are acknowledging that work alone may not be enough. As women today face the conflicts between home, children, and career, Chase's blending of family and art provides a striking example of how to have it all.

Patricia Failing, in chronicling and characterizing Chase's career, points to her tenacious energy. This quality was essential in the post-World War II period, just as women were being banished from the workplace by the return of

the G.I.'s and traditional gender differences were being rigorously imposed by society. The art world of the fifties and sixties was almost exclusively male. Abstract Expressionism, Pop, and Minimalism, leading styles of the period, included few women painters and even fewer women sculptors. When Chase began her career as a painter and sculptor in Seattle she was still raising her children. Art became for her a window and then a door out of the limitations of her life. As she began to receive critical acclaim for her work, she felt justified in embarking on an unusual path. Chase had her first New York City show in 1962, during a time when very few female artists were actively pursuing artistic careers and receiving professional recognition.

When Chase turned from painting to large-scale sculpture in wood, she began to work in a more collaborative way, employing the talents of many people in her projects. These collaborative skills would prove essential to her later film and video projects, which also involved moving from models to full-scale production and collaborating over time to bring projects to completion. As the sculptures grew in size, she began working in steel. Her usual practice was to develop small-scale models which were then fabricated as large-scale steel works. At this time she began to receive public commissions for parks and public spaces. Some of these sculptures began to be kinetic and had revolving parts.

In 1968, after seeing Chase's work, choreographer Mary Staton asked her to create large kinetic sculptures that were moved by dancers in a multimedia production for the Seattle Opera. Chase's love of motion would find fulfillment in her video work of the next decade. Using outtakes from a commercial film record of the performance, Chase began her odyssey, first to filmdance and then to videodance. In both processes, the forms of dance were abstracted and elaborated through the use of film or video special effects.

Chase has described this process: "I used the film to capture moments in the dance. In time I realized film needed to be a part of this, and I began to experiment with special effects because I wanted to use color and line and space the same way I did as a painter. . . . Eventually this led to multimedia productions combining sculpture, dancers, and film. I was working in four studios: constructing in the aircraft-fabricating plant on the large fiberglass structures, in the steel plant grinding and welding, in my own studio working on the models, and in the film-editing room with the optical printers. [My move to film] was a very gradual evolution, a growing as a tree or a flower grows one petal and then another leaf, and expands."

Chase's early work with filmdance placed her in the forefront of contemporary avant-garde movements. In terms of her total oeuvre, and in comparison with other working being done at this time, these films charted an extreme aesthetic position. In work like *Circles II*, Chase radically abstracted the dancers and the sculpture until they became almost abstract forms of light against dark moving kaleidoscopically through space. They were at once concrete figures and forms as ephemeral as smoke rings. Building these films on such precedents as Leger's *Ballet Mécanique*, she saw the dancer's body moving through space as simultaneously lyrical, mechanistic, and abstract. Yet she took this vision of the human figure in motion a step further than that of Leger, using special effects to dissolve the bodies into pure, buoyant form, the kind of form the Russian painter Malevich called *suprematist* because of the supreme purity of its visual sensations. In rendering the dance's choreography, Chase crystallized its patterns into streamlined forms, building on the legacy of photographic movement studies of Muybridge and Marey. With this abstraction of

real movement, her films offered a new paradigm for the audience's empathic response to the sensation of seeing movement created in space.

These films were in some ways an extension of her earlier work with kinetic sculpture, and they also paralleled the work of EAT (Experiments in Art and Technology) with their emphasis on audience-activated machines. Chase's films developed, too, against the backdrop of a renewed hunger for a more human-based art. Minimalism, with its reliance on geometric forms and commercial fabrication, had banished the human touch from art. Recoiling from this far frontier of abstraction, performance and process artists began to challenge the hegemony of Minimalism through numerous post-Minimalist strategies that also opened the door of experimental film and video.

The success of her films set Chase free from Seattle. When her children were grown she moved to New York City in 1972 and began to live in the Chelsea Hotel. The Chelsea was important to her later development. It offered relative freedom from housework, and it was home to a number of artists, filmmakers, and sculptors. By living there, Chase located herself at the center of a dynamic experimental film and video community that staged performances on the roof of the hotel. The Chelsea afforded a home base for the avant-garde of that era who often had to make their living by going on the road. Chase finds it stimulating and supportive: "There's a certain conviviality, a certain ease . . . I mean anything goes, but the most important thing is work. You sense that in other people, so it is a lot easier as an artist to live in an atmosphere where your work is accepted."

In the early seventies Chase began to translate into video her vision of kaleidoscopic and ectoplasmic extension of the figure moving in space. This was during the heyday of the first phase of video art, when video was being extolled as the art form of the future. Chase switched from film to video because she had greater access in New York to video equipment. Video, as artist Nancy Holt has pointed out, was in a unique position at this time. Where else could you be introduced to a new art form in the morning, make a work of art in the afternoon on borrowed equipment, and have a public screening of your work that evening at one of the newly opened exhibition spaces for video art, like the Kitchen?

Chase entered the video art world at its embryonic stage. In the late sixties and early seventies video art emerged as a new genre, influenced by the convergence of several factors: the art world's interest in mixed media and the *Gesamtkunstwerk;* the breakdown of traditional art forms and the exploration of new media, from latex to neon; the introduction of low-cost portable video equipment; and the social concept that it was essential to produce alternative media that challenged the cultural domination of commercial television.

Video art tapes frequently dealt with *real* time. Broadcast television time was short and expensive, and video art time by contrast was long and cheap. A particular work of art frequently lasted the length of the video tape, which was usually twenty minutes or half an hour. Subject matter was often private or political and not included on television. Not hampered by the concept of "good" television or "broadcast-standard" tapes (an impossibility under any circumstance for the early video artist, who had access only to primitive cameras and minimal editing equipment), early video artists experimented with disrupting and altering the television signal to produce strange-looking images. These experiments with the television signal led to the development of colorizers, synthesizers, and sequencers, the direct ancestors of the special-effects generators used in today's television. As the emerging product of a

fringe group, early video art was shown in art galleries, museums, alternative media centers, and on cable television.

Women were equal participants in the evolution of this new art medium. In the early seventies, Doris Chase used the image-processing equipment of WNET's television lab and the Experimental Television Center to pioneer a new spatial and visual language of dance. This was years before some of her approaches to choreography became the norm for adapting performances on the big stage to the small screen. It is striking that Chase felt free to use technology for her own artistic ends without being either a trained filmmaker or a technician. Machines and, by extension, machine art were subject to a kind of quasi-mystical obfuscation. Artists (primarily men) who worked with machines in their art tended to say: "If you don't understand the soul of the machine (i.e., the physics of the machine) you cannot use it in your art." Video theoreticians like Woody Vasulka spoke of the video artist's job as "a dialogue with a tool and an image." The invention of video tools (such as image-processing systems with their first emphasis on hard-wired engineering and, later in the decade, of computer hard- and software) was generally the province of men.

Probably because of her earlier collaborative work with teams of craftsmen in her large-scale sculpture, Chase realized you do not have to invent the wheel to drive a car. Often the video pioneers could be characterized as inventors and mechanics more than artists. Early on, Chase took the then radical position that the purpose of technicians and machines was to produce an array of images; the artist's challenge was to find a way to incorporate them creatively, homesteading and humanizing the frontiers of technology in the process. In taking this position she pioneered a relationship to technology that came to be the norm for video artists as they began in the late seventies to replace homemade Rube Goldberg machines with complex state-of-the-art equipment. These new computerized systems could be operated only by trained technicians. Chase provided a model for a humanistic approach to technology, one that saw the artist's role as developing new content for a machine-based art.

While remaining true to the dance, Chase pursued her subjects in many new ways. Her innovative approach derived in part from her intrinsic formalism, which itself stemmed from her emphasis on abstract forms in her sculpture. It also evolved from the limitations imposed by her working conditions. Like women writers of the nineteenth century who had no "room of their own" and so composed their novels in the more public space of the drawing room, Chase did not separate art and life. She rehearsed and filmed her dance pieces in her apartment in the Chelsea Hotel. The limited cubic space she devised for the dance performances was prophetic in its understanding of the shallow still-life space offered by the average television set. Just as she had earlier constructed a rich life within the limitations of her gender-imposed responsibilities, so she now transmuted the difficulty of her working conditions from lead into gold. Although her work was as radical as that of her fellow video artists, Chase's emphasis on craft along with her more universal subject matter made her "dances for television" or "living paintings" some of the most accessible works of this era. They were shown widely around the globe and they introduced electronic abstraction to a pre-MTV generation.

Feminism profoundly affected the art world during the 1970s. Using the phrase, "the personal is political," women-centered artists examined a wide range of topics, from rape and incest, to myths of the great goddess, to the politics of housework and pregnancy. In challenging the traditional categories of

high and low art, these women opened the door for the art world's acceptance of a spectrum including photographic, performance, and video arts.

Chase explored videodance during the heyday of feminist art, but a decade later she moved from lyrical examinations of form to create a new kind of video theater dealing directly with women's issues. Beginning in the late seventies she worked with language for the first time in her "Concepts" series, combining with drama the abstract elements familiar to her from painting and dance in order to communicate a broader range of emotions. Working with women storytellers, poets, and performers, Chase examined from a feminist point of view such issues as emotional security, relationships with men, family, other women, aging, illness, and death. She used video special effects to augment and interpret this material in innovative ways, stretching the boundaries of video, television, and theater.

Patricia Failing discusses these works, so suffice it to note here that in *Lies*, for example, Chase used multiple superimpositions along with the text to emphasize its drama of compromise. In *Electra Tries to Speak*, Chase established the drift mode—the visual image slowly drifting by—to accentuate the feeling of insecurity. In *Travels in the Combat Zone*, she used digital effects to create electronic masks relating to the character's divided sense of self.

The "Concepts" series seemed surprisingly naked, especially after a decade of lyrical nonverbal productions. Chase's espousal of performance works celebrating angry women came as a shock. Yet, in adopting a new subject matter and methodology, Chase again put herself in the forefront of media theory. According to feminist analysis, women are televised as voyeuristic objects to be stared at by the male viewer, almost always in roles created by men, and saying the words men want to hear women saying. Women directors and producers turn the tables in presenting works for and about women, and the face in the mirror of television is almost always startlingly different from the images of women created by men.

Chase's video theater projects often involve discomforting characters. In mainstream media, angry women are generally marginalized and banished from serious consideration by the judgment that they are hysterical or crazy. Chase's theater productions make us want to tell the woman to stop complaining, but we are compelled to look and so to listen. The television medium brings us face to face in a frame as intimate as our mirror. The angry, poetic, honest voice is a powerful reminder of the realities underlying some of our best-kept illusions. That it took Chase decades to tackle this kind of subject matter perhaps owes much to the kinds of upbringing most women experienced until lately. Like molten magma long kept suppressed, these tapes were produced in a great outpouring of energy that brought renewed vigor to Chase's work.

Always an assiduous craftsperson, Chase redrew these original performances for the electronic tube, augmenting the artist's solo voice and performance with special effects derived from colorizers, synthesizers, and sequencers to heighten and underline the emotional effects of the words. Colorizers allowed alteration in hue to produce color-drenched images like the work of the Fauves and the German Expressionists. Sequencers, creating timeshifts or collages, spliced material from different sources into horizontal layers like a temporal Venetian blind. Synthesizers allowed the creation of an osmotic, multilayered, interpenetrating sandwich of images. Computers offered digital effects. These visual techniques enable Chase to develop a new kind of

electronic theater that, in my view, updates German Expressionist and Constructivist cinema and frequently surpasses it.

Chase recently accomplished the unusual feat, for an independent producer, of crossing over into the mainstream market. Independents pursue a personal vision on a small budget, with little thought for such commercial considerations as mass consumption, market share, or a sponsor. Consequently, avant-garde film and video have existed outside the loop of mainstream film and television. Mainstream producers frequently plunder these idea-rich genres, but rarely do avant-garde artists cross over to mainstream media. In her most recent video series, Chase has done just that.

In the mid-1980s, in a desire to reach out to a broader audience and to give voice to her own interior landscape, Chase began to write and produce "By Herself," a series of videotapes featuring mature major actresses and focusing on the dynamic older woman. Chase's concern in this series was to reverse a stereotype by showing the older actress as an exciting force. As she herself entered the terrain of the older woman, she found it bleak and without positive images. She set out to create what she would have liked to find, using her self and her voice as example. Eschewing obscurity for clarity, Chase's series developed a new mirror for a generation of women and opened another door for video art by proving that one can move toward mainstream video art without giving up the personal vision that makes independent work unique.

Chase successfully produced and marketed the "By Herself" series for mainstream television—notably Channel 4 in England. Chase's marketing task was made more difficult not only because of her avant-garde identity but because her subject matter—older women—was traditionally taboo on television. Her success with this series reinforces her continuing growth as an artist, keeping pace with the higher production values that became the norm in the eighties as video artists began to produce broadcast-standard tapes in state-of-the-art post-production television studios.

As Doris Chase enters on another decade of her life, one wonders what new projects she holds in store. She has achieved significant success as a painter and sculptor and, most important, as a video artist. She has pioneered various media and carved out a place for herself in the world. At a time when many might be sitting back, a different image of Chase stands out. I saw her the other day, jogging down Seventh Avenue near her home in New York City in a shocking-pink running suit with a portfolio clutched firmly under her arm—Chase in motion. She accomplishes what she sets out to do, tenaciously pursuing her innovative artistic vision in the face of odds. Chase lives her life with style while bringing us the lasting legacy of her art.

Preface

Camcorders, satellite dishes, and video cassette recorders now complement the ubiquitous television set in thousands of American households. Videotape rental outlets multiply in shopping centers and supermarkets, vigorously competing with scores of cable television channels. Video simulations of news events merge television and real life into an electronic continuum, rendering obsolete the mock debate among 1960s leftists about whether the revolution would be televised. The accelerated domestication of video technology, however, has done little to enhance public familiarity with the professional life of video artists, whose training, economic support system, exhibition venues, technical accomplishments, and art-historical evolution are often misconstrued, even by art school graduates.

With a few evident exceptions, such as the curriculum of the California Institute of the Arts, opportunities for young artists to pursue video as a medium of personal expression are not routinely available. Economic factors continue to distance video from related genres of artmaking: video cameras are relatively inexpensive, but postproduction equipment can be costly, especially the technology required for broadcast-quality editing and many special effects. The market for artists' videotapes is even more problematic. Few tapes generate revenue from purchase or broadcast. Most are rented for modest fees from small distribution companies or from the artists themselves and rarely provide a margin of profit. Although universities, media centers, and museums throughout the United States collect artists videotapes, there are few private collectors, and there is no system of galleries or dealers to sell and promote works of art in the video medium. To obtain production and postproduction funds many video artists must rely on private foundations, local and state arts commissions, and the National Endowment for the Arts. This economic reality also limits output. So even though many artists have been attracted to video art in the past two decades, production economics have inhibited the growth of this new genre and have reduced its profile, even within the art world.

The professional practice of video art is also complicated by frequent debates within the field about the impact of communications technology upon cultural structures, the relationship of video art to film and television, the relative objectivity or subjectivity of the video camera as an imaging tool, the subliminal effects of television viewing, and the essential qualities of the video medium itself. These kinds of debates, in turn, raise unresolved questions about the potential of video art as an instrument for social change, the status of videotapes as commodities, the applicability of traditional aesthetic categories to

the work of video artists, and the unofficial, often unwitting, function of video art as a research and development service for the broadcast industry. These issues can divide video curators, historians, critics, and artists into theoretical fiefdoms, mitigating against any single, coherent definition of video art or any cohesive assessment of the most praiseworthy forms of artistic practice. The relative youth of the video art movement, which began to attract its first wave of adherents in the mid- and late 1960s, also compounds its uncertain historical footing.

Doris Chase is one of the few women artists who can look back upon a long career in the contentious field of video art. A pioneer in the field of videodance, she has devoted herself in the 1980s to new forms of intimate drama conceived and executed specifically for the video screen. In surveying Chase's accomplishments beyond her early career as a painter and sculptor, a brief sketch characterizes the institutional, critical, and art-historical milieu in which Chase established herself as a video artist (see chapter 4). Much of this background material will be familiar to those with a seasoned vantage point on video art, but this group is still a relatively small one. Although several important articles and catalog essays surveying historical developments in the field have been compiled since the early 1970s, there is not yet a comprehensive study of video art in the United States. Monographs on individual artists are rare; a few museums, however, have published substantial catalogs on the work of well-established artists such as Nam June Paik and Bill Viola.

Despite a consensus among video art curators and historians about many of the critical issues, artists, institutions, technological developments and economic forces that shaped artistic practices, there is disagreement about the interrelationships and relative significance of these diverse factors. This study does not directly engage such disagreements, nor does it offer a substantially new interpretation of the context in which Chase developed her work in video. Instead it provides the nonspecialist with a broad view of a video artist's working environment, while at the same time offering new information about Chase's own artistic evolution.

Exemplary of the historical developments that would figure significantly in any comprehensive study of video art in the U.S. is the strong commitment to video on the part of the New York State Council for the Arts (NYSCA). Beginning in the early 1970s, NYSCA funding for video, unparalleled among state art agencies, catalyzed a system of technical, financial, and educational support for the new art form that assisted most of the country's best-known video art pioneers. Today several regional centers in the United States support video art, but few independent artists working outside NYSCA's purview in the 1970s had access to the range of resources available to their New York peers. Like many West Coast artists, Chase was unaware of NYSCA's commitment to video when she moved to New York in 1972. Her subsequent decision to adopt video as her primary medium, while reflecting her earlier concern with the architecture of movement, cannot be disengaged from the affirmative climate for technological experimentation NYSCA helped to crate.

This study focuses upon Chase's professional development, especially in the fields of videodance and video theater, but it also considers changing circumstances in her private life along with certain shifts in her cultural environment. Colleagues frequently comment upon her unusual vitality, which has been described as a "tremendous life force that's chosen to express itself in film and video." Chase's energy and forward momentum are particularly striking because they seem inversely proportional to her physical substance: in height and

weight, she resembles a slim seventh-grader. Many of her associates and a few of her tennis partners would be surprised to learn that she is in her mid-sixties, for her appearance belies this fact, as does the vigorous pace of her daily life. To visit her two sons, for example, she travels to Australia and Seattle. Film and video centers and festivals all over the United States and Canada invite her to screen and discuss her productions: in the past decade she has accepted similar invitations in France, Australia, Germany, and Russia. Chase is one of the few video artists to travel and show her work under the auspices of the United States Information Agency (USIA), which has arranged tours to India, South America, Europe, Czechoslovakia, and Romania. Since 1982 Chase has also lent support to feminist programs in the arts, speaking out against stereotypes that compromise the professional development of women artists. Although Chase has not invented or constructed new video equipment, the fluidity with which she handles video technology has encouraged other women to develop expertise with electronic imaging tools. Her influence as role model and mentor has affected a wide circle of younger artists who respond to her enthusiasm, lack of pretense, and persistence.

In New York, Chase is headquartered in a petite studio at the Chelsea Hotel, where she has frequently rehearsed her videodances and theater compositions in her nine-foot-square dining area. Most of her studio, essentially one large room with a closet-size kitchen and bath, is given over to video equipment, a few pieces of furniture, and colorful kinetic sculpture eight feet high. The orderly disposition of these incongruous forms shifts attention to the Chelsea's *belle epoque* architecture, the ornamented fireplace and mantle, and, above all, to the expansive bay window looking south to Greenwich Village. From the Chelsea, Chase dispatches a barrage of correspondence, press releases, and telephone calls, nurturing each new contact, tentative proposal, preliminary agreement, and offer of assistance with almost obsessive conscientiousness. Gregarious and comfortable within a wide social strata, Chase alleviates these concentrated sessions with mornings of tennis, evenings of theater, artists' parties, dining in neighborhood restaurants, and frequent outings to museums and video exhibitions. On such occasions, her well-scrubbed appearance and her unaffected conversation and curiosity tend to mask the intensity and long experience that have brought so many of her creative endeavors to fruition. Chase's outward conventionalism, as one of her friends points out, obscures a constant restlessness and an uninhibited fascination with personal discovery. This study, therefore, is a progress report, not the final word.

Acknowledgments

I am indebted to many people for assistance in the preparation of this book. My first debts are to Doris Chase, whose recollections and personal files were my primary resources, to my husband Bob Sitton, who introduced me to Chase and her work, and to Naomi Pascal, editor-in-chief of the University of Washington Press, for her unflagging support. I am also grateful to Chase's friends and colleagues who generously submitted to interviews, especially Elaine Summers, Barbara van Dyke, Jonathan Hollander, Julie Gustafson, Ann-Sargent Wooster, Geraldine Page, LaMar Harrington, Frank Olvey, Robert Brown, and Robin Schanzenbach. A special debt of thanks is owed University of Washington Press editor Gretchen Van Meter for her suggestions and careful reading of the text, and Sara Hornbacher and Annette Insdorf for their editorial comments. Finally, I should like to express my gratitude to Mrs. T. Evans Wyckoff and the Norcliffe Fund for awarding me a grant that was of great help in expediting the progress of this book.

Patricia Failing

Doris Chase
Artist in Motion

Through the art and technology of expanded cinema,
we shall create heaven right here on earth.

Gene Youngblood
Expanded Cinema (1970)

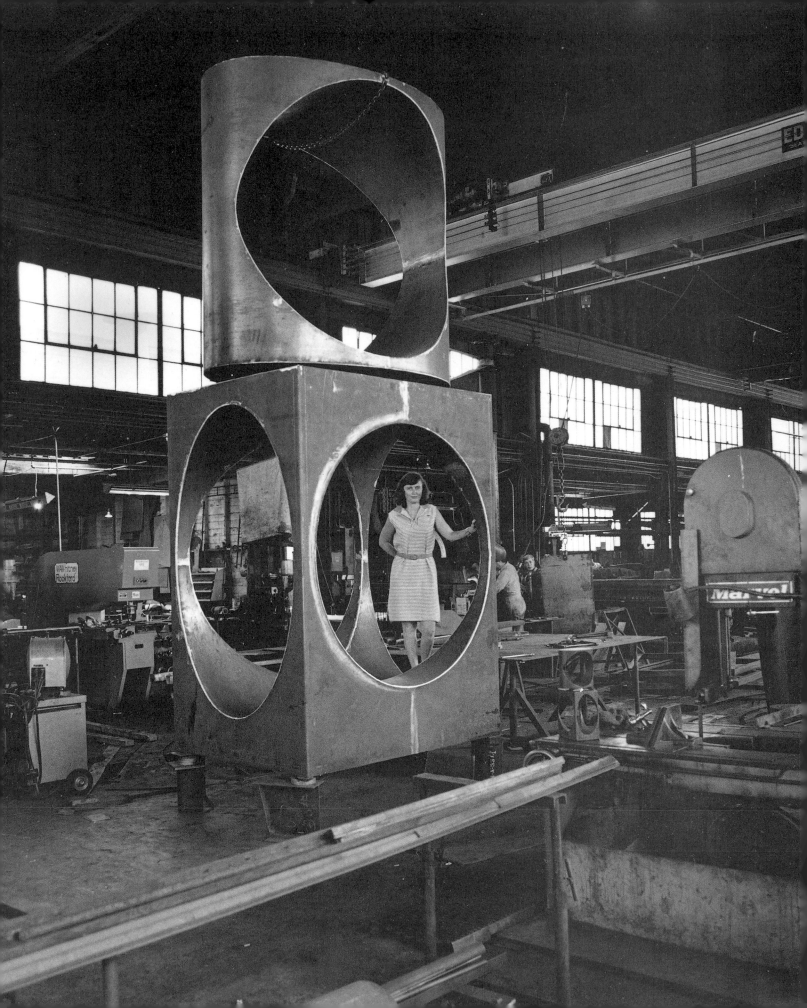

EAT and Circles II

In the late 1960s many artists in the United States subscribed to visionary opinions about the relationship between art and technology which were remarkably reminiscent of pre-World War I Italian Futurism. Since the beginning of the twentieth century, artists have expressed admiration for the functionalism and rationality of modern engineering, but these 1960s artists, like the Futurists, were especially drawn by the invisible, transformative impact of technology upon the structure of human perception. Although the average person is unaware of the process, according to this view, new technological environments are steadily altering fundamental operations of the human mind. The Futurist F. T. Marinetti made this point in 1913: "Those people who today make use of the telegraph, the telephone, the phonograph, the train, the bicycle, the motorcycle, the automobile, the ocean liner, the dirigible, the aeroplane, the cinema, the great newspaper (synthesis of a day in the world's life) do not realize that these various means of communication, transportation and information have a decisive influence on their psyches."[1]

Marshall McLuhan, the media theorist widely heralded in the 1960s as the guru of the new electronic age, offered essentially the same argument, emphasizing that "the effects of technology do not occur on the level of opinion or concepts, but alter sense ratios or patterns of perception steadily and without resistance."[2]

Marinetti and McLuhan also came to similar conclusions about the way in which twentieth-century technology can structure the human psyche. Both predicted a shifting away from conceptual modes involving logical analysis, categorization, and specialization in favor of more intuitive, synthetic, and holistic forms of perception. This subliminal shift in psychic patterning, they further concluded, would profoundly alter the nature of human society. As Marinetti saw it:

> The earth shrunk by speed. New sense of the world. To be precise: one after another, man will gain a sense of his home, of the quarter where he lives, of his region, and finally of the continent. Today he is aware of the whole world. He little needs to know what his ancestors did, but he must assiduously discover what his contemporaries are doing all over the world. The single man, therefore, must communicate with every person on earth. He must feel himself to be the axis, judge and motor of the explored and unexplored infinite. Vast increase in a sense of humanity and a momentary urgent need to establish relationships with all mankind.[3]

Fig. 1. Fabrication of *Changing Form*, 1969. Installed in Kerry Park, Seattle, 1971. Mary Randlett photograph.

McLuhan expressed the same idea more succinctly: "Ours is a brand new world of allatonceness. 'Time' has ceased, 'space' has vanished. We now live in a global village... a simultaneous happening."[4]

The Futurists and McLuhan concurred on another fundamental point: it is the creative artist, not the empirical scientist, who can best gauge the subliminal effects of technology on the human psyche. "The serious artist," McLuhan wrote, "is the only person able to encounter technology with impunity, just because he is an expert aware of the changes in sense perception."[5] These artist/experts, McLuhan argued, have an especially crucial role to play in the emerging global village:

> The artist picks up the message of cultural and technological challenge decades before its transformative impact occurs. He, then, builds Noah's arks for facing the challenge that is at hand.... In the electric age there is no longer any sense in talking about the artist being ahead of his time. Our technology is, also, ahead of its time, if we reckon by the ability to recognize it for what it is. To prevent undue wreckage in society, the artist tends now to move from the ivory tower to the control tower of society. Just as higher education is no longer a frill or luxury but a stark need of production and operational design in the electric age, so the artist is indispensable in the shaping and analysis and understanding of the life of forms and structures created by electric technology.[6]

Although Marinetti was one of the few twentieth-century artists actually to approach a "control tower" of society with his campaign to bring Italy into alliance with France, this reality did not diminish McLuhan's prophetic appeal for the 1960s avant garde. It was in a cultural climate considerably indebted to McLuhan, for example, that artists Robert Rauschenberg and Robert Whitman joined engineers Billy Klüver and Fred Waldhauer in 1966 to establish Experiments in Art and Technology, the nonprofit foundation known as EAT. As the best-known American art and technology group, EAT encouraged neo-Futurist programs that would "catalyze the inevitable active involvement of industry, technology and the arts."[7] EAT newsletters caught the attention of artists and engineers all over the country. Within two years, informal EAT chapters had been established in several U.S. cities, including Seattle, Washington.

In Seattle in 1968 and 1969, the Henry Art Gallery at the University of Washington brought together EAT enthusiasts. The gallery's associate director, LaMar Harrington, organized a series of weekly meetings among artists, scientists, and engineers, and devised an exhibition program centered around technically innovative work by artists from a variety of disciplines. Harrington recalls being "absolutely convinced that if you could just get artists and technicians and scientists together, wonderful things were going to happen. I thought artists were ready for it. We did a lot of work at the Henry trying to develop a system where we could locate the technological means for artists to use in carrying out new ideas."[8] Among Harrington's exhibitions from 1968 to 1970 were an indoor wind-room by Hans Haacke; a neon-light environment by Dan Flavin; computer films by Stan van der Beek; documents of happenings by Allan Kaprow and Wolf Vostell; multimedia performances by Lee Breuer and Mabou Mines; programs of dance by Merce Cunningham and Steve Paxton; and new music concerts organized in conjunction with composer Joan Franks Williams.

EAT groups all over the country, including the Henry Gallery contingent, tended to favor collaborations not only between artists and technologists but

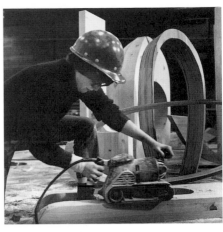

Fig. 2. Doris Chase (above) with multicomponent, rearrangeable wooden sculpture, late 1960s.

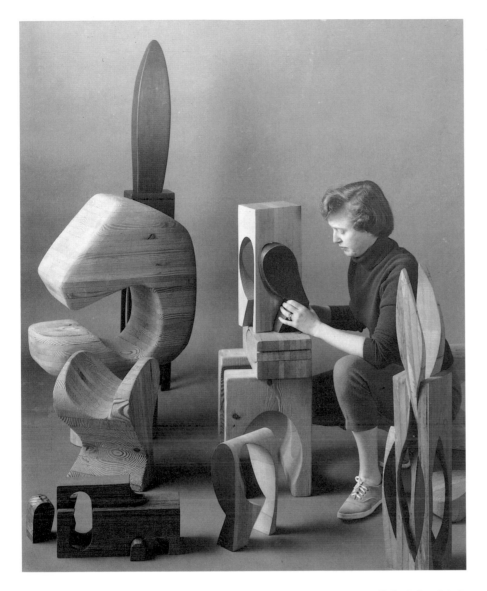

Fig. 3. Doris Chase (left) at Weyerhaeuser Company's wood-laminating plant. Cottage Grove, Oregon, 1966. Robert Lindsay photograph.

also among different art forms. On this point, EAT again paralleled the thinking of the Italian Futurists. The shared assumption was that categorical distinctions among the various arts could not survive the synthesizing force technology would bring to bear in shaping all forms of modern life. By the late 1960s, this presumption had been augmented for many young artists by the Zen-derived teachings of composer John Cage, whom McLuhan championed as the prototypical builder of artistic "arks" to carry his audiences into the electronic age. Cage was reasonably well-known in Seattle, having launched his professional career there in the 1930s at the Cornish College of the Arts.

Doris Chase, an established Seattle sculptor in the mid-1960s, was among the artists who frequented the Henry Gallery and attended Harrington's EAT evenings. Like most of her colleagues, Chase had not systematically studied Cage's or McLuhan's theories, but she was convinced that collaborative, multimedia art forms using new technology represented the direction of the future. Even before the EAT program began, Chase was using collaborative methods, working with engineers to fabricate her kinetic sculptures of laminated wood,

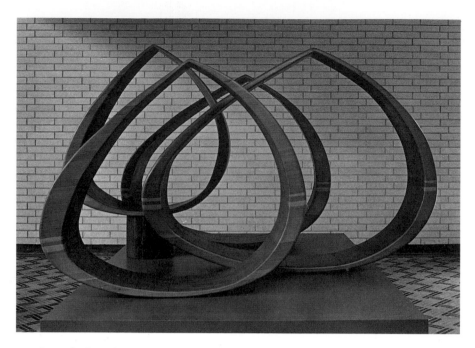

Fig. 4. Untitled, 1968. Laminated fir, H. 68. Installed in Intiman Theater, Seattle, 1987. Mary Randlett photograph.

steel, and Plexiglas (figs. 2, 3). Collaboration had been central to her work since the early 1960s, when she began creating modular forms that could be re-arranged by the spectator. As Chase wrote in 1966, "I want a new kind of spectator, not just an observer, but one who will take part in this sculpture, one who will touch and actively work with the movement and rearrangements of its interacting parts, one who will redesign space, reorganize form, be en-trapped by creating."[9]

In the last half of the 1960s, the scale of Chase's sculpture increased. By 1968 she was creating multicomponent, interactive forms that could be stacked or sat upon, as well as larger compositions capable of enclosing the human fig-ure (fig. 4). A newspaper article about her work caught the eye of Mary Staton, a progressive young choreographer living in New York, who had worked with Martha Graham and Alwin Nikolais. Staton had been commis-sioned by the Seattle Opera Company to create a new ballet for a children's opera. Sensing that Chase's approach to kinetic sculpture might be compatible with her own ideas about extending dance movements with abstract physical structures, Staton telephoned Chase from Manhattan and proposed a collabo-ration. Chase agreed, forming an alliance that was to profoundly alter the course of her artistic development.[10]

Technical feasibility was the first issue Chase and Staton had to resolve. Un-like Isamu Noguchi's celebrated dance sculptures for Martha Graham, which functioned primarily as sculptural sets or props, Staton envisioned movable forms interacting with the dancers on stage. For Chase, this meant rethinking the basic architectural engineering of her work:

> Wood was beautiful, but it was too heavy. I also needed something with tremendous tensile strength to support the weight of a moving dancer. A whole new technology was involved. I started talking with plastics manu-facturers and aeronautical engineers from Boeing and making experimen-tal maquettes. The technological collaboration was essential. I began to work with styrofoam and Fiberglas; the styrofoam allowed for shaping,

and a wrapping of Fiberglas gave the forms strength. The next problem was counterweighting: I put various amounts of lead or steel in the bottom of each form so that the sculpture could continue its motion after being touched by the dancer.[11]

For her first collaboration with Staton in 1968, Chase created three hollow egg-shaped forms that fitted together into a rectangular frame (fig. 5). During rehearsals the dancers discovered how to rock, turn, slide over, and dance within the forms, and many of these improvisations were incorporated into Staton's choreography.[12]

Encouraged by this initial venture, Chase and Staton embarked upon a far more elaborate multimedia project the following year. Like the first, it was produced for children and was masterminded by Seattle Opera Director Glynn Ross. In addition to Chase and Staton, this new production involved Seattle Opera Conductor Henry Holt, New York composer Peter Phillips, the rock-and-roll light-show group Retina Circus, six dancers, three opera singers, a jazz trio, a rock trio, and a small chamber orchestra. Presented to 118,000 schoolchildren in the spring of 1969 and to the public that August,[13] the production typified the interart collaborations encouraged by EAT as well as the theatrical form that helped introduce the phrase "total environmental experience" into the national vocabulary.[14]

In accord with the widespread enthusiasm among progressive artists in the late 1960s for the suprarational insights of Zen, composer Phillips patterned his score for this children's opera after the chants of Buddhist monks: the score and production, therefore, were entitled *Mantra*. Chase created three ringlike sculptures for Staton's *Mantra* choreography, which was based on movements familiar to children such as jumping and skipping.

Chase also chose ready-made forms for her sculptures:

> I found a plastics company that was making tanks eight feet in diameter. I had one of them cut into rings. Since my problem was to use these in creating asymmetrical circles, they had to be cut, re-shaped and spliced together. . . . [In the dance] the circles were used in a fantastically beautiful way, with one or two dancers posed inside them like spokes of a wheel. Often the dancers themselves seemed to be motionless, while the circles slowly moved apart and then back together again. There was a suggestion of Oriental mandalas and emblematic art having mystical overtones. I never imagined the effect precisely this way.[15]

For the audience, the dancer/sculpture interaction in *Mantra* differed significantly from the first Staton collaboration. In the first production Chase's sculptures were painted orange and the dancers wore blue and green costumes. In *Mantra*, the sculptures and the dancers' attire were white.[16] As a result, dancers and sculptures were optically unified in *Mantra*, with the human figures framed by the circular sculpture strongly suggesting the ideal geometry of Leonardo's *Vitruvian Man* (fig. 6).

Impressed by the ephemeral poetry of the dance images in early *Mantra* performances, Chase found a Seattle commercial film company to document the dance. At the same time she was beginning to consider how film technology might be used to elaborate and amplify the dancers' movements. With this possibility in mind, she volunteered to assist the film company in exchange for rights to the outtake footage once the documentary had been completed.

Fig. 5. Dancers with dance sculpture for the first Chase/Staton Seattle Opera Association production, 1968. Roy Scully/*Seattle Times* photograph.

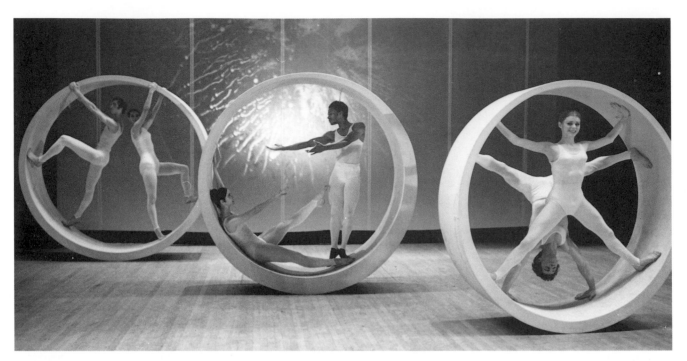

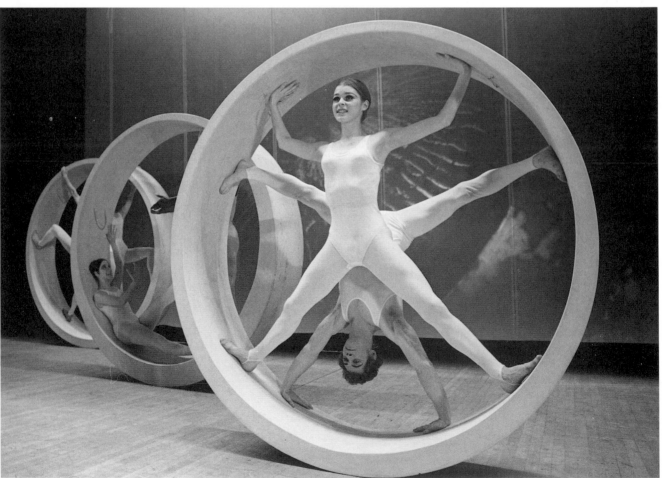

Although Chase had no background in filmmaking, late 1960s McLuhanism encouraged the presumption that it was natural, perhaps inevitable, that contemporary artists everywhere would adopt new technological means. Film also seemed to be a logical continuance of the creative process involved in her kinetic sculpture; in this new medium she might be able to expand her ambition to become an "architect of movement."[17] Cinematic art had been a focus of the Henry Gallery EAT program as well: Harrington was involved for many years with the Bellevue Film Festival, one of the country's well-respected festivals of independent film, and she was especially interested in the artist-filmmaker. Chase attended Harrington's exhibition of Stan van der Beek's computer films in 1968. Within a year Chase was at work on her own computer film, *Circles I*, while at the same time considering what might be done with the *Mantra* outtakes.

Circles I, Chase's first film, was a classic EAT collaboration. Working with William Fetter, chief computer programmer at the Boeing Company, Chase was given after-hours access to a room-size computer and the assistance of programmer Robert Tinguely. Chase wanted to create an abstract film using concentric circles. The circles would, in effect, dance with one another. To communicate the images she had in mind, she made sequential drawings for Tinguely, who attempted to emulate them with his computer graphics systems (fig. 8). Together, artist and programmer worked out timing, direction of movement, and appearance and disappearance of the forms.[18] When completed in 1970, the seven-minute film was scored by electronic music composer Morton Subotnick, who showed *Circles I* during some of his performances in the early 1970s.

The computer-generated dance in *Circles I* was related in certain respects to Staton's *Mantra* choreography, especially where the circular sculptures framing the dancers crossed one in front of another and sometimes seemed to merge. Chase decided to expand upon this kind of imagery in the *Mantra* outtakes, and in visualizing how this might be done, she had a specific precedent in mind. Among her Henry Gallery EAT acquaintances were two independent Seattle filmmakers, Frank Olvey and Robert Brown. Brown worked from time to time at Seattle's Alpha Cine Laboratory, the area's leading film-processing facility, in exchange for after-hours access to the equipment. Brown and Olvey became specialists in color effects. Their seven-minute film, *The Tempest*, made in 1967 as a virtuoso demonstration of color separation and superimposition, toured museums and film festivals all over the country and was shown in the Henry Gallery during EAT evenings. After seeing their work, van der Beek, who was teaching at the University of Washington in the summer of 1968, asked Brown and Olvey to color his computer films, *Poem Fields*.[19] Chase was similarly impressed and enlisted their collaboration in working with the *Mantra* outtakes.

Brown, Olvey, and Chase reviewed sections of the *Mantra* footage, which had been shot in black-and-white, and extracted certain sequences. Chase then selected soft, muted colors for each section, which Brown and Olvey were able to achieve through their exacting color-separation processes. ("I remember that she brought in color swatches we tried to match," Brown says. "She didn't like standard film colors. They were too bright for her, too psychedelic.")[20] Elaborating upon techniques demonstrated in *The Tempest*, Chase, Brown, and Olvey worked out a series of color effects, including complex overlays, repetitions of images, and superimpositions that resemble optical printing.[21] No attempt was made to document the dance, but rather to

Fig. 6. *Mantra*, 1969. Dancers with dance sculpture, two views. Seattle Opera Association.

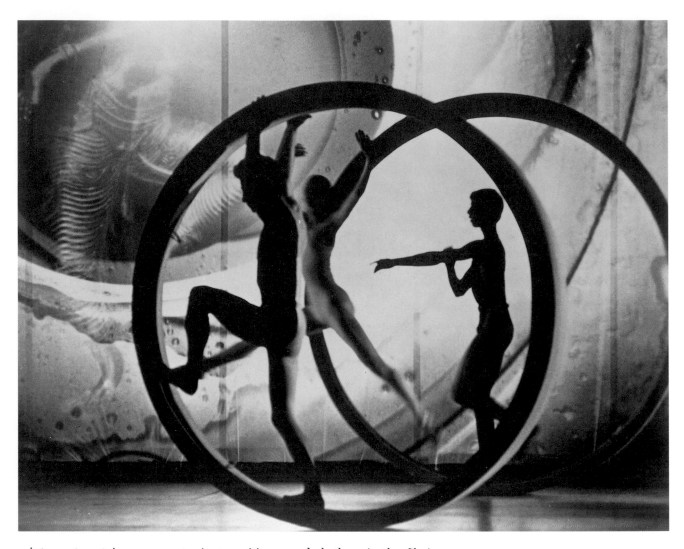

Fig. 7. *Circles II*, 1972. Film still.

reinterpret certain movements, juxtapositions, and rhythms in the filmic medium of colored light.

The result was *Circles II*, a pivotal achievement in Chase's career. In the history of filmdance, *Circles II*, completed in 1972, ranks with Norman McLaren's *Pas de Deux* (1968) in its lyricism, optical poetry, and careful craftsmanship (fig. 7). Although the concept of "filmdance" has been widely interpreted, *Circles II*, like *Pas de Deux* fits the broad definition offered by filmdancemaker Amy Greenfield in 1983:

> A filmdance is the opposite of the documentation of live dance. It is film in which the filmmaker/choreographer transforms the "ground rules" of dance time and space through the kinetic use of camera lenses, camera angles, camera motion, light, optical techniques and "montage," or film editing. Through such filmic transformations of the human body in motion, the collaboration between film and dance creates a *third* experience, a new kind of dance often totally unrelated to live dance. When film, rather than the stage, becomes the context for dance action, a surprising art form results, and dance becomes something which could not possibly be imagined before the invention of film.[22]

Circles II does indeed represent a dance form that could only exist in the medium of film: the graceful exuberance and playfulness of the performers' movements, originally conceived to appeal to children, have in *Circles II* a kaleidoscopic counterpart in hot pink, turquoise, tangerine, and lemon-yellow patterns of moving light.[23] It was first shown in New York at the American Film Festival in 1973, and film critic Roger Greenspun described the composition in the *New York Times* as "a rich, semiabstract movie in which post-production work is almost as important as the lovely rolling and dancing with circles (in fact sculptures by Doris Chase) that takes place in front of the camera. *Circles II* is colorized in soft, monochromatic pastels as beautiful as anything of the sort I've seen in the movies."[24] Later Greenspun compared *Circles II* to "the ecstatic Matisse *Dance* of 1909. The genius of the work rests not only in the relation of the dancers to the circles, but also in the way they approach the frame. *Circles II* begins to feel like an essay in the kinetic possibilities of making contact, or a set of variations on the idea of 'beginning.' It is at once delicate and massive and as a visual experience it is ravishing."[25]

Today *Circles II* stands out as a period piece that transcends its era. The film began with a "total environmental experience" for children of the electronic age, whom McLuhan regarded as especially receptive to multimedia and holistic perception. *Circles II* is also a product of EAT's idealistic conviction that when artists become involved with new technology, "wonderful things will happen." Finally, the mode of production is consistent with McLuhan's presumption that, given the subliminal predilection for synthesis encouraged by our electronic environment, collaborations will inevitably dominate artistic practice in the electronic age.

In Chase's case, these factors were assimilated by an artist whose twenty years of prior experience in painting and sculpture had been predicated upon a commitment to the intrinsic value of color, line, and formal organization, an artist who saw herself as "basically a romantic," aspiring to represent ephemeral visions and dreams in precisely executed formal settings. While many EAT-influenced artists went on to consider the structural properties of various media as the content of their work, Chase continued to operate much as she did in *Circles II*, approaching film, and later, video, as a new technological medium for the expression of an established personal aesthetic. Only a small number of American artists working in film and video in the past two decades have approached these media with the characteristic outlook of a modernist painter; even fewer have pursued the implications of McLuhanism by consistently exploring film and video as collaborative, multimedia art forms. Chase's work incorporates both perspectives. Beginning with *Circles II*, her films and tapes bridge the formalist orientation of the early twentieth century and the broader vantage point of the post-1960s avant garde. This personal synthesis, stimulated by EAT optimism about the role of artmaking in the electronic age, provides the backdrop for Chase's distinctive profile as an artist of her time.

Fig. 8. *Circles I*, 1970. Preliminary drawing.

Seattle: Painting and Sculpture

In Chase's view, "habit" equates with "stasis" in the case of her own artistic development. When she began working with the moving image in 1969, she could already look back upon a respectable career in the 1950s as a Seattle painter, and she had gained even wider recognition as a sculptor in the 1960s. Few in the Seattle art community were aware that she had also surmounted difficult personal circumstances, including physical illness and psychological collapse. A wife and the mother of two sons, she rarely had enough time until the early 1960s to pursue fully her creative inquiries. Chase survived these early impediments by developing a capacity for persistence that sometimes bordered upon fixation. The resolution and tenacity she developed in Seattle in the 1950s and 1960s, in retrospect, were essential in realizing her third career in film and video.

Chase's involvement with painting began inauspiciously. A wartime bride, twenty-year-old Doris Totten left the University of Washington School of Architecture in 1943 to marry U.S. Navy Lieutenant Elmo Chase. After the war, the couple settled in Seattle, the bride's hometown, and in 1945 she gave birth to their first child. "I was totally unprepared for this," Chase says:

> Everyone talked then about painless childbirth, but I was in labor for something like twenty-eight hours, and it wasn't painless. I kept thinking about my less-than-perfect marriage—and I became overwhelmed with the responsibility I was facing with this child. After the birth I had a nervous breakdown and began seeing a psychiatrist. One day he said, "What do you *really* want to do?" I said, "I'd really like to be a painter, but how can I paint? We live in this tiny apartment with a baby." He said, "Never mind; go out and get yourself some paints and start painting." So I did. We had a playpen and I would get into the playpen and paint to keep the baby out of what I was doing. Somehow it worked. Soon I began to feel that I could hold things together again.[1]

The Edison Vocational School was located near her apartment, and in 1948 Chase began night classes in oil painting with Jacob Elshin, and later with Nickolas Damascus. She majored in architecture for two years (1941–43) and had worked as an interior designer, but she had never studied painting formally until enrolling at Edison. "I went to Ravenna Grammar School and Roosevelt High School in Seattle before the era of creative art classes," Chase says. "But around home there were always paper, clay, crayons—materials to

Fig. 9. Doris Chase arriving in Tokyo for Formes Gallery exhibition, 1963. Ralph Demaree/Japan Airlines photograph.

work with. As a child I loved to draw and paint, and I was also happy in the basement, disassembling old clocks and radios and rearranging the components."[2]

Chase made rapid progress with Jacob Elshin. Less than a year after she had enrolled in her first class, one of her paintings was selected for inclusion in the Seattle Art Museum's 1948 Northwest Annual, where her co-exhibitors included such well-known local painters as Kenneth Callahan, William Ivey, Ambrose and Margaret Patterson, her teacher Elshin, Margaret Tompkins, and Mark Tobey.[3] Chase recalls:

> There were very few real art galleries in Seattle in the late 1940s and early 1950s, and the big event of the year was the Northwest Annual. The juried show at the Western Washington State Fair was considered important and also the Henry Gallery Invitational at the University of Washington. The Seattle chapter of Artist's Equity had invitational exhibitions too. But the Northwest Annual was the center of the scene. I would go there to see the Tobeys, the Morris Graveses, the Callahans and the George Tsutakawas. A little later more of the painters associated with the university came into the picture. I remember good paintings by Ambrose Patterson, Boyer Gonzales, Alden Mason and Spencer Moseley. Mark Tobey was the god. At the end of the forties he was showing in Seattle with Zoe Dusanne, a very handsome woman who came from New York. Dusanne's gallery was in her home on Lake Union, a very choice space, very tasteful, designed by Roland Terry. It was a proper salon. One always dressed to go there.[4]

Chase exhibited regularly at the Northwest Annuals in the 1950s. Bringing her paintings into the museum for jury reviews, she met Kenneth Callahan, then a Seattle Art Museum curator, and in the early 1950s she occasionally took classes from him. She began winning prizes for painting, beginning with an award for *Studio Kitchen* at the 1949 Western Washington State Fair. Landscapes were her principal subjects, but she also painted still lifes and human figures (fig. 10). "What interested me most was composing, figuring out what would work in a space, and that's still a primary concern," Chase says. "I loved heavy oil surfaces, and I would sometimes use sand to build them up."[5]

By the mid-1950s Chase had developed a blocky, semi-abstract style in oil painting. "I was very much influenced by Indian basketry and also by Indian carvings and wooden boxes. The University of Washington had a marvelous collection that's now in the Burke Museum—a mummy and masks and big potlatch bowls that all smelled like formaldehyde. I remember distinctly several Kwakiutl and Haida pieces. The very structured design factors I see in my paintings are partly derived from this."[6]

In 1955 Chase's work was first shown in New York at the Kaufmann Gallery in a group show organized by painter Robert Colescott. *Art News* critic Parker Tyler found the group's work skillful but unoriginal. "Young Seattle painters, a baker's dozen of them, prove they are breaking ground with the best," he wrote. "However, while the level of skill is respectable, original statement is hard to discern. In Doris Totten Chase's almost non-figurative, much-pigmented *Sunflowers*... one detects the open hand of the New York School experimentally grasped."[7]

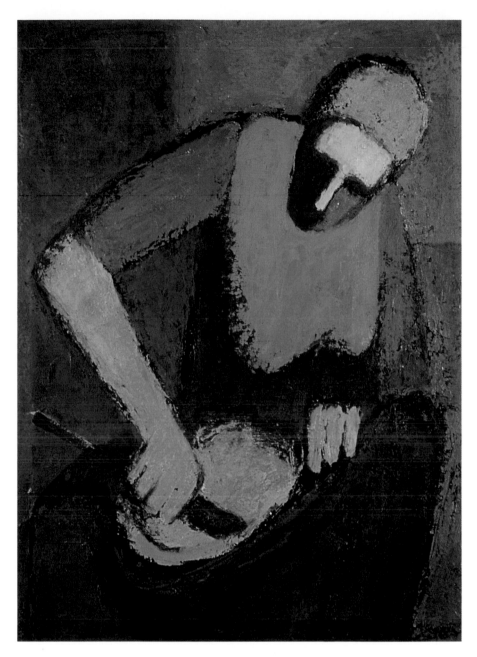

Fig. 10. *Seated Figure*, 1956. Oil on canvas, 18 x 24. Collection of Doris Chase.

Meanwhile in Seattle, Chase's professional progress was affirmed by inclusion of her work in a 1955 exhibition, "Eight Prominent Seattle Women Painters," at the Otto Seligmann Gallery.[8] Seligmann was then the city's most prestigious art dealer, representing Mark Tobey after he left Zoe Dusanne in 1953. Kenneth Callahan, art critic for the *Seattle Times* as well as curator at the Seattle Art Museum, wrote approvingly about Chase's work. Reviewing her first Seattle one-person exhibition at the Otto Seligmann Gallery in 1956, Callahan concluded:

> A serious and talented young painter, Mrs. Chase... has a definite flair
> for panoramic landscapes and often uses marine views of the Puget

Sound area's waterways. . . . The strongest paintings in the show, from the standpoint of design and the formal, structural properties of picture-making, are the figure works. In these the diffused atmospheric-depth depiction of the landscape is concentrated on the picture plane, with the major emphasis on the simplified structural use of human figures for form and color organization. Basically simplified realism, their degree of abstraction never destroys the sympathetic human character of the subject.[9]

The growth and momentum of Chase's painting in the early 1950s is difficult to reconcile with the facts of her private life. Chase recollects:

The apartment we lived in when I started painting was really tiny and depressing, and we needed to get out of it. We bought a lot and I drew up plans for a house, with the help of an architect. We hired a carpenter and worked ourselves on weekends and moved in when the living room was finished, sitting on nail kegs and cooking on a hot plate. The house was three-quarters finished in 1950; Gary, my first child, was three and I was pregnant with my second son, Randy. Then my husband Elmo came down with polio and was completely paralyzed. He was in the hospital for six months and we were broke. Thanks to the Polio Foundation, we didn't lose the house. A lot of our friends dropped away, and I can't really blame them. It must have been painful for them to see. I was twenty-seven years old and thought my life was over. I don't think I could have survived that period without my painting. Sometimes it wasn't very good, but thank God it was there.[10]

After undergoing physical therapy for several years, Elmo Chase was able to walk again with the aid of canes and leg braces. He returned to school to study accounting. Doris Chase took a job teaching design and figure drawing at the Edison School, painting primarily at night after the children were in bed. Professional development was difficult under these circumstances, but she persisted, looking for opportunities to accelerate her progress. She investigated artists' colonies, "places like the MacDowell Colony in the East. Then I read about one on the West Coast—the Huntington Hartford Foundation in Pacific Palisades, California (fig. 11). I applied and got accepted. It was a godsend to go there for a month and paint my heart out with nothing else to do. I was there three times [in 1955, 1956, and 1959] and it opened up a whole new world of creative possibilities, being there with writers, composers, and poets. It was as if someone had taken the lid off the box and I could fly."[11]

In 1958 Chase was painting regularly in watercolor as well as in oils, and by the early 1960s she was working extensively with water-based media (figs. 12, 13). "I had begun to feel more sure of myself and was ready to be spontaneous," she explains. "The rapidity of the watercolor and ink was exciting; compared with oil painting, it was electric, even kinetic. The types of paper I was working with and the paint itself led me to images of skies and hillsides and the effects of wind on clouds—I wanted to catch the essence of what the wind would do." Of her gouache or watercolor or ink pictures, she says, "My big formal problem was keeping the movement contained on the paper. It's very much like the problems I faced later in trying to deal with movement on the screen."[12]

In their restrained palette, Oriental sparseness, and spontaneous liquidity, many of Chase's watercolors and sumi paintings of the late fifties and early

Fig. 11. Doris Chase (on left) at the Huntington Hartford Foundation artists' colony, Pacific Palisades, California, 1950s.

1960s reflect the lingering influences of the so-called Northwest School. The concept of a "Northwest School" in painting was established in the national art press with a 1946 article in *Art News* by Kenneth Callahan.[13] Callahan applied the "school" argument with certain justification to himself and his Northwest colleagues Guy Anderson, Morris Graves, and Mark Tobey, but by the mid-1950s the water-based media, Oriental influences, and "mystic essence" identified by Callahan as the school's common denominators had become a prescription for "Northwest Art." "It wasn't really until I moved to New York many years later that I realized what a big deal the Northwest School was supposed to have been for Seattle," Chase says. "I don't recall being consciously influenced by a Northwest 'look,' but many of my watercolors and gouaches seem to fit right in. It must have been the same for a lot of Seattle artists."[14]

In the "non-Northwest" medium of oil paint, Chase continued to favor thick surfaces, depicting figures with wide, blocky strokes and heavy, dark outlines (fig. 14). She regularly won local awards and by 1960 was represented by galleries in Beverly Hills and New York. In 1961, she had her first show in Europe. "That happened when I met Fiamma Vigo, who published an Italian art magazine called *Numero* and who had a gallery with the same name in Florence," Chase explains. "She invited me to have a show in Florence the next year. I really wanted to go and was selling enough paintings to pay for my ticket. My mother insisted that I shouldn't travel by myself, so she came with me. My first time in Europe and to have a show in Florence—talk about heaven!"[15] Chaperoned by her mother, Chase toured Italy, Spain, London, and

 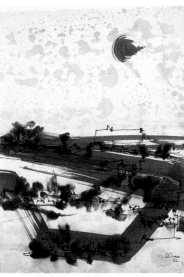

Fig. 12. *Venetian Night*, 1962.
Gouache and sumi ink, 9 x 13.
Private collection.

Fig. 13. *Near the Village of Chokau*,
1962 (right). Gouache and sumi ink,
10 x 13. Private collection.

Fig. 14. *The Fisherman*, 1959. Oil on
canvas, 15 x 19.

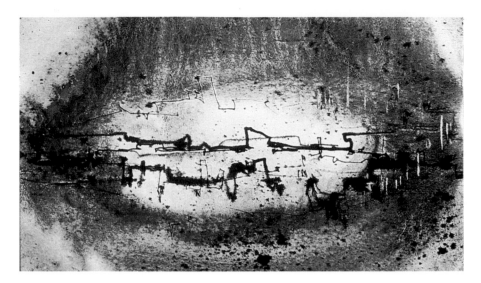

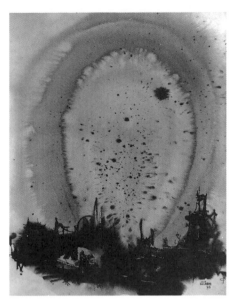

Fig. 15. Untitled, 1963 (left). Watercolor and sumi ink, 9 x 13. Reproduced on cover of *Asahi Journal*, Tokyo, May 12, 1963. Collection of *Asahi Journal*.

Fig. 16. *City Alight*, 1963. Watercolor and ink, 10 x 13. Private collection.

Paris. Vigo gave her another show the following year in Rome, where the Italian press judged her "an accomplished exponent of the avant garde."[16]

In 1963 Chase flew to Bangkok and then to Tokyo for an exhibition of her watercolors at the Formes Gallery (fig. 9). In these paintings, primarily semi-abstract landscapes, figurative passages are delineated with spontaneous black calligraphic lines. Colors are sometimes swept in a circle, introducing this form as a major compositional element in Chase's work (figs. 15, 16). Japanese reviewers took it for granted that her sumi-like style was characteristic of Northwest artists and were intrigued by her departures from Oriental tradition. A *Tokyo Shimbun* columnist observed that "her works are like Japanese sumi paintings—they have a clear and beautiful purity. On first glance they seem rather sweet, but with a closer look there is a severe restriction and design, a strong center. The sweetness is different from Japanese lyricism; the paintings make us joyous and gay."[17] Another reviewer noted, "She uses sumi technique only for the logic of spatial expression and it is no imitation of Japanese sumi; her work is completely different from the Japanese painter. Her show gives us a problem to think about for Japanese artists."[18]

Contemporary with these soft, feathery early sixties watercolors are a number of paintings virtually opposite in conception. In the late 1950s and early 1960s Chase developed what she called her "cement paintings"—large, decorative outdoor compositions executed in colored cement on masonite or asbestos board. "I wanted to work with texture and with paintings that could be hung outdoors," Chase says. "I did a lot of research on adhesives, cement bonding, and the weathering of various pigments. I mixed the cement and pigment in a food mixer and then had to work very fast to make the paintings because the cement would set in about twenty minutes."[19] Using techniques developed for these outdoor panels, she also executed murals on exterior house walls and patios (fig. 17).

Many of Chase's cement paintings, drawings, and oils of the early 1960s depict musicians playing their instruments (fig. 18). At the invitation of Milton Katims, conductor of the Seattle Symphony, Chase began attending rehearsals in the late 1950s to sketch the musicians; by 1962 she had produced more than 1,000 drawings and numerous paintings based on these sessions. "I absorbed a lot about music and the way musicians work," Chase observes. "The movements and positions were fascinating, like dance."[20]

Fig. 17. Doris Chase with cement painting on outdoor patio. Seattle, 1967. Mary Randlett photograph.

The highly textured cement paintings, Chase soon realized, "were really a form of relief sculpture. Then I started painting on shaped canvas and odd pieces of wood. A student of mine whose husband owned a shipyard gave me some wonderful laminated oak, and I began to make small sculptures."[21]

Chase had her first one-person show in New York, at the Smolin Gallery in 1965, just when her allegiances were shifting from painting to sculpture. The Smolin exhibition included twelve cement paintings and several small oak compositions the gallery described as "three-dimensional painting-sculptures of laminated wood."[22] An *Art News* reviewer reported that "Doris Chase mixes pigment with concrete in her heavily textured grey and brown pictures with incised faces peering, lined up in existential perplexity. Her small laminated wood sculptures are fascinating quasi-toys—free geometric forms with interchangeable moveable elements, including lids and hidden receptacles. The same caricature faces appear on the sculptures, but marvelously continued and interrupted by the inventive confusion of parts."[23]

By local standards, Chase's Seattle painting career was on the ascent when she became a convert to sculpture. In 1964, for example, she won one of the city's major monetary awards, the $1,000 top purchase prize at the Frye Art Museum's Tenth Annual West Coast Oil Paintings Exhibition.[24] Although Chase enjoyed painting, she discovered that "sculpture was more challenging. Sculpture has a physical kinetic involvement that I needed. It's like comparing a great tennis game with playing bridge. The painted elements on the sculpture gradually disappeared, too, as I realized the form was more important than the surface decoration."[25]

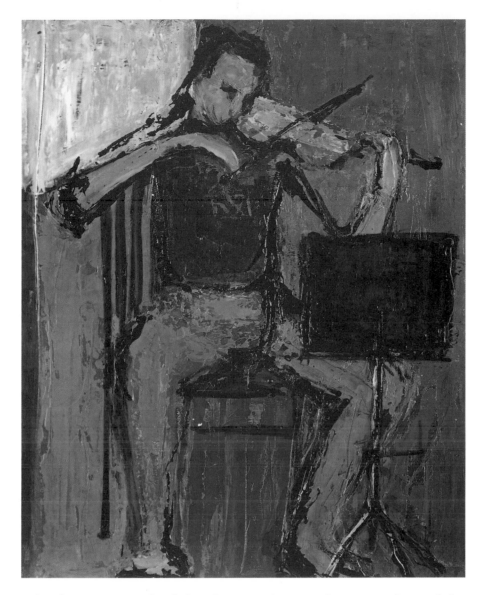

Fig. 18. *Musician*, 1961. Oil on canvas, 24 x 16.

Another motivation for shifting her attention to sculpture was the unwitting parallel Chase began to detect between her favorite compositional motif and that of another well-known artist. Beginning with the watercolors exhibited in Tokyo in 1963, many of Chase's images were based on the form of the circle. "I was enchanted with it and couldn't seem to get away from it; everything got to be circular; like the spring of nature completing itself. Then one day someone said, 'You know who else uses circles like this—Adolph Gottlieb.' I then looked at Gottlieb's work and thought—'Doris, it's time for you to move on to something else.'"[26]

Chase began to find her own personal sculptural style in 1965 with ensemble constructions such as *Claudius* and *Family* (figs. 19, 20). These compositions consist of two or three movable units nesting inside a rectangular block approximately twenty-two inches high. Visual complexity evolves as the rounded geometric components are pulled from the matrix or separated into a series of free-standing forms. The pieces interlock like a puzzle and can be rearranged

Fig. 19. *Claudius*, 1965 (left). Laminated oak, H. 20.

Fig. 20. *Family*, 1965. Laminated oak, H. 24.

into various configurations: Chase has described them as "basic shapes that seem to wish themselves in and out of one another."

It was important for Chase that the viewer, not the artist, determine the composition. "I wanted to introduce an element of chance and I wanted people to become directly involved with the creative experience. Ideas of this sort were in the air at the time and they became part of a philosophy I wanted to incorporate in the work. I didn't want people to think of 'art' only as a static object that can't be changed. I also believed that, if they had the opportunity, people would make tasteful arrangements of the forms."[27]

Chase was only vaguely aware of the maternal and sexual content of these organic, nesting compositions, although her descriptions of the sculpture sometimes imply a kind of sexual seduction. In 1965, for example, she wrote: "This work... pleads for your active participation. It wishes to bring you closer and wants you to look and enjoy and to touch and actively work with the arrangement of its various parts."[28] Chase felt "enchanted with the totality of a piece of wood and how you could, by sawing it, divide it so that both pieces can be works of art and yet both go back to form a whole. The reunion, making it one again, was very important to me. I think this is a feminine idea, a female instinct. It had a lot to do with the way I worked."[29]

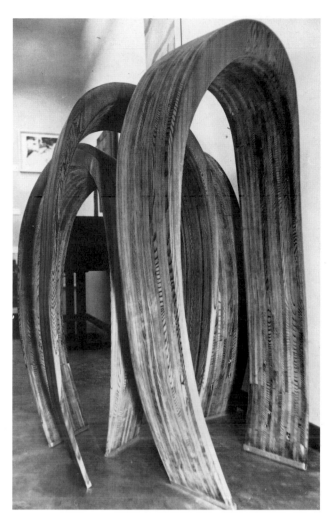

In 1966 Chase's laminated wood, multicomponent compositions were shown at the Galleria Numero in Rome and the following year in New York at the Ruth White Gallery, where she showed her sculpture again in 1969 and 1970. She began visiting New York with regularity after the mid-1960s and was intrigued by Allan Kaprow's happenings and performance events at the Judson Memorial Church. Chase especially remembers one performance at Judson hall by the future "George Washington of video," Nam June Paik. "The performance consisted of Paik mooning the audience and then apparently defecating. *That* was a long way from Seattle!"[30] Chase also encountered Lee Breuer and Mabou Mines on one of her 1960s New York visits, and she later made arrangements with LaMar Harrington for Breuer's performance at the Henry Gallery.

When Chase began showing her work at the Ruth White Gallery in 1967, her sculpture ranged in scale from ten-inch stackable modules to groupings of three-foot-high arches (fig. 21). Working materials now included laminated fir and cedar, and she began investigating the technology of wood processing (figs. 22, 23). "I wanted to know what *could* be done. I researched glues, especially glues that could withstand the weather. I looked into methods of bending woods to understand whether I could make, say, a Möbius strip. The Weyerhaeuser Company did research for me and was very supportive. I found out

Fig. 21. *Eight Modules*, 1967. Laminated fir, each H. 10.

Fig. 22. *Four Arches*, 1967 (right). Laminated cedar with aluminum, H. 5'.

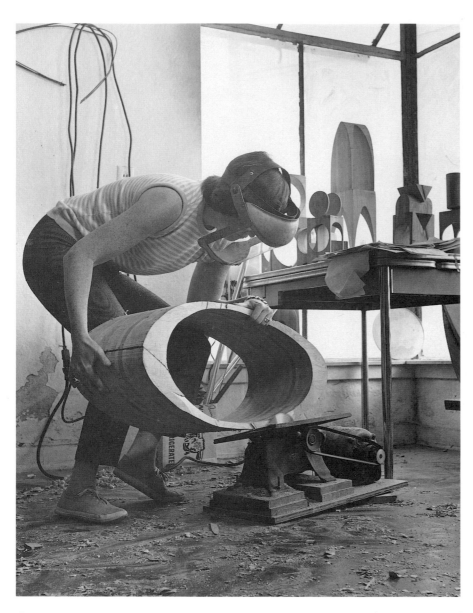

Fig. 23. Doris Chase in her studio with small-scale wooden modular sculpture. Seattle, 1967. Mary Randlett photograph.

that a tremendous amount of heavy equipment was necessary for bending and shaping the wood, so I continued to work with laminates that were prefabricated."[31]

By 1968 Chase's largest compositions were nearly six feet high; arm, shoulder, and upper-body movements were required to turn the forms and rearrange the components. Characteristic shapes included variations on the circle: teardrops, arches, inverted horseshoes, ellipses (fig. 24). In these larger works, components were stacked or positioned next to one another, as opposed to nesting in a matrix. Nesting forms activated by movements of the hand continued in her smaller compositions which, by 1969, were also executed in steel and Plexiglas (figs. 25, 26, 27). Several of these smaller pieces, which often combined natural and industrial materials that suggested contrasting temperatures, were included in Chase's 1969 exhibition at the Ruth White Gallery. According to critic Cindy Nemser, "The viewer is invited to become an active participant in a fascinating game of 'mix and match 'em'.... Some-

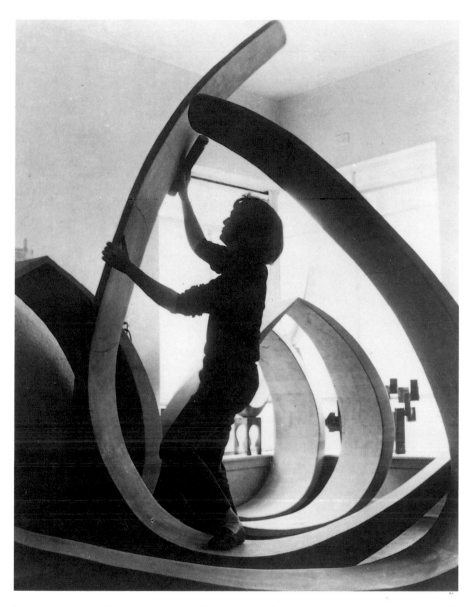

Fig. 24. Doris Chase at work on untitled wooden forms, H. c. 60. Seattle, 1968. Elisabeth Blaine photograph.

how, no matter how one scrambles the modules, the entire arrangement always looks right."[32]

Chase, however, was having second thoughts about these spectator collaborations. "I naively believed that, if they had an opportunity to be creative, people would arrange the forms artistically. But some people have limited design abilities and others simply put the forms together and never moved them again. It was quite a lesson. When I started working on a larger scale, I no longer chose to allow the viewer so much freedom. Change an angle, yes. Change the whole placement, no."[33]

The increasing scale in Chase's late-1960s sculpture afforded another kind of opportunity for addressing the issue of spectator involvement. In addition to stackable multicomponent ensembles, she began to create five- to eight-foot-high wooden arciform sculptures that rocked or pivoted. Viewers were invited to sit on or in these forms or, more precisely, they were encouraged to nest within the sculptural enclosures (fig. 28). This kinetic mini-architecture was the

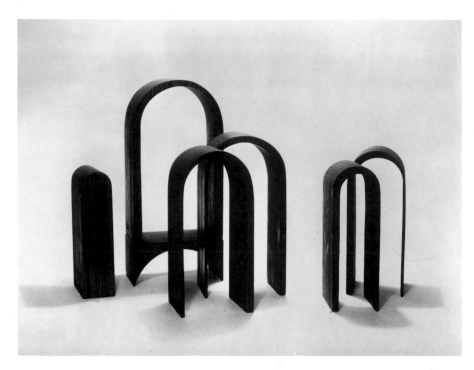

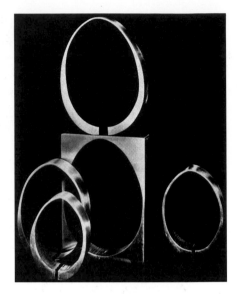

Fig. 25. *Nesting Arches*, 1969. Wood, tallest H. 12. A full-scale H. 8' version of this composition is the dance-sculpture ensemble *Tall Arches*, now in the collection of the Joffrey Ballet and Gerald Arpino.

Fig. 26. *Nesting Rectangles*, 1969. Wood and Plexiglass, tallest H. 18.

Fig. 27. Untitled, 1969 (above). Polished steel modules, tallest H. c. 16.

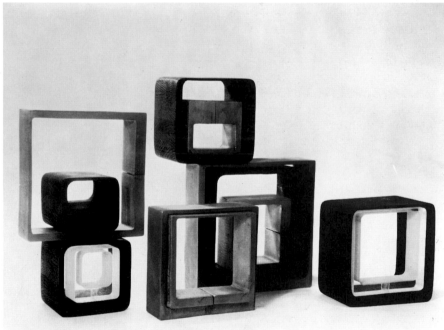

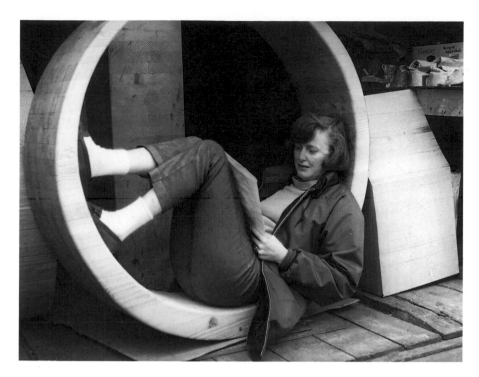

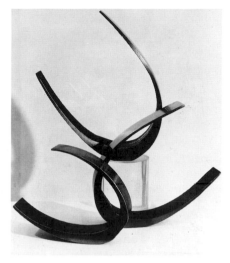

Fig. 28. Doris Chase with wooden sculptural module, 1968. Elisabeth Blaine photograph.

Fig. 29. Maquette for *Changing Forms*, steel, late 1960s.

immediate precedent for the dance sculpture Chase began to create for Mary Staton in 1968, where a wide range of dynamic physical action animated the interior spaces. Elayne Varian, then director of the Finch College Museum of Art, succinctly characterized this late-1960s work when she exhibited Chase's sculpture at Finch early in 1970. Chase's compositions, she wrote, "are resolved with the utilization of perpetual movement both in the kinetic sculpture itself and with viewer participation. Observing the sculpture from an interior position one realizes its monumentality with both linear and solid qualities. It is mathematical in its pure abstract shape, which is delicately balanced for motion and spatial freedom."[34]

Among the largest works in Chase's sculptural *oeuvre* are two public commissions initiated in 1969. The first, *Changing Forms*, was created for Atlanta's Great Southwest Industrial Park, a site conceived as a monument to industry, technology, and art.[35] Chase's two-and-a-half-ton steel sculpture juxtaposes three 14-foot inverted horseshoe shapes, two of them stationary. The third can be rotated by the spectator (figs. 29, 30). Chase's modified views on the role of viewer involvement with composition seem to be upheld here: no matter how the third component is positioned, *Changing Forms* remains an elegant and spatially engaging composition. Equally successful is a similar multicomponent sculpture commissioned in 1976 for Shadyside Park in Anderson, Indiana.[36]

While Chase was completing Atlanta's *Changing Forms* in 1969, she was at the same time collaborating with Staton on *Mantra* and supervising the fabrication of a second public commission, a now-familiar Seattle landmark. This fifteen-foot, cor-ten steel composition occupies a spectacular site in Kerry Park on Queen Anne Hill, where the sculpture is aligned with a view of Mount Rainier, the Space Needle, the Kingdome, and a panorama of downtown Seattle (fig. 31). The clear geometric articulation and interplay of negative and

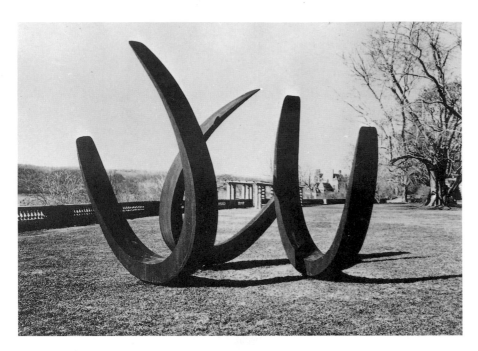

Fig. 30. *Changing Forms*, late 1960s. Cor-ten steel, H. 14'. Shown here in temporary installation at Wave Hill Sculpture Park, Riverdale, New York. Installed at Great Southwest Industrial Park, Atlanta, Georgia, 1969.

positive space in this composition are typical of Chase's late-1960s style, which critic Richard Lorber compared with the "polished geometry of Max Bill."[37]

In keeping with Chase's evolving views on spectator interaction, the bottom component of the Kerry Park sculpture is stationary, but the top section initially revolved when pushed. "I didn't want this work to be a monument to myself," Chase says. "The idea of participation is still very important; I really want people to think of it as their sculpture. When I go back to visit the site I often find people sitting in it, standing on it, feeling it, taking pictures through it—so I think some of my ideas about physical involvement came through."[38]

Another major commission in 1969 was for an interactive sculpture to be sited at the entrance of the Washington State Pavilion at Expo '70 in Osaka, Japan (fig. 32). Fabricated in Japan from Chase's specifications, this polychromed steel composition has three components: a twelve-foot rectangular frame with a large oval opening, and two free-standing horseshoe shapes, one of which can be rotated. Painted ice-blue to contrast with the red cedar of the Washington State Pavilion, Chase's kinetic sculpture was donated by Governor Dan Evans to the new modern art museum in Kobe, Japan (fig. 33).

Expo '70 in Osaka coincided with a peak of enthusiasm for art/technology liaisons within the American avant garde. The United States Pavilion, for example, featured environmental light sculptures by Newton Harrison, laser shows by Rockne Krebs, and a mirror installation by Robert Whitman. These endeavors received polite attention from the press, but the major art-and-technology story of the fair was the Pepsi Pavilion, where New York founders of EAT promised the *ne plus ultra* of total environmental experiences.

Conceived and executed by EAT, the Pepsi Pavilion contained a ninety-foot-wide plastic mirror-dome illuminated by a krypton laser light show. Below, variously textured floor panels wired with audio loops emitted sounds picked up with hand-held receivers. In the entrance plaza were Robert Breer's motorized sculptures—six-foot Fiberglas domes moving so slowly and quietly

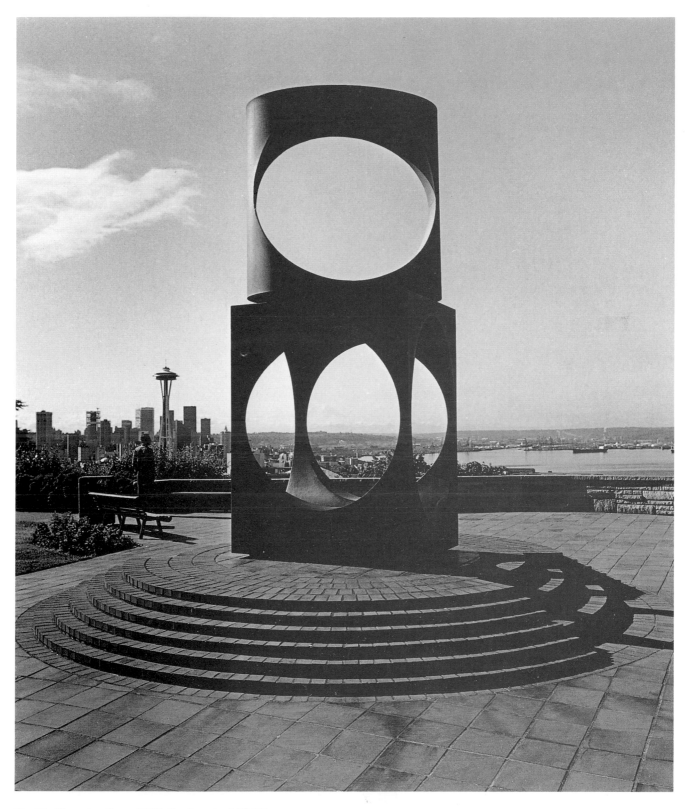

Fig. 31. *Changing Form*, 1969. Cor-ten steel, H. 15'.
Installed in Kerry Park, Seattle, 1971. Mary Randlett photograph.

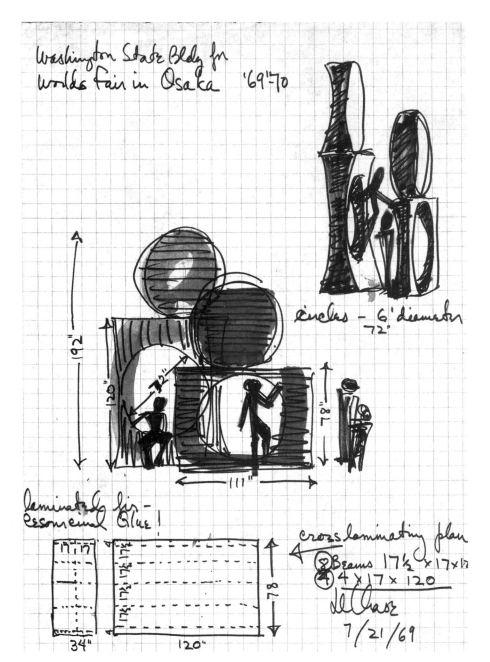

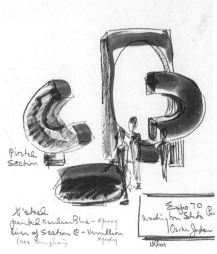

Fig. 32. Proposal drawings for sculpture for the Washington State Pavilion, Expo '70, Osaka, Japan, 1970.

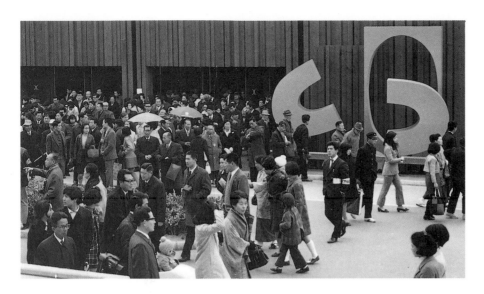

Fig. 33. Doris Chase's sculpture in front of the Washington State Pavilion, Expo '70, Osaka, Japan.

that visitors were often unaware of their motion until being bumped by one of them. The pavilion itself (its architecture was *not* within the purview of EAT) was made to disappear periodically under clouds of man-made fog.[39]

Arriving in Osaka just before the opening of the fair, Chase anticipated an EAT coup. After visiting the Pepsi Pavilion, however, her response presaged that of subsequent visitors. "It was a bit of a bomb. There were some great ideas, but they just didn't come together. Bob Breer's sculptures were nice and people responded to them, but the fog machine kept getting everyone wet. It was meant to be a big climax for the EAT generation, but things began to collapse after that."[40]

Chase remained committed to many of EAT's McLuhanesque tenets in the next decade, despite the gradual demise of the organization. Implicit in her explorations of new media and materials in the 1970s is a McLuhanesque belief in an expanding human capacity for assimilating complex stimuli. A corollary assumption, that it is the artist's role to accelerate this expansion, is presupposed in her efforts to achieve a compelling synthesis of visual and kinetic sensation, not only with new forms of sculpture but also in the medium of colored light.

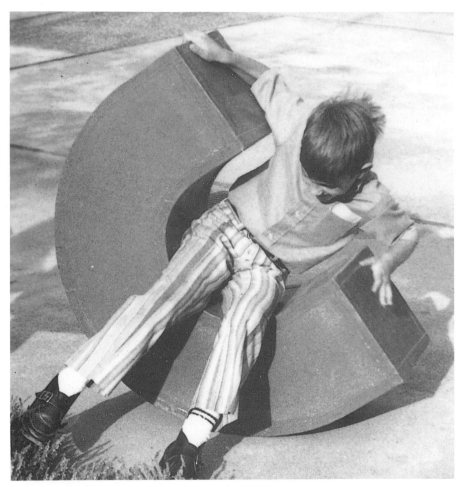

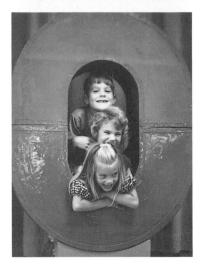

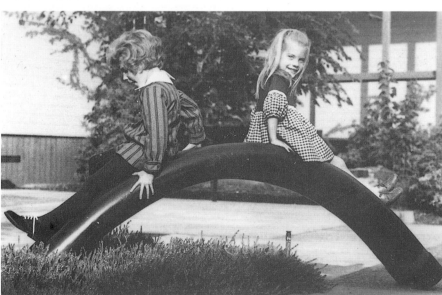

Fig. 34. Prototypes of modular sculpture for children, 1970. Fiberglass polyethylene.

Sculpture for Children: Seattle to New York

Chase's collaboration with Mary Staton on *Mantra* in 1969 inspired not only her film, *Circles II*, but also a new genre of kinetic sculpture. As Chase explains, "The schoolchildren who came to the [*Mantra*] show were really enthusiastic about it. They clapped and cheered and jumped up and down. Several of the teachers who saw the production came to me later and said they would love to have something like the dance sculptures to work with in their classrooms. So I began thinking about child-size versions of the sculptures, trying to make forms that were extremely safe. I did research on body awareness and got together with Seattle plastics people to find the right materials. I became really convinced that getting children involved with moving and rearranging the sculpture could be a great learning tool."[1]

A prototype of the children's kinetic sculptures, twelve Fiberglas polyethylene rocking forms nesting together in a six-foot square, was completed in 1970 (figs. 34, 35). The colorful shapes were graduated in size and varied in surface, with coatings suitable for rolling and sliding and with soft coverings for reclining and jumping. The Boeing Company and General Plastics Manufacturing Company in Tacoma provided vacuum-forming equipment and assisted the artist in developing the molds.

Prototypes were field-tested by children in special education classes at Shoreline School in Seattle during the 1970–71 school year (fig. 36). A 1972 article on the Shoreline project reported that the forms were used in music and dance classes by a teacher who, "skeptical at first about introducing the sculpture into her classes, now says that with their use the children have developed a keener awareness, more self-confidence and a better relationship with others. She report that handicapped children who would previously sit alone and refuse to play with others are now actively participating."

Other Seattle users, the article continues, were also favorably impressed: "[The] head physical therapist at the Lowell School Orthopedic Wing and Coordinator of Physical Therapy Services for the Seattle Public Schools has written an excellent report for therapists and teachers working with cerebral palsy children. She explains how the Chase geometric forms encourage righting and equilibrium reactions.... 'By constant repetition with this type of motor activity it may be possible to develop a more adequate balance mechanism within the body... to reinforce other concepts, such as perceptual development in areas of tactile proprioception, spatial relationships and body awareness.'" Another physical therapist who worked with spastic children added: "The Chase sculptures are absolutely delightful. They are extremely useful; they

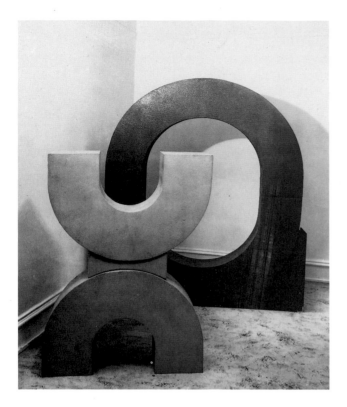 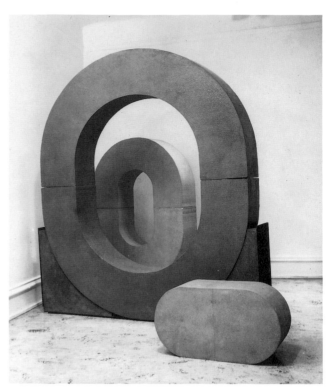

have just enough balance; they are soft enough to be safe and they are tremendously versatile." The therapist concludes that "the sculpture may well replace conventional types of furniture previously used in the classroom."[2]

Fig. 35. Modular sculpture for children in two arrangements, 1971. Fiberglass polyethylene.

The sculptures were also well received by nonhandicapped children, who used them in imaginative conjunctions of aesthetics and athletics. The children's evident pleasure in manipulating the forms convinced Chase that the sculptures could be effective in teaching. "The joy of learning is overlooked in the normal classroom situation," she pointed out. In play sessions using the moving sculptures,

> an amazing bridge can be built by an interdisciplinary approach. The concepts of space, form, balance, change and design can be experienced and then explained to coordinate learning in three directions, by affective, psychomotor and cognitive means. The small sculpture is in fact a meeting place for each participant to be creator and artist. . . . Through manipulation of varied components of the sculpture for the sheer joy of design, the child can be awakened to expanding vistas and sensitivities. . . . From sensing the delight in the very young audiences and from conversations with enthusiastic educators, I was inspired toward involvement in experimental education.[3]

Further research on the classroom employment of the forms was conducted in the early 1970s by the National Program of Early Education in St. Louis and the University of Washington Child Development and Mental Retardation Center. Films were made of children interacting with the sculpture. Teaching guides were prepared, and Chase began looking for a manufacturer to mass-produce the sets.

The children's sculpture was the first of Chase's creations to appear on national television. "Hank Ketchum, the Dennis the Menace cartoonist, happened to see one of my shows at the Ruth White Gallery in New York," Chase recalls. "His friend Chuck Jones, the Bugs Bunny man, was going to be executive producer of a new ABC children's TV series [Curiosity Shop]. This was ABC's answer to Sesame Street. ABC wanted a set of my sculptures for the show, so I went to L.A. and made a set for them."[4]

She made several trips to Los Angeles in 1970 and 1971 in connection with this project. During one visit Chase concluded an agreement with composer Morton Subotnick, who offered to create a soundtrack for Chase's computer film, *Circles I*, in exchange for permission to use the film in his performances. Subotnick introduced Chase to faculty at the California Institute of the Arts, where Allan Kaprow was teaching; there she met Alison Knowles and saw performances by artists associated with Fluxus. She was also introduced to Nam June Paik, who was continuing his experiments with magnetic alterations of video images while collaborating with Japanese engineer Shuya Abe on one of the first Paik/Abe video synthesizers. (The synthesizer is an analogue device that mixes pure and distorted electronic signals, facilitating the production of abstract images and a variety of special effects.) Paik's eccentric charm attracted Chase at once: "He struck me as someone who just woke up or walked in from the rain. He was always entertaining and always performing, stage or no stage."[5]

Chase traveled extensively in 1971. At Expo '70 in Osaka she met representatives of the U.S. State Department and was invited the following year by the United States Information Agency (USIA) to lecture about her film and sculpture in India and Iran. Later in the 1970s, the USIA arranged tours for her in South America and Europe. In 1971 Chase also spent time in New York, where she met Gerald Arpino of the Joffrey Ballet and Jean Erdman of the Open Eye Theater Company, both of whom were interested in her sculpture for dance.

Recognition for Chase's accomplishments in kinetic sculpture was beginning to broaden outside Seattle. Louis Chapin pointed out in the *Christian Science Monitor* in 1971, for example:

> Once upon a time, when an expert was extolling the "movement" in a piece of sculpture, he could only mean that quality in line, in shape or in rhythm of the forms which might invite the attention to move; nobody expected the work itself—once installed—to change position. Then came along Alexander Calder and his mobiles, followed in due course by those artist-engineers who enabled the parts of sculpture to turn, wobble, jump and become in various ways kinetic without any help at all from interpretive verbiage. But most of this change and movement was generated—or at least developed—by the work itself. A new contingent of artists, of whom Doris Chase of Seattle is perhaps the most articulate, is producing work that not only accepts change for itself, but in so doing requires it of the spectator-become-performer.[6]

This spectator-performer concept also attracted the Wadsworth Atheneum in Hartford, Connecticut, where plans were being formulated in 1972 for a major exhibition of Chase's sculptures for dance and children in the museum's new Tactile Gallery. Both Chase and Mary Staton were invited to hold workshops in Hartford during the exhibition, and the two began making plans for new multimedia collaborations.

Fig. 36. Children in special education classes performing with Doris Chase's modular forms at Shoreline School, Seattle, 1972. Elisabeth Blaine photograph.

In the interim, Chase traveled to Fort Lauderdale, Florida, to address July sessions of the 1972 International Montessori Convention. Serving on a panel with B. F. Skinner, she reported the promising conclusions being drawn about her children's sculpture and argued that "in conventional schools [children] come in and sit down and write and use little finger and eye muscles. Many more children can learn if they have a chance to use the whole body.... We know there is a coordination between balance and learning and balance and reading."[7]

Several schools and teachers expressed interest in the sculpture, but Chase had yet to find a manufacturer to produce and distribute the sets at moderate cost. Investigating the possibility of federal funding, she went to Washington, D.C., to consult with Senators Henry Jackson and Warren Magnuson. They purchased one of Chase's small, re-arrangeable compositions as a gift for President Lyndon Johnson but were unable to further her education venture.

The accelerating pace of Chase's professional activity in the late 1960s and early 1970s reflects her tenacity as well as her sincere enthusiasm for investigating new participatory art forms. It also suggests an attempt to escape, and indeed, Chase was desperately unhappy in her private life. "I was subconsciously trying to kill myself," she admits. "I would get pneumonia every year, and each time it got worse. I had two automobile accidents because I was aiming the car, not driving it. I was very depressed and felt that if I couldn't get away, I couldn't live."[8] After the Montessori conference in Florida, Chase decided to fly to New York for a few days to consider the future of her twenty-eight-year marriage and life in Seattle:

When I landed I considered two hotels I knew that were reasonably priced—the Tudor and the Chelsea. I literally flipped a coin and headed for the Chelsea. I'd been there years before when a painter had invited me down to look at his work. I liked the studio spaces but thought the

hotel was pretty grungy. Also, it seemed so far from the center of New York—it was all the way down on 23rd Street! But I went, anyway. The second day I was there I met George Kleinsinger, the composer, and he introduced me to Shirley Clarke. She invited me to a party in her penthouse. George, Harry Smith, Jonas Mekas and I all went up there to watch films. George brought his pet tarantula, which used to slide down his chest. Jonas asked to meet me the next day to talk about something really important, which turned out to be *his* work. After that George had a party; he played and sang and all sorts of writers and musicians came. This was just what I needed. I'd been hyperserious and all wrapped up in my personal problems. I saw that there was another world and there is a second chance.[9]

Returning to Seattle, Chase filed for divorce. Her sons were grown, the elder enrolled in a graduate program at Harvard and the younger traveling in Europe. Her husband had become a successful accountant and property consultant. She was forty-nine years old.

Intending to stay only a few months, Chase moved into the Chelsea, where she still lives. In addition to Kleinsinger, Shirley Clarke, and the hotel's famous floating retinue of junkies and pop musicians, Chelsea residents at the time of Chase's arrival in 1972 included Clifford Irving, Arthur C. Clarke, Virgil Thomson, and Andy Warhol's film star Viva. Chase began to see a great deal of Kleinsinger and his legendary top-floor apartment. Appointed like a set for a Tarzan musical, Kleinsinger's spacious studio housed a large piano (which he sometimes played while he was wrapped in his pet boa constrictor), a running waterfall, aquaria containing tropical fish and giant sea turtles, considerable tropical foliage, a skunk, an iguana, free-flying birds, and Mehitabel the cat (fig. 37). It is still difficult for many of Chase's Seattle acquaintances to imagine how the well-scrubbed, earnest, rather naive woman they remember could have felt immediately at home in the Chelsea Hotel.

"I moved to New York for personal reasons," Chase says:

> My two sons were grown and I simply had to get away to survive. Professionally, it seemed foolish. I had a terrific base of support in Seattle, and I really wanted to do more big public sculpture. On the other hand, I'd begun to think that too many *things* were being created. It wasn't just me—wherever I looked artists were cramming the world full of their creations. I thought maybe everyone, including myself, should pare down and be more caring about what they created. That's one reason why film seemed to make sense: it's not a thing, an object. You can make a statement and pack it into a little can. But I was really committed to the sculpture for children too. The Battelle Institute in Seattle was putting together a booklet on the sculpture for me and I thought I could make contacts with East Coast plastics manufacturers and maybe talk an insurance company into underwriting the sculpture. Unfortunately, just at that time oil prices were beginning to zoom and so the price of plastics went up too. School budgets were dropping. A good accountant advised me that to make it happen I would have to promote the sculpture for perhaps five years. I couldn't do that, and I have a lot of regret about giving up.[10]

Fig. 37. Doris Chase and George Kleinsinger working in Kleinsinger's apartment at the Chelsea Hotel, New York, 1976.

Chase's first professional obligations upon her arrival in New York included completing a program of performances and film exhibitions for her show at the Wadsworth Atheneum which opened in January 1973. Sculpture she had created from 1970 to 1972 for Mary Staton's dancers was featured in the exhibition, and Staton arranged several performances of her dance-sculpture choreography (fig. 38).

Collaborating with Chase strengthened Staton's views about the intimate kinship between dance and abstract sculpture. Staton wrote in 1969, "Motion, form, space and time—these are the elements I work with as a dancer and choreographer. . . . I try to imbue the space of the stage with new life—life growing out of time (fast, slow, rhythmic); form (open, closed, symmetrical, asymmetrical); and motion (vibrating, sustained, swinging, percussive). . . . The sculptor faces a similar problem. He [shapes] the raw material. . .into a form which exists in space with definite rhythms and motion. The dancer and the choreographer create perhaps 10,000 pieces of living sculpture in one ballet."[11]

Staton's dancer-choreographer perspective on the relationships between dance and sculpture was complementary but not identical to Chase's: while Staton viewed the alignment of dance and sculpture in terms of shaping and animating space, Chase approached dance movement as a means of extending the fluidity and dynamism of her sculptural forms. As Chase saw it, "The [dance] sculptures are a definite architecture in space, becoming a fluid environment when interwoven with the human form. Elements of form and motion are multiplied to achieve an abstract and dramatic line of action. The dancers fuse with the forms and ultimately transcend them through motion and change. Dancers tend to feel that the sculpture extends their bodies, where I feel the dancers extend the sculpture. Depending on the creative bent of the choreographer, an infinite number of conclusions can be reached with the same form."[12]

This range of conclusions, as Chase discovered in making *Circles II*, could also be expanded through the kinetic medium of film. After opening-night festivities at the Atheneum, she arranged for Staton and her dancers to remain in the museum's Avery Sculpture Court. Chase brought in two cameramen, set the lights, and directed the shots while the dancers performed until 3:00 A.M. After extensive postproduction revisions, Chase used the resulting footage to create three films: *Moon Gates*, *Tall Arches*, and *Rocking Orange*.[13]

In the performance filmed for *Moon Gates*, Staton reworked her choreography for dance sculptures Chase had created for a 1970 Seattle Opera Company production. These are lightweight half-cylinders, standing approximately seven feet tall, with ovals cut out in the center. These hemicycles move slowly when touched and are designed to come together to form a barrel shape or to be combined as undulating concave and convex loops (fig. 39). Staton's choreography suggests children playing with blocks, and the dancers' positioning and movements emulate the negative and positive interplay of the sculptural forms. The dance sculptures in *Tall Arches* are three concentric nesting arches that roll on casters and fit together like a mobile Chinese puzzle. The dance parallels the logic of the sculptural system, utilizing the rolling arches to create images of unity and multiplicity, dispersion and consolidation. In *Rocking Orange*, the dance sculptures are egg-shaped and hollow. The choreography is again lyrical, emphasizing rolling and swaying movements that harmonize with the rocking motion of the sculptures (fig 40).

Sections of the Atheneum footage were sent back to Seattle for processing at Alpha Cine, where Chase continued her technical collaboration with Frank Olvey and Robert Brown. "The films were shot for high contrast—very sharp im-

Fig. 38. Doris Chase at the Wadsworth Atheneum, Hartford, Connecticut, for 1973 exhibition of her sculpture for dance and children. *Hartford Courant* photograph.

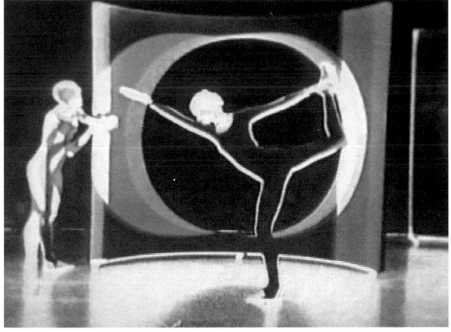

Fig. 39. *Moon Gates*, 1974. Two film stills.

ages against white or black backgrounds," Chase explains. "We worked with superimpositions and step printing, using the color separations to get the effect of solarization. The basic approach was like *Circles II*, except that I had a lot less film to work with. The company that shot *Circles II* did four or five days of shooting in a studio. At the museum we did all the filming in a few hours after the opening-night reception, so we had to be even more creative in editing what we shot."[14]

When he compared the Atheneum films processed by Brown and Olvey with *Circles II*, Bob Sitton, former director of the Northwest Film Study Center in

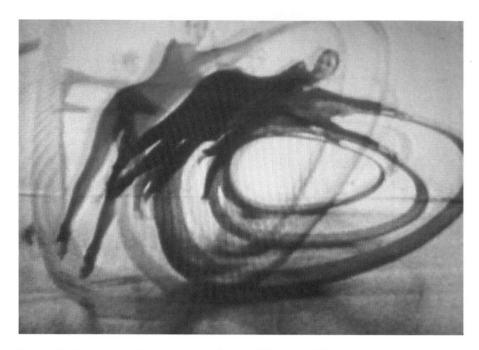

Fig. 40. *Rocking Orange*, 1974. Film Still.

Portland, Oregon, and an early exhibitor of Chase's films, detected a more calculated refinement in the later compositions:

> There have been "dance films," but Doris's are something more. Like other avant-garde works, hers resist classification. Yet their beauty is quite traditional. The undulating forms and colors... are appealing for the same reasons we learned to accept Kandinsky's paintings. They are formally rich.
>
> There is also the element of chance. It seems sometimes that Doris is fending off her work rather than creating it. The images rush toward her at the editing bench with such force that it seems all she can do to grasp their edges and try to shape them.
>
> Sometimes, particularly in her recent work [the Atheneum films], she seems in total control. *Tall Arches*, though less exciting and spontaneous than the earlier *Circles II*, is nonetheless a purer realization of what she is trying to do. In this film she manipulates the images throughout, while at the same time letting us have little surprises of improvisation.[15]

The scores of the Atheneum films, as for almost all of Chase's dance films and tapes, were selected in the final editing process and do not repeat the music utilized in the live performances. The films have their own rhythms, pacing, and crescendos which place a new set of demands on the musical accompaniments. Kleinsinger composed original scores for *Moon Gates*, *Tall Arches*, and *Rocking Orange* as well as new music for *Circles II*. "George just loved the films," Chase says. "When he saw *Circles II*, which I had brought with me from Seattle, he immediately said, 'I can do music for this,' and started composing. *Circles II* originally had a marvelous score by William O. Smith, who taught at the University of Washington, but the style of the music wasn't popular with film distributors. George's music was more upbeat, and immediately after his music was put on the film it got a good distributor. Not too long ago [in 1986] I was told, not by a film distributor but by a top film curator, that

George's music should be replaced because it was too old-fashioned. I could never have imagined that an artist would have these conversations when I began making films."[16]

While Chase was working with Brown and Olvey in 1973, sending the Atheneum footage back and forth from New York to Seattle, she renewed her acquaintance with Nam June Paik. Paik was then artist-in-residence at the Television Laboratory at WNET-TV/Channel 13 in New York. He suggested that she visit the studio and meet the director, David Loxton. A showing of *Circles II* was arranged for Loxton, who then invited Chase to experiment with the Lab's equipment. "The Television Laboratory had the latest in video technology, which was a Paik/Abe synthesizer and colorizer," Chase recalls. "I met Steve Rutt and Bill Etra there, who were developing the Rutt/Etra synthesizer. I experimented and found out that a lot of the effects I'd struggled to get in film I could get instantly and much less expensively in video. Of course there were also a lot of effects that a video synthesizer could do that couldn't be done in a film lab. It was a revelation."[17]

Chase had made one videotape in Seattle, before moving to New York, which she brought to WNET for her initial experiments with video processing. Shot in black-and-white at Television Station KCTS in Seattle, the tape documented a performance of the Philadelphia String Quartet. Chase found working with these images at WNET to be "better than sketching the musicians. With that equipment I could show several musicians together or expand upon a detail, like the fingering. With the colorizer I could do color effects, which was terrific because I always experience music in color."[18]

After processing the Philadelphia String Quartet tape at WNET, Chase transferred a copy of the tape to film stock. She also transferred a copy of the unprocessed tape to film stock and sent it to Seattle for optical effects. These two films, originally derived from the same videotape, one processed with a video synthesizer and the other with film equipment, are generally not exhibited together as comparative technical studies, but Chase did put together several such demonstrations in the mid-1970s. The Atheneum films *Rocking Orange* and *Moon Gates*, for example, were both exhibited as three-part variations to illustrate film and video postproduction techniques. In *Moon Gates—Three Versions* (1974), the first section is a straightforward filmic document of the dancers and sculpture in performance. The second sections shows the same footage transferred to videotape, processed with a Paik/Abe synthesizer, and then reconverted to film. The third section re-presents the images processed on film by Brown and Olvey in Seattle. *Rocking Orange—Three Versions* (1975) follows the same pattern. The contrast is striking in both studies between the vividly colored and patterned electronic imagery of the video segments and the more lyrical and delicate superimpositions achieved on film stock at Alpha Cine. Sections of both films are also exhibited separately.

Less than a year after her first visit to WNET, Chase purchased her own video camera and began making tapes. Her EAT background left her little doubt that video would be the privileged art form of the future. Like most New York artists investigating video in the early 1970s, she assumed that new art institutions and support systems would arise spontaneously to serve the medium McLuhan had identified as the pivot point of the electronic age. Her assumption was not incorrect, at least for artists who found themselves in the right geographical locations.

Fig. 41. Doris Chase with artist-engineer Peer Bode at the Experimental Television Center, Owego, New York, late 1970s. David Gronbeck photograph.

Video Art and New York: The First Decade

As the "big bang" model of video history would have it, video art in America was just seven years old when Chase moved to New York in 1972. The art form was launched, according to several accounts, on October 4, 1965, the day multimedia artist and composer Nam June Paik acquired a Sony Portapak. Although a case can be made for the appearance of "video art" prior to 1965, the big bang model dramatizes the new range of technical possibilities suddenly opened to artists in the mid-1960s. No matter how the origins of video art are construed, there is no dispute about the conclusion that the introduction of the Sony Portapak, the first video production equipment widely marketed in America for the nonprofessional consumer, provided a clear line of demarcation in the development of artists video.

Prior to the appearance of the Portapak, videotapes were almost entirely the province of the professional television studio. Costs for studio-produced videotape averaged about $260 per hour in the mid-1960s; with the advent of the Portapak, the per-hour cost fell to $18.[1] This reduction was possible, in part, because the Portapak used half-inch videotape and its camera did not shoot color pictures. Unlike the standard two-inch tape used in network studios, half-inch tapes could not be broadcast without additional processing because they do not contain enough electronic information to produce a high-quality image on home television receivers. Despite these drawbacks, the Portapak was compelling: commercial TV cameras weighed more than 100 pounds and cost between $50,000 and $100,000. The Sony camera, hand-held and portable, was priced at $2,500. With a camera crew no longer required, greater individual mobility was possible, and with it, greater opportunity for creative experimentation.[2]

Paik made his first videotape in a Manhattan cab, riding home after purchasing his camera. Caught in a traffic jam surrounding the motorcade of visiting Pope Paul VI, Paik shot the passing spectacle and showed the tape that evening at the Café à Go-Go.[3] Paik's Café à Go-Go exhibition, if not the first exhibition of independently produced artists video in the U.S., represents one of the earliest appropriations of television technology by an individual artist.

The career of Nam June Paik, whom Chase first encountered in the late 1960s, coincides with the history of artists video at several points. Before the Sony Portapak enabled him to produce his own tapes, for example, Paik was credited with the first exhibition of television "sculpture" at the "Exposition of Music-Electronic Television" presented at the Galerie Parnass in Wuppertal, Germany, in 1963. Korean-born Paik came to Germany in 1956 to study

twentieth-century music at the Universities of Munich and Cologne. He met Karlheinz Stockhausen and John Cage, under whose influence he began incorporating a variety of physical actions and ordinary objects into his concert performances. This trend was accelerated in the early 1960s when he encountered George Maciunas and Fluxus, an artists' group that organized multimedia performances reminiscent of Futurist *serate* in several European cities. Among Paik's Fluxus colleagues was Wolf Vostell, a German pioneer in the creation of video sculpture, who exhibited "de-collaged"—partly destroyed—television sets in 1963 at New York's Smolin Gallery, where Chase had her first one-person New York show two years later.[4]

In the 1963 "Exposition of Music-Electronic Television," Paik parodied John Cage's prepared pianos: just as Cage altered the piano's hammers and strings to create sounds pianos were not supposed to make, Paik rearranged the wiring and voltage of thirteen used television sets to bend and distort their images. The historic significance of this decision, according to WNET's David Loxton, was enormous. "It was Paik who saw that the way the signal was created on the monitor presented all sorts of opportunities for new images. That vision obviously made everyone stop and think. You could really make TV just by manipulating the signals electronically, without all this insane $2,000-a-minute business of studio production."[5]

After moving to New York in 1964, Paik continued to experiment with prepared television sets. He also began using magnets to alter the electronic wave patterns on the screen, creating abstract rhythms of light. As the 1960s progressed he continued to perform, but he became more and more absorbed by the challenge of demystifying television and diverting the medium from its commercial broadcasting monopoly.

The Rockefeller Foundation Arts Program, one of the first major foundation programs to support video art, awarded Paik a grant in 1968 to continue his television research. The foundation also supported experimental programs at public television stations KQED in San Francisco, WNET in New York, and WGBH in Boston, where producer-director Fred Barzyk invited a group of artists to produce videotapes in 1968: sections of these tapes were shown in a half-hour program, "The Medium Is the Medium," in 1969, the first national broadcast of artists video. Among the WGBH contributors, in addition to Paik, were Allan Kaprow, intermedia artists Aldo Tambellini and Otto Piene, and James Seawright, a kinetic sculptor and supervisor of the Electronic Media Centers of Columbia and Princeton Universities, Paik's segment of "The Medium Is the Medium," *Electronic Opera No. 1*, was the first of his tapes to be broadcast.[6]

In 1969 the Rockefeller Foundation began funding an artist-in-residence program at Boston's WGBH: the first artist selected was Stan van der Beek, whose computer films had been a stimulus for Chase's production of *Circles I* in Seattle. The second nominee was Paik, who convinced WGBH to build the first prototype of the Paik/Abe synthesizer. Within the next few years Paik and Japanese engineer Abe built synthesizers capable of creating video images or altering prerecorded material for the California Institute of the Arts, where Chase had first met him, WNET in New York, and the Experimental Television Center in Binghamton, New York. Together with other video-imaging tools, such as those designed by Eric Siegel, Steve Rutt, Stephen Beck, and Bill and Louise Etra, this technology produced a quantum leap in the art form.

The burgeoning video art movement claimed the attention of the New York art establishment in 1969 with a seminal exhibition, "TV as a Creative Me-

dium," at the Howard Wise Gallery. Among the show's highlights was Paik's *TV Bra for Living Sculpture*, a collaborative production in which cellist Charlotte Moorman's breasts were covered with three-inch television sets displaying images modified electronically by the sounds of her cello. This composition, according to Paik, represented an attempt to humanize technology by showing that "television has not yet left the breast."[7] The exhibition also featured Ira Schneider and Frank Gillette's closed-circuit *Wipe Cycle*, where viewers glimpsed their own images from several points of view at different moments in time on a bank of monitors. This attempt to "integrate the audience into the information" was an influential early prototype for the artistic employment of interactive television.[8]

The first museum exhibition devoted to artists video, "Vision and Television," was presented at the Rose Art Museum at Brandeis University a year later. The museum's assistant director Russell Conner was the exhibition's curator. Conner was subsequently invited to become director of the newly established video grants program of the New York State Council for the Arts. This program marked another turning point in the history of artists video.

The financial commitment to video on the part of the New York State Council for the Arts (NYSCA) was critical in assuring the preeminence of New York City as the first major center of video artmaking in the United States. Between 1970 and 1977, the years in which Chase adopted video as her principal medium, the council awarded $4,758,000 in support of video art alone.[9] In the first years of NYSCA's video grant program, funds were allocated primarily for purchase of expensive video equipment by organizations that would make hardware available to artists. These organizations included New York state's public television stations, which received grants to acquire technical facilities such as time-base correctors. These machines correct the distortion in a video image caused by failure of a video recorder to record an action in the same amount of time actually encompassed by the live action. (This problem might occur, for example, when a Portapak's batteries were slightly run down.) Together with equipment for transferring half-inch video tape to two-inch tape, this technology enabled independent video artists to produce broadcast-quality images, which began to appear on the state's public television stations in the mid-1970s.[10]

Perhaps the most historically consequential NYSCA grant to a public television station was awarded in 1971 to New York's WNET for the establishment of an "Artist's Television Workshop." In 1972, combining NYSCA funds with a grant from the Rockefeller Foundation, the workshop became "The Television Laboratory of WNET/Thirteen," where Chase received her introduction to recently developed video technology. At first, time to experiment with the Lab's equipment was distributed among artists from many disciplines so that "the fruits of the artists' experience could be applied to raising viewer consciousness." In 1974, following this period of broad McLuhanesque experimentation, the Rockefeller Foundation began funding long- and short-term artist-in-residence programs at WNET for a select group of artists. The first long-term awards went to Nam June Paik and Ed Emshwiller, a filmmaker and former painter.[11] Emshwiller and Paik had previously produced tapes at the Lab that were among the first artists videotapes to be broadcast in New York. These included Emshwiller's *Scape Mates* (1972) and Paik's *Global Groove* (1973). *Global Groove*, a tribute/spoof on McLuhan's concept of a worldwide global village wired together through the electronic nervous system of television, became one of the world's most influential and well-known artists videotapes.

In 1973 the Lab began working with video groups committed to alternative documentaries investigating social phenomena not covered by commercial broadcast journalism. The first of these groups supported by the Lab was Top Value Television (TVTV) an organization whose members were initially drawn from several video collectives who had joined forces to report on the network coverage of the 1972 Republican and Democratic Conventions. Documentaries produced by Manhattan's Downtown Community Television, a production organization founded in 1971, also received support from the Lab. Among their productions were *Cuba, the People*, one of the first U.S. documentaries shot inside Castro's Cuba.[12]

Although the Lab continued to support experimental work by artists from various disciplines, by the mid-1970s less emphasis was being placed on experimentation and more on the production of potentially broadcastable videotapes.[13] Alternative documentaries and work by WNET artists-in-residence, such as Paik, Emshwiller, Peter Campus, and William Wegman, were among the more likely candidates for broadcast, so the Lab began to consolidate its range of support. WNET was also one of the few broadcast outlets for video art in the country in the mid-1970s; artists supported by or granted long-term access to the Television Laboratory thus assumed a position of privilege over many of their peers.

Other technical facilities funded by NYSCA, however, kept the field open to artists such as Chase who did not have extended access to WNET's Television Laboratory. Significant among them was the Experimental Television Center, currently operating in Owego, New York (figs. 41, 42). Founded in 1971 by Ralph Hocking, the center offered workshops and instruction programs in conjunction with the State University of New York in Binghamton. Independent videomakers could apply for several-day residencies at the center to work with a variety of image-processing tools, including computerized video synthesizers. Fees were nominal and artists-in-residence had sole use of the equipment.[14] Starting in the mid-1970s, Chase worked at the center with engineer David Jones and artist-engineer Peer Bode, who collaborated with her on several productions.

Fig. 42. Doris Chase with artist-engineer Peer Bode at Owego, New York, late 1970s.

The Newhouse Communications Center at Syracuse, a multimillion-dollar professional editing and postproduction facility, was also open to artists in the 1970s. Syracuse entered video history in 1971, when the first American museum video department was established, with David Ross as its curator, at Syracuse University's Everson Museum of Art.[15] Later the university hosted the Synapse Artist Visitation Program, open to New York artists from all fields interested in exploring unique qualities of video.

Another important video postproduction facility available to artists in the 1970s, Electronic Arts Intermix, was founded by Howard Wise, whose gallery in 1969 presented the landmark exhibition, "TV as a Creative Medium." After the exhibition Wise closed his gallery, where he had shown kinetic and light sculpture earlier in the 1960s, and founded Electronic Arts Intermix, initially a funding agency for video and performance art. In 1972 and 1973 the agency evolved into a Manhattan video distribution company and postproduction facility, where Chase worked in the late 1970s and early 1980s. Today Electronic Arts Intermix continues to distribute the work of many seminal video artists. The other prominent distributor of tapes by well-known artists in the 1970s and early 1980s, Castelli-Sonnabend Videotapes and Films, was established by art dealers Leo Castelli and Ileana Sonnabend in 1972.

One of the first organizations to receive support from Electronic Arts Intermix was the Kitchen, a screening and performance center founded by video artists Woody and Steina Vasulka in 1971.[16] The Vasulkas, who began working with video in 1969, were attracted by the fluidity and lack of structure the art form offered in its nascent period. At the Kitchen in the early 1970s, video artists found a rare opportunity for peer-group exchange: in part because of these discussions, the outlines of the new art form began to cohere and solidify, countering the fluidity that originally had attracted the Vasulkas, who left the organization in 1973.[17] Like the Vasulkas, Chase cites the early years at the Kitchen as a unique professional milieu. "There wasn't a lot of cooperation among artists in video even then," Chase observes, "but at least we would get together and share some ideas about how to do things. The Kitchen stands out in my mind as *the* early gathering place, one of the few places where artists could go just to watch each other's work. It gave us a certain sense of community. I think almost everyone who showed there felt that way."[18]

In 1974, the Vasulkas moved to Buffalo, where Woody became an associate professor at the Center for Media Study at the State University of New York. Founded by Gerald O'Grady in 1972, the Center for Media Study is a component of one of the most extensive and elaborate media programs in the United States. In conjunction with the Educational Communications Center (which supplies media services to the local New York State University campus) and Media Study/Buffalo (a video resource center with facilities including a former hotel renovated to house fifty film- and video-editing rooms, living spaces, and one of the largest sound studios in the state), the Center for Media Study offers degree programs in film and video production and in media psychology, history, and criticism. In the mid-1970s the faculty included such highly regarded artists and theorists as James Blue, Hollis Frampton, Paul Sharits, and Brian Henderson, as well as the Vasulkas, who were beginning to use digital computers to alter the internal structure of their video images. Well-funded and sophisticated, the center's programs added depth to both the theoretical and practical development of video art within New York state.[19]

For independent artists, the accessibility of expensive video equipment, editing facilities, and training serves as a key determinant for the growth of video as an art form in any locale. NYSCA grants in the early 1970s focused on creating the costly technical prerequisites for the emergence of this new artistic genre, a singular achievement among state art agencies. In addition to grants for postproduction facilities and to public television stations for equipment available to artists, NYSCA also funded organizations such as Young Filmmakers/Video Art, a statewide media access and training group founded by Rodger Larson. In New York City, the group opened the Media Equipment Resource Center (MERC) in 1971. MERC loaned or rented video equipment to nonprofit organizations and artists, including Doris Chase in the early 1970s, as well as maintaining a multicamera production studio. Elsewhere in New York state, similar access facilities were established in Long Island, Ithaca, Jamestown, and Rochester.[20]

In New York City hands-on production classes and video workshops were widely available by the mid-1970s. Among the leading instructional organizations was Global Village, one of the country's first nonprofit video organizations. Established in 1969 as a video collective, Global Village today is a major center for the production of alternative documentaries. With the establishment of resources such as Anthology Film Archives' videotape and research library, opportunities widened for New York artists to view the productions of their

peers. Already one of the city's most highly respected avant-garde film organizations, Anthology appointed Shigeko Kubota as its first video curator in 1974 and began offering a regular program of video exhibitions and screenings.[21] In 1971 the Whitney Museum of American Art held its first videotape exhibitions, which became an established feature of the museum's program in 1976. In the same year the Museum of Modern Art initiated its videotape collection. With NYSCA support, major New York State Public Libraries began circulating videotapes in the early 1970s; a number of libraries, in addition, held production workshops and screenings. In New York City the Donnell Library established a Film/Video Study Center, where an important collection of artists videotapes was assembled and exhibited.[22] Under the direction of William Sloan, now director of the Circulating Film Library at the Museum of Modern Art, the Donnell Library program was among the first New York venues for Chase's work.

As this selective survey of technological resources and institutions suggests, Doris Chase launched her long and productive career as a video artist in a uniquely promising milieu offered by New York in the early 1970s. The mushrooming of support structures for New York video artists was incomparable in the U.S., and although strong regional media arts centers have been created in several other cities, New York still retains preeminence.[23] Chase's artistic evolution and institutional involvements, however, were also affected by the nature of the critical systems and hierarchical interpretations of various approaches to video artmaking. Unlike the development of technical and organizational resources, the development of video art systems and hierarchies has often seemed bafflingly amorphous, unsystematic, and self-serving. As video historian Ann-Sargent Wooster noted in 1985, "for all its historical precedents and for all the varieties of criticism to which it is open, video art has proved opaque not only to its critics but also to its practitioners, who frequently do not understand the origins of the structures they share." As of the mid-1980s, she concludes, "a critical model for video has not been constructed."[24]

A review of various attempts to define "video art" confirms Wooster's observation. Although there are exceptions, most attempts to define video art in the U.S. have been initiated with one of the following questions: "What distinguishes the medium of video *art* from other art forms?" Or, alternatively, "What distinguishes *video* art from television?"

The form of the first question signals the legacy of America's most influential visual art critic, Clement Greenberg. From the late 1940s to the early 1960s, Greenberg defended the proposition that the history of modern art had been characterized by a bias or tropism which encouraged progressive artists to focus upon the qualities of a particular medium that belonged exclusively to the medium. For example, since the medium of easel painting is essentially flat, Greenberg maintained that the modernist tropism resulted in the gradual elimination of formal mechanisms, such as spatial illusionism, inconsistent with the medium's essential two-dimensionality. The elimination of spatial illusionism led in turn, he argued, to the waning of traditional representational imagery.

Whether or not they accepted his specific conclusions, many artists and critics in the late 1960s and early 1970s followed Greenberg's lead in attempting to isolate and focus upon the definitive characteristics of particular artistic media. Under these circumstances, "What distinguishes the medium of video art from other art forms?" seemed the first and most reasonable question for video theorists to settle. Furthermore, one of McLuhan's best-known catch phrases "The medium is the message" also seemed to suggest that the meaning of "video art" was to be found in the essential qualities of the electronic medium

itself. McLuhan was not in fact alluding to Greenberg's thinking when he formulated his famous phrase: the point he meant to convey was that "the message of any medium of technology is the change of scale or pace or pattern that it introduces into human affairs."[25] Few video theorists traced McLuhan's slogan back to its original context, however, and it was freely employed in pursuit of a Greenbergian definition of video art.

For a Greenbergian analyst, the evident answer to the question: what distinguishes the medium of video art from other art forms? would seem to be: the essential characteristics of the electronic tools. As the medium of oil painting is fundamentally a matter of applying pigment to a flat canvas, so the medium of video can be analogously characterized as the manipulation of electronic signals on a video screen. Some writers noted further that video is essentially a temporal medium and thus has an affinity with theater. It is also a kinetic medium like dance, an aural medium like music, and when video monitors are grouped in ensembles, video shares the three-dimensional physicality of sculpture. This wide range of basic attributes suggests that video might hold great promise for the development of new intermedia art forms, and certainly Chase's artistic development was inspired by such a presumption.

The question: What distinguishes the medium of video art from other art forms? also presupposes that video is an *art* form, like painting or sculpture or printmaking, and thus, as Chase presumed, partakes of related aesthetic concerns. In the mid-1970s Paik reinforced this equation by comparing the cathode ray tube to an electronic canvas, predicting that the video synthesizer would enable artists to shape the TV-screen canvas

> as precisely as Leonardo
> as freely as Picasso
> as colorfully as Mondrian
> as violently as Pollock
> as lyrically as Jasper Johns... [26]

In a catalog for a major video exhibition mounted in 1984 at the Stedelijk Museum in Amsterdam, one of Western Europe's most highly respected contemporary art museums, critic Wim Beeren provided a more recent formulation of the argument for equating the aesthetics of video art with those of painting and sculpture:

> My premise is that not all uses of the video medium qualify as 'art.' I am prepared to regard video as art when... it concentrates on aspects of color, line, three-dimensional forms and their possible interrelationships. It differs from traditional forms because it moves, because its changing forms occupy time, and because of its material.
>
> Painting and video art have color and the way it is formed in common. Drawing and video both employ line and the way it [the line] is formed. Painting, drawing and video share an interest in space, open and closed. Like these art forms video art can concern itself with perceptible reality or transpose it into abstract signs or precepts.... Like painting and drawing, video is two-dimensional and manifests itself in color and line, creating them into forms and units of forms.... Like sculpture, video art can concentrate on three-dimensionality and how to formulate it.[27]

If the cathode tube is a kind of kinetic canvas where artists explore line, color, space, and form, as Beeren indicates, artistic advancement within the medium should come about as new electronic means are found to expand the range of visual effects. Video history in the late 1960s and early 1970s is thus marked by the development of video synthesizers and colorizers and by creative experimentation with standard television equipment. Abstract or semi-abstract compositions that resulted from virtuoso employments of electronic imaging tools came to be known as "image processing." Since image-processed tapes seemed to provide the closest visual analogies to modernist painting, it was not difficult for contemporary curators in the early 1970s to accept image-processed videotape as "art."

A decade later, as Whitney Museum of American Art curator Lucinda Furlong has pointed out, many American video artists and critics have come to regard "image processing" as a pejorative designation equated with "visual Muzak" or "visual candy." In the mid-1970s the historical model of progressive modernism associated with Greenberg came under attack by an influential segment of the New York critical establishment: when this occurred, the links established between image-processing and modernist painting became a liability rather than an asset. The problem was not so much that image-processed work was inherently "bad," Furlong explains, as that it came to be seen in association with an exhausted modernist theory. After the mid-1970s, she maintains, "no one in art circles wanted to hear about—let alone look at—video art that seemed to be based on the conventions of modern painting."[28] A lingering of late-1960s EAT idealism is reflected in the continuing admiration for artists who actually built image-processing tools, as did Bill Etra, Stephen Beck, and Daniel Sandin,[29] or who collaborated on the design of specialized imaging equipment, as did Paik and the Vasulkas. With the conspicuous exception of Paik's work, however, image-processed tapes by artist-engineers gradually fell out of major institutional favor in the 1970s, as did other forms of cybernetic art.[30]

Image processing did gain one clear theoretical advantage in its association with modernist painting: a claim to the status of art. In contrast, many museum curators questioned the artistic status of videotapes devoted to social commentary. Whitney Museum film and video curator John Hanhardt, for example, has made a distinction between "activists" who "use video as a tool for social change," and "video artists" who produce "tapes and installations designed to explore the medium's potential for new aesthetic discourse."[31] Documentaries, especially those with pointed social or political content, have not been well represented in most major museum exhibition programs, and public television's early support for alternative documentaries has gradually declined. Videotapes with topical social content, therefore, seemed ill-suited to replace image processing as a potential paradigm for "video art."

If "no one in art circles wanted to hear about—let alone look at" image processing (except for Paik's), and if social documentaries tend to be produced by "activists" rather than "video artists," what other uses of the medium might qualify as a definitive direction for the field to take after the mid-1970s? Surveying museum catalogs and anthologies on video art published in the late 1970s and early 1980s, a certain enthusiasm can still be detected for interactive systems that "integrate the audience into the information," and for the employment of video as an intermedia art form. Multimonitor video installations and quasi-architectural video environments by artists such as Bruce Nauman, Shigeko Kubota, Nam June Paik, and Bill Viola are repeatedly singled out for

acclaim. A third, very broad category of videotapes, however, has received the most serious critical attention. These can be generally characterized as tapes that communicate an intellectual message about the nature of the medium itself, without resorting to the "artistic" visual effects associated with image processing. Among them, for example, are "narcissistic" tapes by Vito Acconci, Richard Serra, and Joan Jonas from the early 1970s that investigate the instantaneous recording and transmission of the artist's own image by a video camera and monitor. Also exemplary is the work of Peter Campus, one of the few early video artists with experience in commercial television.[32] Witty and technically confounding, Campus's tapes dispute the assumption that video is a truthful medium.

Some of these self-conscious inquiries into the nature of the video medium were generated by attempts to confront the question, "What distinguishes *video* art from *television?*," another potential route to a definition of the field. The first and most obvious answer was provided by the low-tech photography of early Portapak art tapes and by high-tech image processing; artists video didn't *look* like broadcast television. This difference in look seemed significant. According to Lucinda Furlong, "'Image processing' as we know it today grew out of a very intensive period of experimentation that for some, in a vague way, was seen visually to subvert the [television] system that brought the Vietnam war home every night."[33]

A distinction between broadcast television and video art based on differences in visual surface alone has limited utility, and a number of artists and critics in the 1970s found other criteria for distinguishing the two fields. Compiling one of the first widely distributed American anthologies on video practice and theory, editor Gregory Battcock observed in 1978 that "video art" might be defined as "what television is not." In surveying the field, he noted, "We first became aware that art video, although sharing the general technology of commercial television, deliberately rejects many of its basic rules and principles."[34] As a theoretical backdrop for this negative definition of artists video, Battcock singles out the writings of critic and poet David Antin and video artist Les Levine.

In an influential 1974 article, "Video: The Distinctive Features of the Medium," Antin developed the argument that artists videotapes are defined by their inverse relationship to the formal and commercial organization of network television programs. For example: network programs are built around ten-second sequences, the smallest salable unit of television time, arranged in linear sequences. In many early artists videotapes, in contrast, timing was determined by the actual time required to carry out the task at hand. Many artist's programs, therefore, appeared long and boring to viewers conditioned by the temporal pacing of broadcast TV. Distinctive video art, Antin suggests, can be created when artists engage and parody the mannerisms and structure of broadcast television programs in order to produce a "curiously mediated but serious critique."[35]

Antin removes video art from television primarily by stressing the differing formal structure of the programs. Les Levine emphasizes that the artist's approach to content also separates the two fields. Artists use television technology, he wrote, "to express art ideas instead of simply to sell products, the most common use of broadcast TV."[36]

In their 1970s writings, both Antin and Levine approach television and video as two different employments of the same basic electronic medium: if an artists videotape produced in a television studio and a network television program

were viewed side by side, presumably the form and content of the artist's tape would enable the audience to tell which was which. Here "medium" essentially means, as it did to most Greenbergian analysts, "the electronic tools." But equating "medium" with "tools" can be highly problematic in sorting out the differences between video art and television, for this equation fails to come to grips with the true import of McLuhan's incantation—"The medium is the message." McLuhan approached television not just as a form of new hardware but as the major mass communications medium of the mid-twentieth century. Its "message" is the profoundly different way in which television-watchers subconsciously structure their perceptual experiences compared with the subliminal habits of people reared in cultures where print was the dominant form of mass communication. McLuhan repeatedly stressed that the commercial or artistic content or form of television programs is not the essential "message" of the medium: television changes culture not through its programming, he maintained, but by a collective psychic reaction to bombardment of the senses by electrons shot from the cathode ray gun. Thus from a McLuhanesque vantage point, video art and television are not the same medium because video art is not a mass medium. Video theorist Gene Youngblood, furthermore, now argues that video art cannot be a mass medium because "art and communication are fundamentally at cross purposes. Art is a process of exploration and inquiry. Its subject is the human potential for aesthetic perception. It asks: How can we be different? What is other? In a basic sense art is always non-communicative: it is about personal vision and autonomy; its aim is to produce non-standard observers. Television in its present form represents exactly the opposite. Its goal is the production of standard observers. . . . The notion that video 'belongs on television' is both a contradiction in terms and a confusion of issues. Personal vision is not public vision; art is not the stuff of mass communication."[37]

The relationship of video art to television, as Youngblood indicates, has been further convoluted by the fact that many artists who make categorical distinctions between video art and television believe nevertheless that their work belongs *on* television. A leading question among video artists of the 1970s was: How soon will artists have their own TV channels? Paik predicted that with the advent of cable television, *TV Guide* would be as thick as the Manhattan telephone book. Not only did he envision different TV channels for different art forms but also single-artist channels—an all-Mozart or John Cage station, for example. Nourishing related expectations, Russell Conner founded the Cable Arts Foundation in New York City to produce and distribute art programs to cable systems. In 1976 video curator David Ross predicted too that "the role of the museum in regard to video art may well become that of a catalyst for museum-operated art-specialized television channels."[38]

Most video artists who began their careers in the early 1970s were in fact drawn to video by television, by television's capacity for delivering visual information directly to the intimate and familiar environment of the private residence. Although they welcomed museum support, many artists recognized, as did Ross, that the sociological implications of a medium designed and developed for casual, home-oriented, serendipitous access are "in a way perverted when videotapes are shown in a public gallery space."[39]

When the end of the 1970s did not bring a proliferation of artists' channels after all, videomakers began to see their work as not only "in a way perverted" by the stiff ambiance of museum exhibitions, but also as increasingly ghettoized and estranged from nongallery audiences. Because of this ironic

privatization of, theoretically, the most public of new media forms, Chase and many of her colleagues began to be led, in frustration, back to the mass medium of television. As video artist John Sanborn said in 1981: "The fact is we are interested in television. Either in changing it, adapting it, getting rich off it, co-opting it, selling it, free-basing it or just plain getting our work on it. . . . Three years ago your honest video artist wouldn't be caught dead with his or her work on TV. Just not done, old chap. But those artists are now independent producers, with work on cable (pay or otherwise), PBS, CBS, and dare I say it, satellite. We're in the business, in some form."[40]

Like many other artists, Chase responded to the convoluted critical climate for video art by trying to ignore it and move ahead with her ideas, recognizing at the same time that her approach to the medium, as well as her subject matter, positioned her work within the shifting politics of critical theory. She remained essentially in agreement with Nam June Paik's observation: "Everyone is trying to define what video art it. Art critics struggle with that a lot. But I think the best thing is not to try to define video. In New York every art movement is destined to die in five years, but I would like to save video from such quick obsolescence. It is more than a fad."[41]

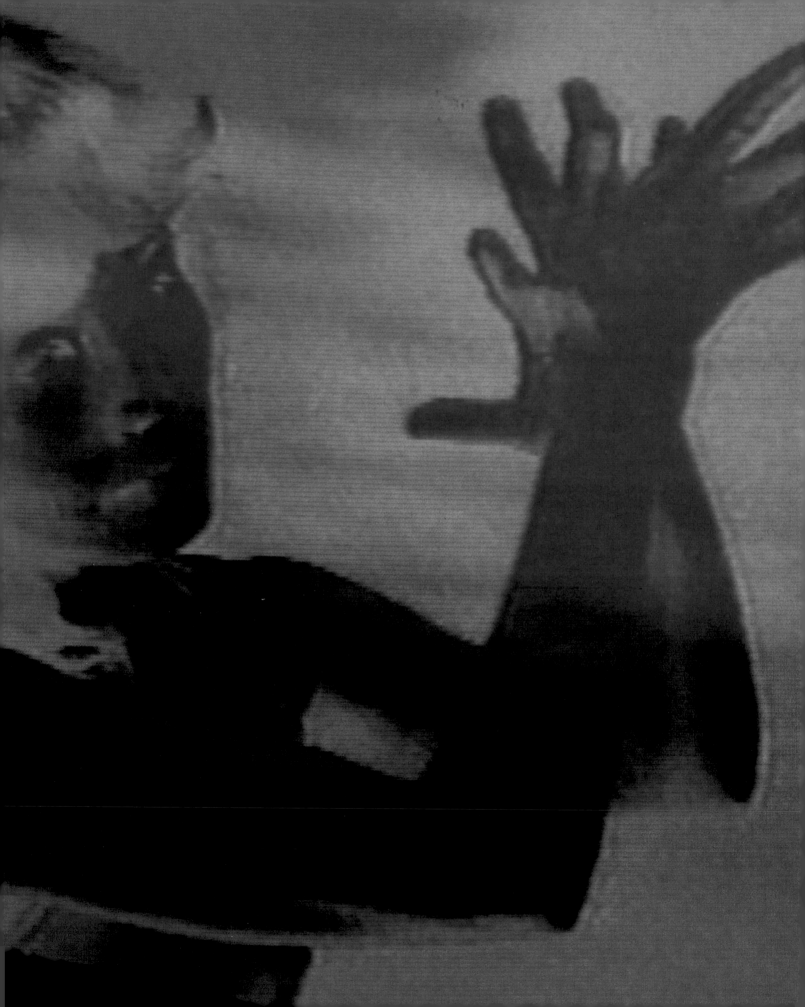

Videodance

When Chase first took up residence in the Chelsea Hotel in 1972, her professional ambitions were still centered around kinetic sculpture and collaborative multimedia performance. "I thought I'd be coming to New York to design sculpture for groups like the Joffrey Ballet. Gerald Arpino had been very supportive and wanted to see whatever I produced. Jean Erdman at the Open Eye Theater Company started using some of my sculpture right away in dance performances at New York University. Also, I was still very involved with the sculpture for children.[1] . . . I didn't suspect that all those video centers would be opening up in New York. . . . The show at the Atheneum had put me in touch with some East Coast experimental film people, and things began to happen in that area too."[2] *Circles II*, for example, was among thirty-one films selected for the first exhibition of American independent film at the Cannes International Film Festival in 1974, where Chase's work was shown with productions by seminal artist-filmmakers such as James Broughton, Jordan Belson, Stan van der Beek, Scott Bartlett, and John Whitney.[3]

Another extensive exhibition of Chase's sculpture for dance and children opened at the Museum of Fine Arts in Montgomery, Alabama, in 1973. In this exhibition, Chase showed sculpture that incorporated film. Early in 1972, Gregory Falls, founding director of Seattle's A Contemporary Theater (ACT), had given Chase use of his facility to experiment with expandable structures illuminated with film projections. Made from stretchy nylon attached to flexible frames, these sculptures suggested sails or clouds and could appear transparent or opaque, depending on the lighting and projections. The museum also commissioned a new kinetic sculpture and held a workshop for dancers, directed by Mary Staton. "After the [Montgomery] exhibition," Chase says regretfully, "the work was returned to New York and I never again found the space to creatively develop this kind of thing."[4] Instead she began attending a wide range of contemporary dance performances, familiarizing herself with the styles and techniques of several dancers. "I was beginning to sort out ideas about how to develop my work with dance and sculpture and film. For example, I met Meredith Monk, whom I admire, but I saw that I couldn't work with choreography like hers. It's too interior, too self-referential. Her sensibilities don't fit moving sculpture. Only a certain kind of choreography will work, like Alwin Nikolais's for example, with whom Mary Staton had worked."[5]

Inspired by her initial visits to the Television Laboratory at WNET, Chase also began borrowing video equipment from the MERC access center. Moving to Manhattan had revived her interest in architecture, her college major; New

Fig. 43. *Kei Takei*, 1976. Video still.

York buildings became the subject of several of her first videotapes. She became acquainted with pioneering video artists, including Woody and Steina Vasulka, Bill and Louise Etra, Jud Yalkut, and Frank and Laura Cavestani, all of whom joined her in 1973 to shoot a tape of Calvin Hampton playing the organ at Calvary Church. Chase often saw these artists, along with Nam June Paik and Shigeko Kubota, at Saturday-night screenings at the Kitchen, where they discussed one another's tapes.

At the Kitchen in 1973 and 1974, Chase found professional camaraderie; her social friendships were centered at the Chelsea. In the hotel's El Quixote Restaurant Chase dined with such Chelsea residents as poet Isabella Gardner and Newark Museum curator Mildred Baker. Other El Quixote diners might include Virgil Thomson, Milos Forman, and John Hultberg, who lived at the Chelsea, or Larry Rivers, Rip Torn, or Gregory Corso. Most often her companion was Kleinsinger, whose parties and pets were legendary, even by Chelsea standards. "George's parties were places where people got together to make or talk music, show films, and have fun," Chase recalls. "There were never enough chairs or glasses or places for coats. We often ended up sitting on the floor, trying to avoid the bird droppings, the turtle, and the skunk (fig. 44). Finally the skunk had to be exiled to Siberia—the Staten Island Zoo. The skunk was very jealous of me and took to biting. George had his front teeth pulled, but that didn't stop him. We'd go out to Staten Island and visit him occasionally. We also once delivered a ten-foot black snake to the zoo. Some Chelsea neighbors found it in their basement and called George for help. George rescued it and put it in a box, which we took on the ferry. *That* was an interminable ride."[6]

Fig. 44. Doris Chase and George Kleinsinger administering eye drops to Kleinsinger's pet, 1976.

While Kleinsinger created scores for the films generated from the Atheneum performances, Chase investigated outlets for exhibition and distribution. "I was completely naive. I knew there were galleries for painting and sculpture, but I had no idea how tapes were distributed. I did know something about film exhibition, and that's the real reason I often transferred my video to film. In the field of independent film there were places to show, but there were very few places to exhibit video. So my films were shown pretty widely."

As for the mechanisms of sale and distribution, Chase remarks:

> It was only later I found out that in making a film or tape I should be ultimately thinking about a market for it. None of this crossed my mind then. I kept working just as I had in painting and sculpture, which was to take a direction because I was completely enthralled with it, not because it might appeal to a certain audience.... I wasn't alone in being naive; the field as a whole was naive. Like most video artists then I was sure that we were in the forefront of changing the look of television. I was sure there was going to be space for all manner and mode of video art. Some of my work was programmed on PBS early on [*Circles II*, for example, was first nationally broadcast on the PBS "Theater in America" series in 1974]. I didn't know that I was just lucky—I thought everyone would be doing it. I was certain that more video art would be broadcast and that the taste of the nation would grow, not necessarily intellectually, but aesthetically, until people would just *demand* us.[7]

Chase also believed that artists' organizations could accelerate audience development. In 1973 she became a founding member of Women/Artists/Filmmakers, a group of ten painters, sculptors, dancers, and poets including Maria

Lasnig, Alida Walsh, Martha Edelheit, Ros Schneider, and Carolee Schnee-mann, who "found in the film medium a way to extend and transform their creative ideas." In 1974 the organization began operating formally as a film-production cooperative and screening organization, headquartered first at Anthology Film Archives and later at Global Village. The group organized film and video exhibitions in New York City Public Libraries, and it remains committed to the development of showcases for visual and literary artists who work in video.[8]

By 1975 Chase had laid the groundwork for production of her first significant body of work in video. She began a series of image-processed tapes produced with the Paik/Abe synthesizer at the WGBH Experimental Television Center in Boston. Chase refers to this genre of her work as "video sculpture," and each tape actually begins with shots of one of her three-dimensional compositions (fig. 45). Her first "video sculpture" series, *Moving Forms* (1974), consists of four tapes, each based on one of the dance sculptures used in the Wadsworth Atheneum performances. Using the synthesizer's capacity to deform, repeat, and echo the image, Chase created hypnotic abstract compositions that are the literally kinetic equivalent of what was called "Op Art." Formal organization of the medium of electronic light itself is the principal subject of these tapes, which Chase began to produce just as image-processing was coming under critical attack for its affinities with formalist canvases. Chase continued to produce image-processed "video sculpture," nevertheless, investigating the frontiers of video technology.

In contrast of the artist-engineers who actually built and operated the new image-processing hardware, Chase continued to approach technical production as an EAT-type collaboration. "I was considered weird because I didn't have to have my hands on everything," she recalls:

> It's not like that now, but earlier, people thought that if you didn't do it *all* by yourself you weren't really a VIDEO ARTIST. To me that was like saying that you are not really a painter unless you grind your own pigments. I think my best efforts come in a collaborative venture of putting together the best people and the best equipment to work toward what I have in mind. There's no way for me to operate equipment and be free of the operation to think creatively. On the other hand, you have to know what the hardware can do. The way I usually learned was to look for someone in each studio who really knew the equipment, who would often be a young kid dying to show you what can be done. Then you say, "O.K. What else can you do? Can you double that up or reverse it?"— and so on. You keep challenging them again and again until they sometimes surprise themselves. That was what was so exciting about technology in the early days. We were pushing its limits, often not being able to get what you meant to get but sometimes coming out with something even more exciting.... This chance element was very important, very stimulating. There isn't that same wild and crazy atmosphere any more.[9]

In 1975 Chase began another kind of collaborative enterprise that generated her most memorable early videotapes. Along with Stan van der Beek, she was invited to teach at Brooklyn College, where she coordinated an alliance between the Dance Department and the Brooklyn College Television Center. This alliance was formed expressly to develop dance for television, and Chase

Fig. 45. "Video Sculpture" series,
1974—81. Three video stills.

approached several dancers whose work she had been studying during the previous two years. Choreographers Jean Erdman and Gerald Arpino also recommended dancers from their troupes. The result was the first "Doris Chase Dance Series," a seminal accomplishment in the new field of videodance.

In a 1977 article, "Video and Dance," critic Peter Grossman outlines the evolving history of dance for television, noting the contribution made by the kind of work Chase began producing at Brooklyn College. According to Grossman, most dance for television falls into two categories: documentation or translation. "Pure documentation of live performance pieces is, in video terms, a sterile business." The result "is never more than a pale shadow of the live piece and often much worse." While these documents may have educational or archival value, they tend to show dance people what video could do to them, not for them.

More promising, suggests Grossman, are the translations, works originally conceived for live performance and then adapted for television. These included all the pre-1977 productions shown on Public Broadcasting Service's "Dance in America" series, among them Twyla Tharp's *Sue's Leg* and Martha Graham's *Appalachian Spring*. "Translations done by 'Dance in America' (and others) are more expert and interesting than similar work in the past. More than static documents or arty jumbles, they truly pay homage to the important stage works of modern dance. But they are still stage works and are only approximately as effective as the originals. Just as great literature is usually best in the original, so too is a great stage dance piece. Translation is necessarily second best."[10]

The smallest but most successful category of dance for television, Grossman concludes, is a new one, videodance. "Videodance pieces are by definition new works—dances for video. It is a true and full collaboration of the artistry of video and of dance. These collaborations generally don't come easily. Unless the video is done by a dancer or choreographer, the people in front of the camera and those behind them start with differing perspectives that must eventually mesh. It can't be accomplished overnight, and so it's not surprising that the most interesting videodance work is being done by video people (usually with video-wise choreographers) who've worked extensively with dancers."[11] Among the videodance pioneers Grossman identifies are Merce Cunningham, who sometimes choreographed and videotaped his dance troupe simultaneously, Cunningham's collaborator Charles Atlas, Jeff Bush, and Chase, who is singled out for her command of video effects that preserve the flow and continuity of dance movement.

Many of the practical and theoretical issues confronted in the development of videodance had previously been addressed by artists such as Maya Deren and Shirley Clarke, who were among the first to create dances exclusively for film. Deren, for example, noted that although both film and dance are temporal media that convey arrangements of movement, "there is a major difference. The dance choreographer works with an essentially stable environment. Once the stage has been set, he is concerned with the arrangement of human figures on it, with their movements within that set location. He arranges only dancers. The film-maker, however, arranges whatever he has in his frame, including the space, the animate and even the inanimate objects. . . . It represents an effort to make the dancer understand that this is not theater space you are operating with, but another kind of space. You are operating with a whole set of different possibilities."[12]

Videodancemakers, similarly engaged in the representation of dance forms in nontheatrical space, shared with filmmakers the challenge of capturing the flow, energy, tension, and physical presence of dance in media that convey only illusions of dance movement. These illusory spaces, subject to neither the law of gravity nor conventional temporal ordering, provide film- and videomakers with analogous opportunities to re-invent dance experience by tilting, inverting, or floating images, or by reorganizing choreographic successions and pace.

A number of visual factors, however, distinguish the two media. The frame of the standard video monitor is distinctively intimate; the video screen's convex surface flattens and stretches images from side to side; and video commands a singular repertoire of special effects. Furthermore, colors in video differ from those of film, not only in range but in chromatic quality. Color on film is the product of light acting upon a color-sensitive chemical emulsion; color in television is created by combinations of electronically generated, primary-color dots. Film colors are more "natural"; video colors, more arbitrary and surprising. Videodance images differ from their filmdance equivalents not only in visual appearance, therefore, but also, owing to their relative artificiality and more intimate scale, in psychological and empathic impact.

With three major productions at Brooklyn College in 1975, *Dance Seven*, *Dance Nine*, and *Dance Eleven*, Chase began to stake out her own distinctive videodance style. She both developed collaborative working methods with dancers and achieved production techniques that were to characterize her dance compositions for the next five years. Although Chase worked with several dancers at Brooklyn College, three collaborations were the most successful— with dancers Cynthia Anderson from the Joffrey Ballet, who came to Chase at the suggestion of Gerald Arpino; Marnee Morris of the New York City Ballet Company; and Gus Solomons, Jr., a former member of the Merce Cunningham Dance Company. In these collaborations, the dancers conceived the dances, and Chase created the videodance, her own interpretation of the kinetic content, physical flow, and visual structure of the performers' movements.

"There are certainly performers who don't consider working with me a collaboration," Chase says, "because in my collaborations there's ultimately one director, one boss. . . .

> But I always start with a seed that comes from the dancer and then garden it, so to speak, without knowing at first whether I'll get a gardenia or an ivy plant. There are few dancers who really understand and sympathize with the needs of the screen. It's very hard for performing artists who work with their entire bodies to think, for instance, that what's most important is what the left eye is doing, if that's what the camera is going to catch, and still keep the total feeling. Dancers concentrate on getting the entire body involved in executing a move, and to have that totality abstracted or minimized in any way isn't easy to accept. It's hard to put down the personal excitement of addressing a particular movement when, from the camera's point of view, the best part of the whole thing is the way the right hand gestured just before you got to that movement.[13]

Concluding that groups of dancers tend to "look like oatmeal" on small television screens, Chase decided to concentrate on solo performances and to incorporate details of dance movements not accessible to audiences through conventional stage settings. Productions began with weeks or months of

rehearsals using Chase's own small-format video equipment. During these sessions, Chase shot sections of the dance, replayed them, and repeated the process until both she and the dancer concurred on the particular movement or pose to occupy the screen at any given moment.

All these rehearsals took place in Chase's studio apartment in the Chelsea. "When I moved in I had no idea my apartment could be used as a rehearsal space. What I found by the time I worked at Brooklyn was that, in order to get the effects I wanted in video, I needed incredible lighting—very precise and intense. To light a large area so precisely would cost a fortune in time and technicians, but I could set the lights myself for an area just about nine feet by nine feet. I realized those were the dimensions of my dining area."[14]

These technical circumstances shape the dancers' approach to choreography in Chase's tapes. Her dancers do not perform space-consuming leaps, nor do they execute expansive territorial patterns. They occupy instead an empty cube of space measuring about two body-lengths in height and width, filling it with animated arm movements, tight turns and jumps, arabesques and ground-level torso extensions. Silhouettes are emphasized, as are linear patterns of upper and lower limbs. Hand, finger, and ankle movements are frequently singled out to fill the screen. The result is a contemplative and measured mode of visual choreography that never threatens to slip out of the TV-screen frame.

Dance Seven with Marnee Morris presents some of the most traditional dance movements found in Chase's tapes. The composition begins with the dancer poised on one leg in the center of the screen like a Degas statuette (fig. 46). As the tape progresses, the dancer is represented in close-up and full-figure shots simultaneously, freighting the screen with visual information. Detailed shots of ankles and toe shoes reappear at rhythmic intervals, illustrating the relationship between footwork and the overall dynamic of the dance.

This initial suite of juxtapositions is followed by a series of progressively more abstract and colorful interpretations of the dancer's image created with the electronic technique known as debeaming (fig. 47). While this effect is a surprising one for conventional TV-viewers, it could be created with standard

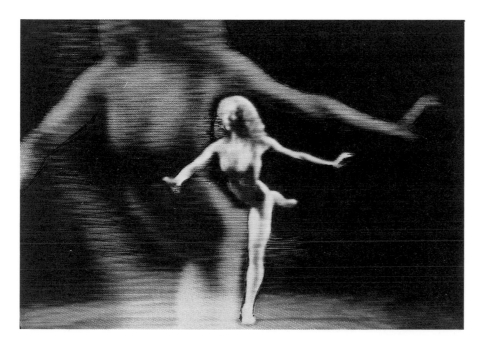

Fig. 46. Marnee Morris in *Dance Seven*, 1975. Film still.

Fig. 47. Cynthia Anderson in *Dance Eleven*, 1975. Three film stills.

Fig. 48. *Loie Fuller at the Folies-Bergère*, 1893. Color lithograph by Henri de Toulouse-Lautrec. Private collection.

commercial studio equipment. The Brooklyn College Television Center, in fact, had no special or experimental hardware: to create the special effects in the Brooklyn tapes, Chase pushed the ordinary capacities of television technology.

Debeaming provides a liquid, painterly veil of color trailing behind a moving form. The effect is created by depriving the beam of electrons emitted by the TV camera's photoconductive tube of sufficient electronic current to reproduce images sharply and completely, causing the image to "smear." Levels of electric current to each of the camera's three primary color guns are then selectively manipulated to vary the smears in hue and shape.[15]

Although Chase was not familiar with the analogy at the time, the debeaming effects in *Dance Seven* suggest the illuminated veils of Loie Fuller, *la belle epoque*'s legendary serpentine dancer.[16] In the 1890s Fuller frequently performed on a glass panel inserted in the stage floor and illuminated from below by colored calcium or electric lights. Costumed in yards of floating iridescent silk that could be extended with wands attached to the inside of the garment, Fuller transformed her body into abstract color configurations suggestive of flames, clouds, feathers, or butterflies (fig. 48). Chase's imagery is reminiscent of Fuller's, not only in its flamelike deformation of the figure but also in its painterly choreography of colored light.

The most lyrical and gently captivating of Chase's Brooklyn tapes is *Dance Eleven*, in which Cynthia Anderson performs duets with images of herself created through multiple camera shots and superimposition. Like most of Chase's subsequent tapes, *Dance Eleven* begins with a direct statement of choreographic theme generated by the dancer. The tape then progresses through several round-trip excursions from its thematic center, each representing an electronic expansion of the original statement. In *Dance Eleven*, Anderson's image is sometimes paired with ghosts of itself or expanded with superimpositions of her torso stretched across the entire screen. In a third cycle of variations the image is debeamed, filling the spaces the dancer leaves behind with floods of color reminiscent of Helen Frankenthaler's canvases (fig. 47). Although he preferred *Dance Seven* to *Dance Eleven*, critic Roger Greenspun aptly described the "breathtaking passage" of debeaming at the end of *Dance Eleven*, "where Anderson sinks to the floor and suddenly her figure radiates brilliant yellows, reds and the Doris Chase favorite, pale blue."[17]

The technical *tour de force* among the Brooklyn College tapes is *Dance Nine*, in which Gus Solomons performs a jazzy duet with an abstract video-synthesized stand-in for one of Chase's dance sculptures. The video animation process used to create Solomons's electronic partner was relatively simple: Chase first made a cutout of an arch form based on one of her dance sculptures and then mounted it on a black background. The cutout was shot with a camera attached to a Rutt/Etra video synthesizer operated by Steve Rutt. Responding to verbal cues from Chase, Rutt multiplied, bent, stretched, collapsed, and otherwise manipulated the arch into a variety of moving patterns and shapes. Chase reviewed the resulting tapes and selected certain segments for possible alliance with a human performer.[18]

She showed the tape to Solomons, who agreed to collaborate; together in her Chelsea dining room they worked out the video duet. To accomplish this dance, as videodance critic Richard Lorber explains, Solomons "timed-out the edited version of the arc animation according to its rhythmic sequences, and designed a series of dance movements within this time structure. Chase taped his dance and electronically mixed it (through superimposition and 'keying,' which is a nontransparent fusion of disparate images) with the 'dance' of the

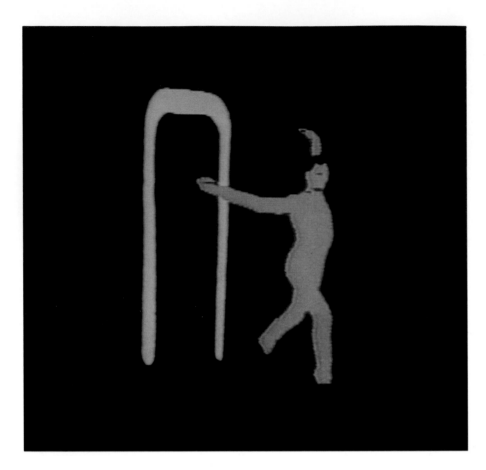

arc. The resulting tape was a remarkable duet between a moving human being and an electronically kinetic abstraction."[19]

Tall, lean, elastic, and playful, Solomons was an exemplary foil for his electronic counterpart. The video-synthesized form has a varied but predictable range of movements: it sways, quivers, oscillates, swings, tumbles, and revolves, always in symmetrical patterns. Solomons, in contrast, might move in one direction with his arms and another with his legs and torso, or might execute irregular gestures simultaneously on the right and left sides of the body. More often, however, he mimicked and parodied the computerized movements, at one point apparently squeezing himself into one of the electronic arches. Chase tightened the integration of the dancer and the arch by transforming both into boldly graphic patterns of light, the performer predominantly blue and the arches white, silhouetted against a dark background (fig. 49).

Although conceived of as dances for television, *Dance Seven*, *Dance Nine*, and *Dance Eleven* were also transferred from video to film, where wider exhibition opportunities continued to build Chase's reputation as an independent filmmaker. Reviewing films made from the Brooklyn tapes, critic Greenspun wrote that on film, the work "is a lot easier to watch than on a TV monitor. The colors, the gorgeous pastels and their uses—for example, a *flaming* pale blue—are from video, as are the shadow images, the transformation of objects into lines and back again. But the reticence and spatial intelligence I am more used to associating with film, or perhaps with architecture." Chase, he concludes, is "one of the loveliest and most precise talents in American independent cinema."[20]

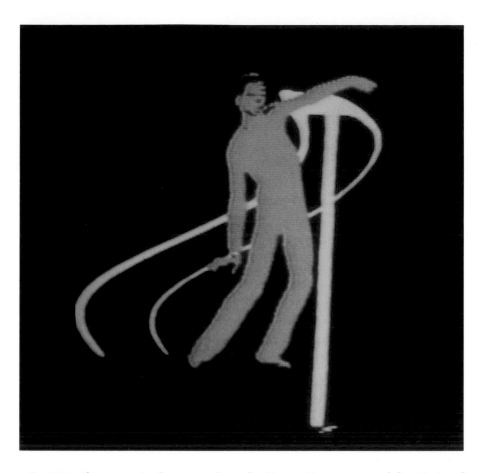

Fig. 49. Gus Solomons in *Dance Nine*, 1975. Two film stills (left and right).

In 1976 Chase received a grant from the Dance Department of the National Endowment for the Arts to continue her exploration of videodance, producing a series of tapes in collaboration with dancer-choreographer Kei Takei. Takei and her Moving Earth Company had developed a distinctive style of elemental, angular movement which struck Chase as "both prehistoric and Japanese." Chase began videotaping Takei's work in 1974 and shot a composition with Takei and her dance sculpture at Brooklyn in 1975.[21] Most of the Takei tapes, however, were shot at WNYC-TV, Manhattan's municipal television station, after Chase received her grant. Postproduction work was done at the New York State Television Network in Albany, a facility available to artists working with public television stations.

Chase summarized the visual results of her Takei collaboration in a 28-minute program completed in 1977. (The 28½-minute length is standard for tapes broadcast as 30-minute programs on Public Broadcasting Service, an artistic fact of life for video artists who expect their work to be considered for broadcast.) The tape contained four "movements": *Dance for Television*; *Excerpts from Light—Part Nine*; *Dance with Me* and *Improvisation*.[22] *Dancemagazine* critic Norma Mclain Stoop outlined the Takei program after it was broadcast on WNYC-TV in mid-1978:

> How many times, in reviewing dance television programs, have I strongly decried the multiple images, superimpositions and other tricks of the video trade. However, after viewing two programs of the "Doris Chase Dance Series," I realize the difference it makes when sophisticated video

and film techniques are used for purely artistic reasons and not simply for effect.... "Dance for Television" (music by George Kleinsinger) starts dramatically with a close-up of the dancer's eye. This dance is first shot rather straightforwardly. One sees Takei study her hands as a child might, [playing] the air as if it were an instrument. Suddenly the dancer melts into flowing white and flowing colors, predominantly yellow and red. Color becomes the dancer, becomes the dance.

To a compelling drumbeat, "Improvisation" begins as broken-up bits of blue and orange. Takei's head seems a series of disembodied dots. Superimposed figures melt away; multiple images bend and writhe. The dancer's outline, traced in white, is erotic and exciting. In the midst of fantasy, the real dancer (what we term real) searches the floor for something.[23]

The best section of the program, *Dance with Me*, Stoop continues, uses more video effects, including "a Jackson Pollocky effect of dripping color behind the dancer's body. Dramatic multiple images multiply the drama of the hands, and to my amazement, there's little doubt that the dance comes more alive than when photographed realistically" (figs. 43, 50).

In a 1977 interview Chase outlined her working relationship with Takei. "She knows movement. She knows the body. But she doesn't know which moves are going to be successful. That's where I have to direct her. I'll say, 'Face this way,' or 'Give me a profile,' or 'Slow your motions' because the camera will lose them if they are too rapid. In a way I have to be very controlling and cannot work with all dancers. I have to work with people I admire tremendously because I spend a lot of time with each of them. And they have to admire me enough to trust me."[24]

Once Chase and her dancers entered the television studio, production costs set the course of their collaboration. "It often seemed as though half my life was spent on the telephone bartering for studio time. At WNYC, where I shot the Takei tapes, I was able to get time in the studio in exchange for giving them certain broadcast rights. This means every minute is precious and you can't use the studio just to try things out."[25] By the time Chase began to work at WNYC with Takei, she had developed a number of strategies to accommodate both production economics and her own aesthetic vision. Lacking funds for rehearsal time with the camera crews, for example, she usually found it necessary to work with cameras locked into position, one for long shots and one for close-ups, each shot carefully mapped in advance with a story board. Exceptions might be possible in a three-camera studio where one of the camera operators was familiar with the kinds of moving shots Chase wanted to execute: in this case, two cameras would be locked in while Chase talked the third camera through the mobile shots. The dancer, instructed to perform for the long-shot camera as if it were the audience, carried out the entire performance without stopping. This methodology aided the dancer in maintaining the flow and continuity of the choreography, but it was also devised to maximize the resources of the crew. "I don't allow anybody to stop. I don't care what happens," Chase explained in 1977. "We shoot the thing through as we have choreographed it. We don't even look at it; we just go right to the next one. Then maybe we'll stop. I just try to keep it flowing. The minute you stop, camera one needs coffee. Someone else goes to the john. Then it's twenty minutes before you get everybody back. So I make them sweat it out with me just to keep it rolling."[26]

This production process, together with the space limitations imposed by lighting requirements, shaped the basic format of Chase's videodances, including the Takei compositions. Following the precedent of Maya Deren's film, *A Study in Choreography for Camera* (1945), a number of film and videodance artists have employed moving cameras as kinetic elements in themselves, swinging, inverting, tossing and tilting the camera to create, in Deren's words, dances "performed by the camera and beings together."[27] Chase's tapes, in contrast, are conceived as moving paintings in which forms circulate within the frame established by static camera shots, like a kinetic portrait or still life. In her earlier film, *Circles II*, mobile cameras were used to film a troupe of dancers moving across the stage. In this film, the images unfold with a relaxed, dreamlike fluidity in a cinematic space for which there is no real equivalent in the tapes.[28] By comparison, movements in Chase's carefully composed video spaces are more distilled, tightly knit, physically intense, and systematically patterned, even when they are as elastic and playful as those in Solomons's electronic duet.

Chase recognizes that her formalist aesthetic has distanced her videodances from the conceptual and critical investigations favored by many influential videomakers, although the concentration and the developmental logic of her videodances often requires a level of intellectual engagement not unlike that required for more "conceptual" tapes. Chase's compositions are not, however, conceived of primarily as intellectual demonstrations. Especially in the longer compositions, such as the four-part Takei tape, she demonstrate systematically how dance documents can function as raw material for highly sensual videodances. By juxtaposing successive suites of images derived from different postproduction amplifications of the original choreographic statement, she provides a lesson in video process and visual indulgence at the same time.

In 1977 Chase renewed her involvement with performance art for children, collaborating again in an elaborate multimedia stage production. Together with Broadway choreographer Pat Birch, Chase produced *Light Sings* for the Imagination Celebration at the Kennedy Center in Washington, D.C., the first national arts festival for children. This highly successful romp brought together singers, dancers, poetry, music, Chase's sculpture, and computer films. During the same year she also produced *How Do You Feel?*, an audience-participation, body-awareness film for four-to-ten-year-olds. Kleinsinger composed a sing-along score that asks young viewers to verbalize their feelings and Lloyd Ritter, who demonstrate the workings of various joints and the expression of moods through posture.[29]

In addition to her children's productions and a six-week's USIA lecture tour to Europe in 1977, Chase was also involved with *Op Odyssey*, a multimedia dance production awarded first prize at the 1977 International Festival of Dance in Paris. Choreographed for Chase's dance sculpture by Valerie Hammer of Erdman's Open Eye Theater Company, *Op Odyssey* utilized Chase's films, live and taped music by Robert Mahaffay, and surreal poetry by Diane Wakoski. First performed in 1976 at the Open Eye Theater, the production was revised and refined during a two-year national and international tour before final performances at the Brooklyn Academy of Music in January 1979.

In *Op Odyssey*, the dance itself suggested an enigmatic love triangle between a male dancer and two female dancers, one of whom was choreographer Valerie Hammer. Most reviewers agreed with *New York Times* commentator Jack Anderson, however, that "the productions most remarkable features were the films and sculptures by Doris Chase." After viewing the Brooklyn

Academy of Music performances, Anderson reported, "The sculptures resembled arches that could be pushed about and turned upside down. When overturned, they looked like giant U's. In abstract film interludes these shapes were shown multiplying themselves, melting away. . . . Dancers sat on the U-shaped sculptures and rocked back and forth. They clambered on them, dangled from them and held onto them while the sculptures swayed from side to side. Miss Hammer made ingenious use of these objects. With equal ingenuity she

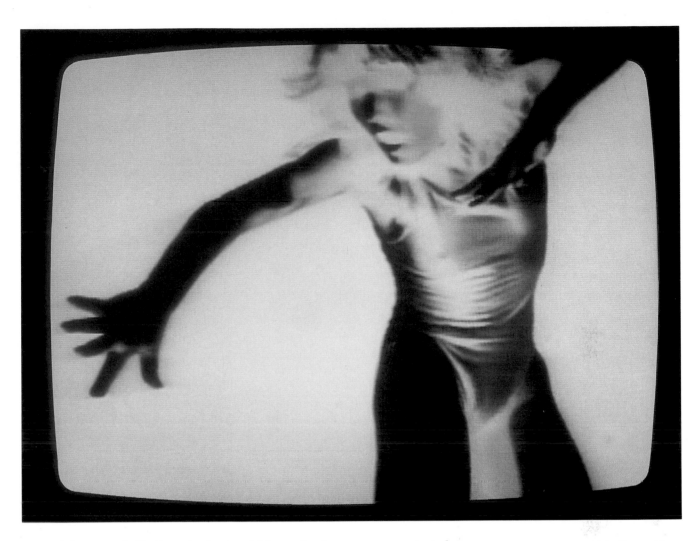

merged dance with film in episodes in which moving images were projected on a scrim, behind which dancers were dimly visible."[30]

During *Op Odyssey*'s 1977 U.S. tour, Chase made a 17-minute tape of the performance at WCET-TV in Cincinnati, concentrating on dancer interaction with two rocking U-shaped sculptures (fig. 51). In the tape the dancers are just as comfortable with the sculptures as with their human partners, pushing the rocking forms just to the point of overbalance and then riding rebounding waves like seasoned surfers.

Op Odyssey marked the last major appearance of Chase's dance sculpture and the end of a ten-year cycle of involvement with multimedia stage productions. Chase devoted the last years of the 1970s primarily to a technological *tour de force* in videodance, marshaling her experience with kinesthetic communication and visual form to mount a true homage, although it would have been unfashionable to characterize it as such, to the early ambitions of EAT.

Fig. 50. *Kei Takei*, 1976. Three video stills. David Gronbeck photographs.

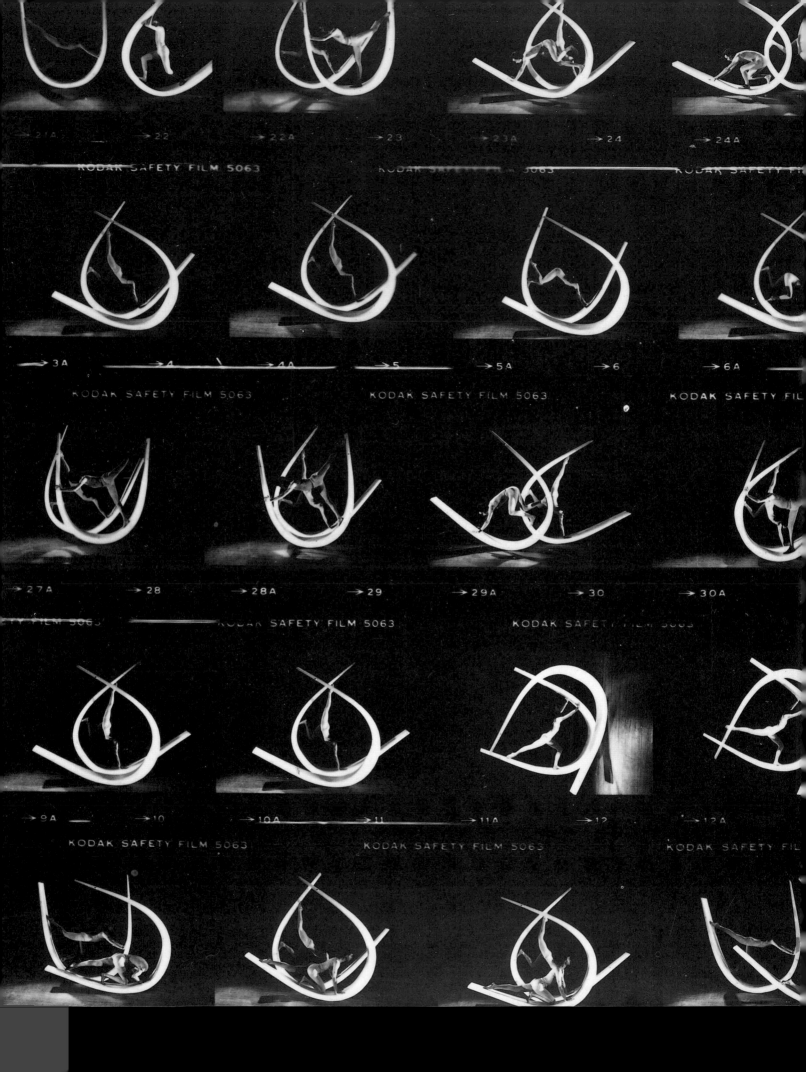

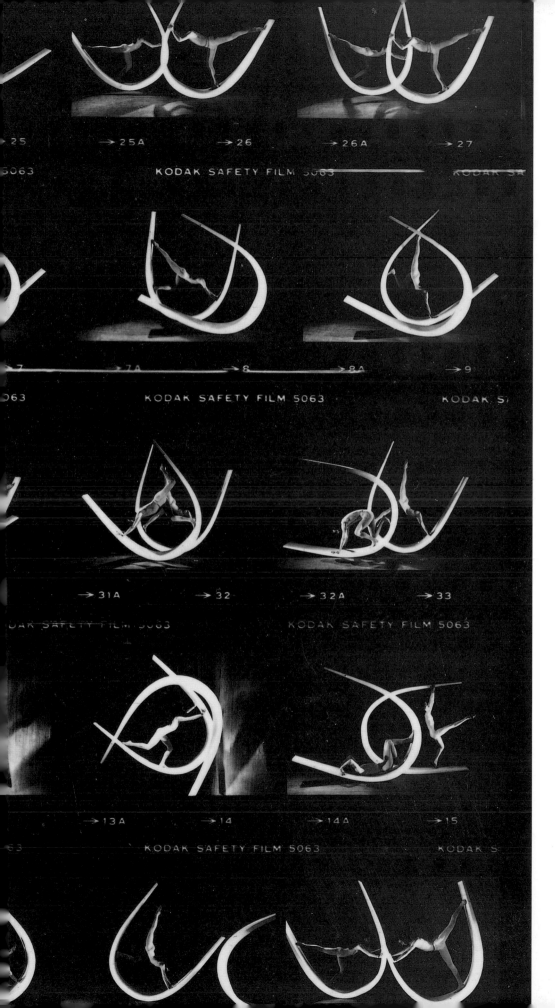

Fig. 51. *Op Odyssey*, 1977. Dance sculpture variations.

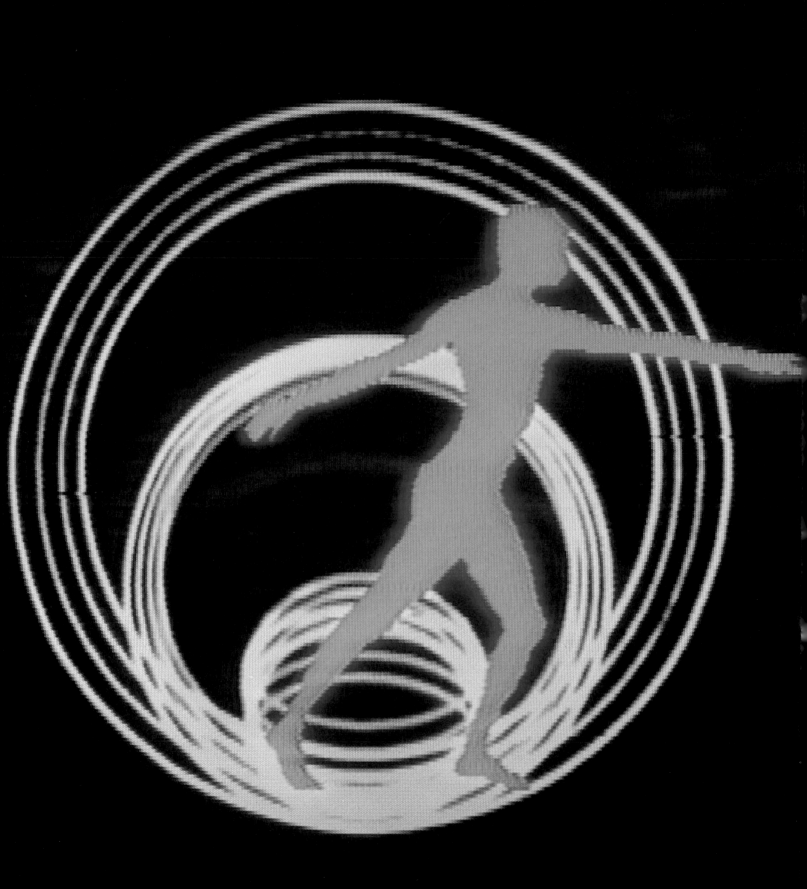

Videodances of the Late 1970s

Op Odyssey not only brought Chase favorable reviews for her dance sculpture; it also introduced her to a new dance collaborator, Jonathan Hollander. Hollander, now director of Manhattan's Battery Dance Company, the resident dance company at Pace University, was the male dancer in *Op Odyssey*. He began working with Chase in 1976, appearing in several videodance compositions and a film for children. After these collaborations he became an articulate spokesperson for the dancer's point of view in videodance as well as a seasoned observer of Chase's working methods.

"The first thing that encouraged me was that I knew Doris had really followed my work," Hollander begins. "She came to see my choreography and was enthusiastic about it. I always felt very much appreciated by Doris and felt that she thought highly of me as a dancer and as an artist. Knowing this already, I felt good about collaborating with her when she asked me."[1]

Chase approached Hollander with a proposition for choreographing a dance to accompany another abstract video-synthesized tape she had created with Steve Rutt on the Rutt/Etra synthesizer. Like the arch form animated for Solomons's *Dance Nine*, the images in this tape were based on one of Chase's dance sculptures: the rocker used in *Op Odyssey*. Transformed by the synthesizer, the rocker became a sinuous cipher that pulsated rhythmically across the screen. In addition to using the tape in her collaboration with Hollander, Chase planned to make the rocker images into a solo composition, eventually titled *Rocker*. Finding the means to execute this latter decision was by no means routine, and *Rocker*'s evolution is revelatory of the 1970s working milieu for many Manhattan video artists.

"I'd generated about an hour's worth of variations on the rocker image with Steve Rutt and the Rutt/Etra synthesizer," Chase recounts. "I cut this down to nine minutes of material I wanted to process further. I was in touch with the TV Lab at WNET about getting time on their Paik/Abe synthesizer. After waiting nearly a year, I did get in. I was just finally getting things to go right when John Godfrey, the head engineer, walked up behind me, turned off the equipment and said, 'OK, time's up.'—and that was it for *Rocker*. This sort of thing happened to other people, too, but we were willing to put up with almost anything to get in. Looking back, you can see that there had to be restrictions, but you can also see that people like Paik, who were able to use the equipment month after month, were able to make rapid advances technically. What saved a lot of us were places like Binghamton [the Experimental Television Center], where you could experiment freely for five days at a time. The results weren't always as professional-looking, but you could make progress."[2]

Fig. 52. Jonathan Hollander in *Circles with Jonathan*, 1977. Video still. David Gronbeck photograph.

By comparison, working out a composition with Hollander for the rocker, even though months of rehearsals were required, was a relatively straightforward undertaking. "We got together often in Doris's apartment at the Chelsea with her camera and monitor," Hollander relates. "As I developed the choreography we would tape it, discuss it, and critique it. She timed the sequences on the synthesized tape so I could memorize all the interpolations of the form and deal with them choreographically. The music by William Bolcom turned out to have just the right mixture of seriousness and whimsicality, just like the rocker. Sometimes it's hilarious, like an animated cartoon, and sometimes it's frightening and fantastical. I choreographed the dance right down to the last second—I'm not an improviser. When the rocker was in a certain configuration, I wanted to be in a certain position. I hadn't done anything like this before, but Doris gave me all the time I needed to work it out in my own way."[3]

While Hollander fine-tuned his choreography, Chase negotiated for studio time and was able to contract a schedule with the Albany public broadcasting facility, the New York State Television Network. When she and Hollander arrived in Albany for the taping, however, they found less than ideal conditions: not only was the studio exceptionally small but it was bisected by a cement pillar. "It also had a cement floor and was really air-conditioned, which is terrible for a dancer," Hollander adds. "If there's a weakness I see in our rocker tape, it comes from the cement floor and the small space. The dance doesn't take off and move in an entirely fulfilling kinetic way. Yet there's an intimacy and a personal quality to it that we might not have gotten otherwise." The sociology of the production studio was another factor that shaped the final product. According to Hollander, "The workers there were strictly technicians, people used to doing talking-head interviews. They had had no experience whatsoever with Doris's kind of mentality or her aesthetics. It was an all-male environment, and the first thing she had to do was to get them to take her seriously. They had a problem with me, too, me in my nude-looking leotard. We both had to earn their respect. Not only was Doris able to do this but she was able to inspire them to do beautiful work."[4]

Several tapes were shot during this one-day Albany session: two videotape versions of *Jonathan and the Rocker* were among the compositions eventually put together from the footage, as were two different versions of *Dance Ten*, one on tape and the other transferred to film.[5]

To integrate shots of Hollander's live performance with the pre-existing video-synthesized rockers tape, Chase called upon a standard television studio technique termed "chromakey," a technique first applied to dance by the Alwin Nikolais Dance Company in 1968.[6] Chromakeying involves an electronic switch programmed to flip over when a certain color signal, usually blue, is fed to it from a three-tube color-TV camera. Everything blue in the image—a solid blue background, for instance—will drop out. Other images from another camera can then be used to fill the "holes" left by the electronic erasure of the selected color. In the Hollander type, chromakey merges the dancer and the video-synthesized rocker into an apparently seamless video duet (fig. 53).

Hollander's choreography for *Jonathan and the Rocker* and Solomons's composition for *Dance Nine*, both designed to accompany video-synthesized translations of Chase's dance sculpture, offer contrasting conceptions of choreographic interplay with an abstract electronic form. Solomons tends to respond to the leggy, synthesized arch in *Dance Nine* as if it were a partner in a duet, sometimes moving in unison with the image and sometimes engaging it in a counterpoint that suggests a tease or one-upmanship. Hollander, in contrast,

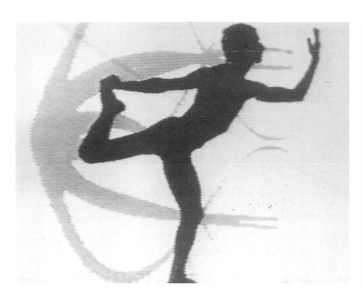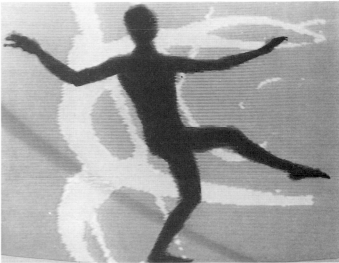

Fig. 53. Jonathan Hollander in *Dance Ten*, 1977. Two video stills.

reacts to the synthesized rocker more often as if it were a kinetic set or environment within which he constructs suites of moving shapes and linear poses. Hollander's response is more graphic and imagistic; Solomons's more anthropomorphic and physical.

In Hollander's case, the collaboration drew upon his early training in painting and sculpture, which came into play as he organized his movements to emphasize line and silhouette. The project also led him to certain conclusions about the contrast in the experience of the audience when viewing dancer/sculpture interaction on stage and on the video screen. "The video medium has an advantage in that it takes the human body and puts it in the same world as the animated sculpture," Hollander observes, "whereas on stage you can't get away from the fact that the dancer is skin and bones and what you are dancing with is rock or Fiberglas. It's difficult to deal with that difference or barrier organically and to interact with the forms in a way that makes the audience believe in them. If the audience only thinks, 'Look what a great time they're having—wouldn't it be fun to get up there and rock in them,' then you're not making art. It's easier to accept this kind of thing on television because the image is homogenized. Both the abstract form and the human body are calligraphy and can be appreciated on the same level for design and cartoon value."[7]

Of the tapes generated at the Albany session, the most frequently broadcast, as it later turned out, was a four-minute composition called *Circles with Jonathan* in which Hollander performs with computer graphics from Chase's first film, *Circles I* (figs. 52, 54). (A public broadcasting station might use a tape of this length as a filler, for example, at the end of a symphony broadcast.) From Hollander's point of view, this tape represents an instructive example of the difference between active videodance collaboration and singular artistic vision:

> *Jonathan and the Rocker*, which I really planned and worked out, is very much a joint product. But Doris also shot material I improvised or had choreographed before, and the tapes she made from this are all hers. She chose the music and edited all the movements; I'm just the performer. This is especially true for *Circles and Jonathan*, which I have no feelings

of ownership about at all. When we made the tape [in Albany] the conditions were unbelievable. I had been in the studio all day long and was really tired and cold from the air-conditioning. Yet there was more studio time, so we had to keep working. Doris asked me to improvise something for her *Circles* film, which I hadn't seen, nor had I heard the music. So I did. At one point I kind of melted down to the floor, thinking it was the end. Then I heard Doris's voice over the loudspeaker saying, 'Get up and keep going; it's not over yet!' When I look at this tape I see this geriatric dancer who can't move. But when Doris finished the tape, people really liked it, and it's gotten some very nice reviews."[8]

While the artistic opportunities for the videomaker in videodance collaborations are varied and numerous, what do these projects offer a dancer like Hollander? "It allowed me to develop another chapter of my work for a world that's very different from theater," Hollander replies. "I was able to explore movement in a very intimate way, whereas in the theater I'm working in a broad, projective environment. There had been a certain intimacy in my work before, but I realized that some of my gestures were too small to carry. Working in video let me pursue the jewellike gesture or expression that would never show on stage. It also put me in contact with an artist I respect. Artists tend to work in hermetic environments, and it's very hard to share the process of creation. When you can develop a kind of osmosis with another artist, as I did with Doris, it's like a gift. I learned some personal lessons from working with her, too," Hollander adds. "Doris in my mind is a true artist. She keeps going, whether or not her works get a great write-up. She's beyond that. Of course it hurts when something doesn't get recognized, but that doesn't stop her from working. What I learned from her was an obvious lesson you have to learn from someone you respect: don't dwell. Just go for it and don't look back."

As for the future of videodance, Hollander concludes that "it's hamstrung by the expense. Many artists, including me, have dropped away because they can't afford it. Some of what's been done is very effective, but it's just a foretaste of the possibilities. After what I've learned from Doris, and later from working with Jamie Newman and Allan Esner, who were Doris's assistants and came into the field because of her encouragement, I think I could do some really inventive things. The dances I created for Doris I've never performed in another setting. They don't exist and can't exist in any other medium. It would be thrilling to keep pushing forward with this kind of work."[9]

As she did with Takei, Chase summarized the visual highlights of her collaboration with Hollander in a four-part tape. This composition, *Jonathan and the Rocker* (1977), brings together two versions of *Jonathan and the Rocker, Circles with Jonathan*, and *Dance 10*. Winifred Meese, director of the Dance Collection of the New York Public Library at Lincoln Center, described the production in 1978:

Opening with a pleasantly repetitive musical motif by William Bolcom, a hypnotic tone is set for *Jonathan and the Rocker* that permits the viewer to drift into study of the silhouetted movements of Mr. Hollander and the synthesized 'u'-shaped images, which may rotate, disappear and reappear, become multiple or single-strand formations, or break up into static-like or snowy patterns only to melt together and re-form again. The size, shape, movement and spatial effects of the rockerlike images' everchanging convolutions and its relationship to the dancer's movements or

Fig. 54. Jonathan Hollander in *Circles with Jonathan*, 1977. Video still.

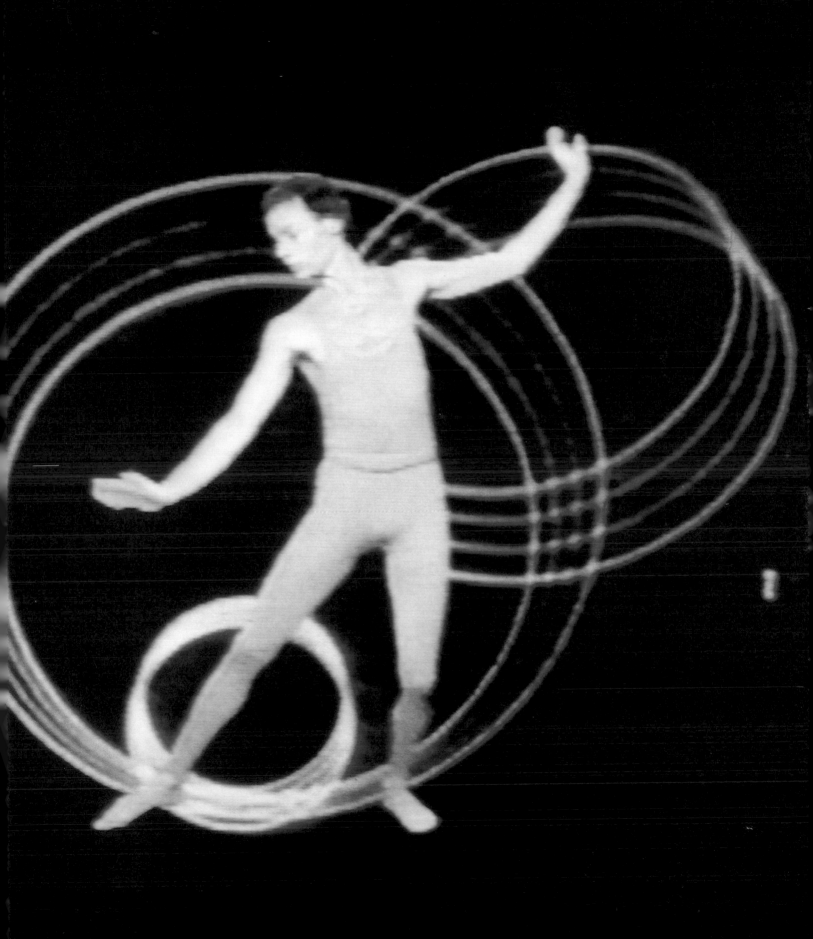

stillness is combined with frequent vivid color changes and music. At moments the dancer and shape parallel one another, performing in partnership. Often no particular relationship seems to exist; the shape then serves as a backdrop. The dancer may alternately pose with the shape, letting it frame or engulf him, move through it, around it or jump over it. The final section, *The Rocker and Jonathan*, is a more intricate rendering of the same basic material used in the first section. It is these two portions that are most successful.[10]

In *Dance Ten*, she adds, "the viewer first sees the dancer in full detail rather than as a two-dimensional silhouette. The interplay of his actual shape with that of his abstracted shape adds an aspect only obtainable with film or videotape. The most powerful image, one that highlights this section, shows streams of light projecting diagonally from the dancer's figure, creating soaring, birdlike imagery."

Chase's work, Meese concludes, "is a celebration of color, movement, shape and music. . . . The tape is an exploratory effort toward a genuine and organic synthesis of dance and film/video techniques. It contains many exciting and promising moments, exposing the viewer to the incredible versatility of present technology and the inroads that Miss Chase has made in its application to dance."

This four-part tape does not review the entire range of Chase's work with Hollander. In addition to his capabilities as a dancer and choreographer, Hollander struck Chase as a "Prince Charming type," whose image would appeal to children. Highlighting this quality, she brought together Hollander's dancing, Kleinsinger's music, and selections from her 1975 video sculpture series to create *The Emperor's New Clothes*, a ten-minute filmic reinterpretation of the classic fairy tale. Video-synthesized sculpture appears as a recurring theme in this 1977 film, she explained, because "it allowed me a multi-colored abstract form while disavowing Disney animation techniques. Because I wanted the viewer's imagination to have more play, the gestures of the dancer and the shimmering, shifting ground are suggestive rather than literal."[11]

In 1978 *The Emperor's New Clothes* toured New York schools as part of a kinesthetic awareness program presented by dancer Nancy Cohen, who performed with Hollander in the film and in *Op Odyssey*. The program began with *How Do You Feel?* and *Improvisation* with Kei Takei, to which Cohen added her own demonstrations of movement. Children were then asked to follow her in exploring various body articulations, such as flowing, jabbing, and punching. A screening of *The Emperor's New Clothes* came next. Afterward, members of the audience were encouraged to relate their muscular sensations to their own feelings as well as to the emotions expressed by the dance movements in the film.[12]

In the Hollander collaboration, Chase worked with an artist whose carefully structured, premeditated choreography complemented her own compositional logic. Her earlier experiences with kinetic sculpture, however, also established a disposition for engaging the operations of chance: not only did she welcome unexpected and sometimes unrepeatable video effects but she also engaged improvisational dancers and choreographers, including her next major videodance collaborator, Sara Rudner. Rudner, whom Hollander characterized in comparison to himself as "a very physical dancer with an animal energy in the way she approaches movement," choreographed for Chase an athletic composition just barely restrained by the edges of the video frame. Bicycling,

backstroking, and airplaning movements churned and atmosphere in the dancer's cubic space, alternating occasionally with tighter passages of movement executed with the rib cage and shoulders.

To shoot the Rudner tapes, Chase again arranged studio time at WNYC-TV in exchange for broadcast rights. *Sara Rudner*, the 28-minute, three-part composition subsequently broadcast by the station, utilized the theme-and-variation cycle established with Takei. In program notes for an exhibition of Chase's work in 1979, Amy Greenfield offered a videodance colleague's perspective on the Rudner tape:

> Doris Chase loves the simplicity of presenting the dancer and her dance with the joy of realistic video flesh tones speaking for the dancer's actuality. And then she loves, step by step, through hard-edged decisions, to abstract this physicality into the mesmerizing array of movement scans possible in video. Through this process, the more she dematerializes the body, the more she literally visualizes the movement-traces of the dancer. The tape... of Sara Rudner for me most successfully shows this process, which seems both carefully laid out and not possible to predict beforehand. Chase first lets us see Rudner's clean-edged, subtle dance with straightforward clarity and in good broadcast color. With this laid down, the video graphics machine, colorizer and debeamer have a lot to grab hold of and can recreate the essence of what is both *outside* of and *within* the body—the colorful ghosts of videodance.[13]

Dancemagazine critic Norma Mclain Stoop described the reaction of a viewer unfamiliar with the hands-on operation of video technology:

> The Sara Rudner program begins with the "seed" dance, *Theme*, from which the rest develops. It is a lyrical solo, the dancer's arms usually wide, with the frequent spins and turns. There are also swimming motions, and towards the end, arms, and then legs, wind-mill. After hopping happily the dancer turns and then comes to a rest. All this is shot traditionally, using three cameras. Superimposition is the only video effect used.[14]

Variation One uses the same movements, she adds, reprocessed to resemble pen-and-ink drawings. "These drawings are more representative of the movement itself than of the moving body. It conveys a mystery—seems a double art. Suddenly the dancer's actual body brushes away the outline, but conquered by them, finally dances with her other (video) selves." To the layman, *Variation Two* "seems a combination of blobby figures eventually joined by the (not quite) actual image of the dancer. The viewer is confronted by choices. By a new face of dance.... If all this seems indescribable, it's because it is. One must see it; experience it is a better term. It can only describe itself. It in no way lessens the importance of the dancer or the choreography, but complements both. Technically dazzling, artistically daring, Doris Chase's work gives the televising of dance the freedom to grow that the flying buttress gave to the medieval cathedrals."

Another of Chase's compositions with Sara Rudner, *Dance Frame* (1978), might serve as a paradigm for "kinetic painting." *Dance Frame* plays off the curvilinear form of the dancer against brightly colored rectangles floating in the center of the screen (fig. 55). The dancer has been transformed into an outlined

Fig. 55. Sara Rudner in *Dance Frame*,
1978. Video still.

video clone, a positive color-shape moving around and within a series of mobile, geometric boundary frames. Program notes accompanying a 1979 American Film Festival presentation in New York explain that *"Dance Frame* is an aptly titled work whose interest lies in its equal division between the spaces and movement of dance and those of film/video framing." The complex manipulation of video color and imagery, the notes continue, "enables Doris Chase to set up and explore a number of opposites—line against shape, abstraction against representation, spatial depth against pictorial flatness, and the most basic, most interesting and certainly most pleasing opposition, the flowing movement of Sara Rudner's dancing body against the fixed geometric fields of the filmic frames."

A statement by Chase concludes the note: "This film was created because of my wish to reconcile organic human movement with an abstract architecture and also to. . . develop a three-dimensional plane on a two-dimensional screen through the use of color. The tension resulting from the conflict between stability and fluidity provides the underlying dynamism. *Dance Frame* was created on video with final changes being made in the film transfer."[15] In another statement about the composition, Chase adds: "In *Dance Frame*, the color development determined the form. . . . I developed intervals through formal tensions and color tensions, both dealing with the problem of depth. Video intervals are color harmonies and relationships produced in planned formulations which give you the illusion of depth on the two-dimensional television screen."[16]

By the late 1970s, Chase's command of video techniques had reached an apex, although the intraprofessional communication necessary to execute the highly specialized effects in her tapes was difficult to achieve. "Sometimes when you begin postproduction," Chase explains, "you say to an editor, 'I want the sequencer effect here and later I'll ask you to do a delay, so please set the switcher.' You are communicating. In the next situation or editing studio, the same conversation would involve a different vocabulary, because there isn't a universal language for these things."

> The best thing to do, even in the top studios, is to show them a cassette with a particular effect. Then someone will say, "Oh, you mean a collage!" In another studio the same effect might be called "postcarding" or the "special 72/60." It's the same for those kids who really love to experiment. Now I bring a cassette of clips along and show them the sort of thing I'd like to do, and often they'll say, "I can do that better, or differently." They love to be challenged, to use their imaginations. Let's say they work in a place that typically makes commercials. They deal with clients, like people from a bank, who will say, "We want to have a small bank building in our commercial and we want it to have a pointed roof. We want a background of blue waves and a lamp post on the right." The clients' ideas are completely preconceived and nothing exciting happens for the technicians. But once you give people who do this sort of thing on a day-to-day basis a chance to be creative with you, they get excited. They start producing bouquets instead of headaches.[17]

This kind of artist/technician rapport produced a *tour de force* in 1979 when Chase created a series of dances for television with dancer-choreographer Gay Delanghe. These tapes stretched the limits of conventional late-1970s television-studio technology, beginning with an oscilloscope "reading" of the musical score in which small patches of color expand and condense in response

to variations in sound quality. In certain sections of the tape, traditional figure/ground relationships are reversed and the principal subject is a color field rather than the figure. In other sequences, the dancer's image is transformed into an abstract shape that might have enticed Futurist sculptor Umberto Boccioni. Like Boccioni's famous figure, *Unique Forms of Continuity in Space* (1913), Delanghe's body fuses with her spatial environment, providing a simultaneous image of what is and what used to be. Video feedback, a technique frequently used in artists videotapes to multiply single forms, is employed here to achieve shadowy afterimages reminiscent of such Futurist photographs as Anton Bragaglia's *The Bow* or *The Slap*. As are Bragaglia's pictures, Chase's Delanghe tapes are more concerned with an advanced algebra of movement than with capturing particular actions or gestures. The Delanghe compositions are Chase's most painterly, as opposed to dancerlike; the image of the performer often serves solely as a pretext for a striking video effect.

The Delanghe dance for television has five variations: "Theme," "Divide," "Space," "Tide," and "Change." The first and last variations are linked by the sound-activated oscilloscope patterns. Sections of the original tape have also been used to create a four-minute composition, *Jazz Dance* (1979). Unique in its artistic conception, *Jazz Dance* is the most lighthearted of Chase's videodances. In *Jazz Dance* the dancer functions as an impersonal electronic cipher, a white outline doubled and then tripled against a dark background. As the line-drawn dancer swings and turns, rainbow streaks of color appear, revolving like cards on a Rolodex, tying the figures together. Later the figure outlines are stretched from armpit to kneecap to accommodate banded inserts of colored light. In this composition Chase makes effective use of the outline generator, an electronic tool that transforms a three-dimensional figure into an empty, moving outline. The outline generator creates a slight exaggeration of certain movements, particularly at the tips of the extremities. In *Jazz Dance*, Chase highlights hand and wrist movements that appear even more expressive and rhythmic in outline form than in live performances, most notably when she repeats them in triplicate in the center of the screen (fig. 56).

Jazz Dance not only presents an engaging display of electronic graphics; it also has a delightful score: a sassy, oom-pa composition by Jelly Roll Morton, performed by the Uptown Lowdown Jazz Band. This lighthearted sound track represents a departure for Chase, who had selected serious electronic or romantic music for all her other videodances. "Music has always been a second or third consideration for me," she admits. "More important are my ideas about time and choreographic space. Music is never something I build around. It's something that's built around me."[18]

Looking back on her videodance work of the 1970s, Chase has published a number of her conclusions in various catalogs in the early 1980s. She notes, for example, that "the most successful recordings of dance do not pretend to be real or emotional, but instead allow the movement to define the design. While dance is conceived kinesthetically, it is seen visually, which makes for an immense distance between the audience's perception and the dancer's awareness. This is similar in nature to the vast difference between theater space and media space." Her major ambition, she emphasizes, is always to try to capture the dancer's experience of the dance by presenting the dancer as a flowing reality. "I carefully organize the total structure, slowly abstracting the physical into an array of movement phrases possible in video. The more I dematerialize the actual physical body, the more I actually visualize the movements of the dance." Using every possible technical device "to meaningfully extend the en-

ergy fields of the media I use... I structure the tension between the predictable form and the human movement experience. This painterly approach is my particular metier."[19]

Generalizing broadly about her work in video and film, she writes:

> My films seek a spontaneous balance but are intellectually arranged. There is a surface simplicity governed by a deep poetic awareness.
>
> There are vast amounts of energy stored in the images I create. I want the viewer to relate to these reserves, allowing the movement of light to reverberate. It is sometimes this extended tension and unleashing of energy that overstimulates and exhausts my audiences. The images operate freely—within their orbits distortion works on many levels. (The ideal viewpoint is the actual physical sensation and its kinesthetic relation.) I prefer to create visual and mental tension rather than contemplative reverberations, and I treasure the audience's delight as well as their serious appreciation.
>
> My film images are juxtaposed and repeated, reiterating themes and obsessions. Basically I'm a romantic; I'm fascinated by visions and dreams and try to present them in a formal setting. I offer an aesthetic experience which encompasses an intense, dynamic energy and the universal quality of mystery.
>
> The films are records of particular movement patterns which I attempt to articulate. I draw from a myriad of diverse sources to illuminate the intricate communications between energy fields; I am not a formalist nor do my films tend toward structuralism. I prefer to use the nature and parameters of film and tape by dealing with the various technical manipulations possible in the labs and television studio to extend some of their possibilities.[20]

From the audience's point of view, Chase's "spontaneously balanced but intellectually arranged" films and tapes of the 1970s exhibit a visual style recognizable on its own terms. Four factors in particular distinguish the Chase "look": polish, treatment of the video screen as a framed painting, vivid color effects, and fluidity in editing. Chase's approach to video editing contrasts sharply, for example, with that of Nam June Paik in *Global Groove*. *Global Groove*, widely admired and emulated, is technically sophisticated yet deliberately crude. In this hyperpaced collage of disparate images, Paik bombards the eye with an overload of electronic stimuli, drawing spectators into a retinal workout analogous to that of the breathless tap dancer, who dances at the beginning of the tape and falls down with fatigue at the end.

Chase, in contrast, works to attain a seamless flow of concentrated images, pacing visual information in suites that suggest organic growth and development. With evident discipline and finesse, her dance tapes build toward, and then retreat from, crescendos of special effects, moving languidly from passage to passage even when the dancer's actual movements are energetic and tense. These fluid transitions were accomplished in part because Chase edited many of her dance tapes after they had been transferred to film. Film stock, a strip of individual photographs, can be edited manually; video tape, a magnetic continuum like audio tape, must be edited electronically, and in the early 1970s only the most simple alterations could be accommodated by conventional editing equipment. Thus Chase attempted to organize her initial footage as carefully

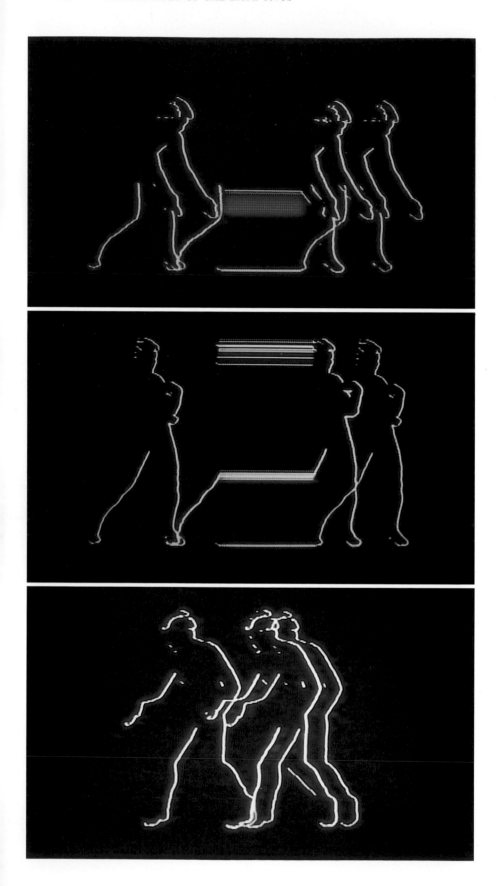

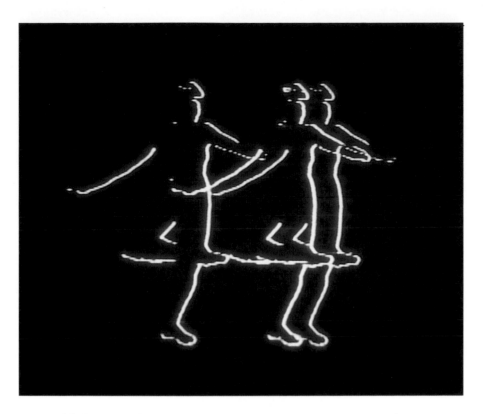

Fig. 56. Gay Delanghe in *Jazz Dance*, 1979. Outline generator effects. Four video stills. David Gronbeck photographs.

as possible by meticulously mapping out shots on a story board before entering the production studio.

The final editing and temporal organization of Chase's dance tapes, however, derive from her intuitive painter's sensibility. In a typical Chase composition, design elements predominate. Negative spaces are often as significant as positive images. Careful attention is paid to edges and focal points created when an image crosses the sides of the framing screen. The electronic palette, usually bold and vivid, tends to heighten video's flattening effect and to augment surface tension. Balanced shapes circulate in rhythmic and harmonic groupings. Special effects are used not only to highlight movement but also to create textures, many of them liquid and gauzy counterpoints to flat, graphic divisions of space.

These stylistic concerns, however, do not exhaust the content of Chase's videodances. Although most reviewers focus primarily on their visual form, the tapes also communicate a romantic vision of reconciliation, uniting nature and technology, muscle and spirit. Stimulating an empathy with the dancer's energy and physical discipline is another primary objective. Color is used not only to forge chromatic harmonies but also to establish psychological atmosphere, ranging from the high drama of *Dance with Me* to the almost wistful lyricism of *Dance Eleven*. The theme-and-variation Takei, Rudner, and Delanghe tapes are studies of movement and light, but they are also instructive demonstrations of video process. Thus, while Chase's work in the 1970s is primarily concerned with painterly expression, it also intends to convey lessons in body awareness and video technology. In the 1980s, the relative weight of form and content in Chase's tapes begins to shift, pulling her farther from her modernist foundations and established personal style than she had ever ventured before.

Video Theater

By the end of the 1970s Chase was well established in the field of videodance. Measured on an intraprofessional scale, her national broadcast credits were numerous and her films and tapes had received significant awards from festivals all over the country. She was among the very few video artists toured by the United States Information Agency: her South American and European trips were followed by a tour of Australia in 1978. Respected critics supported her work, most notably Richard Lorber, who in the late 1970s was an editor of *Dancescope* and a critic for *Artforum*. But because there are no comprehensive studies of videodance as an artistic genre, assessments of each artist's historical profile must begin with first-hand testimony.

Elaine Summers, founder of the Experimental Intermedia Foundation and New York's *grande dame* of intermedia dance, offers her observations about Chase and her work with dancers:

> I first got involved with filmdance beginning with Stan van der Beek in 1958. . . . I did the first intermedia dance concert in New York in 1964, so I've been into this stuff almost forever. Doris . . . first came to my loft in the early seventies. She brought this very beautiful film of her sculptures that you could get into and dance [*Circles II*]. She had come down from Canada or the Northwest, someplace like that, someplace far away and very romantic. I thought the films were quite wonderful, and the sculptures and the dance—the whole thing. . . . Doris was one of the first to combine dance and film and sculpture, and she just kept blossoming out. At the same time it was clear that she's a highly professional woman, very good at technique, who works very hard at something that's not the world's best way to earn a living. When there are so few people in a field, the field has no *weight*. It isn't until other people see what you are doing and begin to explore the field too that you begin to get noticed and attention gets paid to your work. That's what's happened to all of us. . . .
>
> Doris was somewhat unusual here because she was never a dancer herself. But I think Doris sees things with a choreographic vision as a film- and videomaker. When I think of Doris's films I think of her visions, of kinetic art. . . . In Doris's work you can see too why the electronic media have been wonderful fields in helping the women's movement. We were all brought up to believe that women can't handle machines or mathematics. Doris proves that, although collaboration is involved in video, the vision and the ability to assemble the necessary equipment can

Fig. 57. Claudia Bruce in *Window*, 1980. Video still.

be done by a single woman. . . . She continues to be a romantic figure to us because she travels so much and communicates so well with people. She has this tremendous life force that's chosen to express itself in film and video. Somehow, very dear to me is this image of Doris in some far-away country talking about video equipment, being a woman with this strong life force who can organize things and choreograph. I think Doris has contributed to all of us—sometimes she goes to places where they've never seen video art before, let alone video by a woman.[1]

From WNYC-TV, where Chase shot her Takei and Rudner tapes, manager of television acquisitions Barbara van Dyke offers her assessments and recollections:

I first met Doris because of Kleinsinger, whom my husband Willard knew. I bumped into her frequently, but I didn't really get to know her work until round 1980. When I was involved with a project called INPUT [an international television screening conference], I had a chance to do something with her tapes. I was North American program director, and we had an "experimental video" category. A lot of the work I saw was imitative of the experimental film we'd included earlier—films by Jordan Belson and John Whitney and his sons and so on. There was a whole early period of video that was sort of "Oh gee whiz, the hair is green," and I just didn't respond to it very well. I knew I had to take something by Nam June Paik, a John Sanborn, and a Kit Fitzgerald, but I was also looking for something new. It was an international conference and a lot of the European artists had already seen and been influenced by some of the early experimental U.S. work, so I was thinking, "Why bother with it?" Doris's work was something different and it spoke for itself. She came to the conference in Italy. She's awfully good in that kind of situation. She's interested in other people's work, she socializes, she talks, she has an exploring quality that makes her an invaluable participant. . . .

Doris was one of the first women I met, besides Shirley Clarke, who was working in video; and comparing their work is interesting. Doris has a way of structuring that's very different from Shirley's. Doris has this central idea—a form—that she expresses through video technology. With her, the video and the subject are intrinsically together in a way that's different from others. Another thing about Doris: a lot of work that's been very big at places like the Kitchen and the Whitney [Museum of American Art] is very negative and nihilistic, and Doris has never been nihilisitic. She's still a straightforward woman from Seattle—honest, healthy, and together—and I think that's why some people have trouble dealing with her as an artist. She doesn't titillate them by being pathological or manipulative or decadent. She could be a kindergarten teacher, except that there's a restlessness in her that's always out there saying, "What's next? What else?" She's not scared. It all comes from the center and she has a way of just plowing in and plowing through.[2]

For Julie Gustafson, video documentarian and a former codirector of Global Village, Chase was an early mentor:

I met Doris very soon after I came to New York around 1972. I was very young, twenty-four or twenty-five, and I'd just finished my first video-

tape. . . . I remember that she took a real interest in my work and what I was doing to get it out and seen. She was very encouraging and was concerned about my being businesslike and assertive about the work—she had a lot to say about those aspects of artistic life. She was an appreciator, but she also wanted to shape me up. . . . I think the things that appeal to me most about Doris are her commitment and her vision and her persistence. She's prolific and works in a lot of areas in a way that's very different from what I do—she's very straight arrow. She has this sense of herself as an artist and a kind of iconoclastic person. She's a real individualist and is very firm and certain about the touch she applies.[3]

Gustafson also emphasizes that "Doris never stands still in her work. After she had done so much with the more painterly kinds of expression, I think she was ready to turn to something else." Indeed, after the completion of *Jazz Dance* in 1979, Chase stopped making videodances altogether and turned to another frontier: video theater. Although there are evident formal and conceptual continuities between the older and newer work, her video theater compositions confront feminist issues and social tensions foreign to the highly aestheticized videodances. As a result, even though Chase was known and respected for her professionalism and innovation in the field of videodance, the institutional supporters and colleagues she had developed earlier in her career sometimes found it difficult to embrace her video theater productions. To accomplish her objectives in video theater, furthermore, a new set of professional resources was called for which could be developed only in stages.

Chase's motives for initiating another ambitious juncture in her artistic development seem both unambiguous and complex. One factor was her conclusion that she had reached the edges of a technical frontier. "When I finished the tapes with Gay Delanghe, I think I had amalgamated all the different effects possible in a conventional television studio," Chase explains. "It was a kind of *tour de force* of the possibilities, at least as they were then. Then I thought, 'Where do you go from here? Only down.'"[4] She also found herself "a lot less enchanted" with video art. In her assessment, "The audience [for video art] is so small and seems to be growing very slowly, if at all. All those ideas people used to have about arts channels, about narrowcasting—they just haven't happened. So either you deal with the realities of television or stay in the unreal world—or at least the very small world—of video art. At least for me, my work gets shown at festivals, wins awards, and then it's right back here in my lap. If awards from festivals led to distribution, that would be great. But that's not the way it works."[5]

The most compelling stimulus for refocusing her work, however, was a growing desire for more concrete forms of communication. This desire, Chase found, necessitated "bringing the WORD into my abstract pieces." Her initial conception of how this might be done was inspired by innovative off-Broadway theater performances, which she attended frequently in the late 1970s. Redesigning some of these productions for the intimate, flat video screen, she decided, was a problem that might be solved, at least in part, by retooling her approach to videodance.

In 1979 she began discussions with advisors at the New York State Council for the Arts, emphasizing that she "wanted to do something with theater using my background of dance, using words to give it more meaning—to take it out of the abstract." At the same time she renewed her acquaintance with theater artist Lee Breuer, whom she had met years before when she helped arrange

his performance at the Henry Gallery in Seattle. "[By] 1980 I had seen a number of Lee Breuer's theater projects and I liked them very much," she recounts. "He was interested in doing something that would incorporate some of my dance film or dance tape. At any rate, the proposal for *Lies* went in [to NYSCA] from both of us and we got the grant. It was the first breakthrough in narrative at that time using effects and video techniques."[6] *Lies*, a performance poem by Breuer originally entitled *Haji*, is described by the author as "an idea about a list of lies and their prices." In Chase's 1980 *Lies* tape, the text is performed by Ruth Maleczech.[7]

Reviewing his collaboration with Chase, Breuer explains: "When Doris and I began to work, I was particularly taken with the... way she abstracted video images. I thought that an interesting combination, with that level of visual abstraction, would be very realistic and intimate acting plus a certain kind of basically abstract text that would go along with it. So that's what we've attempted to do" (fig. 58).[8] From Chase's perspective, she faced two major initial challenges: adapting a performance intended for three-dimensional theatrical space for video space, and selecting special effects to visually heighten the spoken script. Chase also wanted to use video effects to

Fig. 58. Ruth Maleczech, Doris Chase, and Lee Breuer discussing *Lies*, 1980. Video still.

awaken the viewer's subconscious with changes in texture, expressive colors, dynamic timing, odd spatial relationships, and unexpected juxtapositions. The subtle psycho-perceptual mechanism of our sensations and reactions can be upset by distorting and fragmenting the real image to the point where it brings us back to dreamlike, subliminal images we have buried. Texturing a video piece in this way requires careful attention to mood changes in the script and to the unique performance style of each actor. If the essence of these elements blends just right in the frame, the viewer can experience two ways of seeing, the real and the unreal, the conscious and the subconscious.[9]

To begin adapting *Lies* for video, Chase set up taped rehearsals with Maleczech in her tiny Chelsea dining area, just as she had done with dancers. In these sessions, she explains, "I'd plot my camera shots. Later, I'd have [Ruth] view them. Many times I wouldn't say anything, just let her see the tape. That way I could show her the way instead of telling her. It made it more comfortable. If I needed tight close-ups, then I would say, 'OK. On this line in the script I want your hand here because my camera is going to be zooming in, and it's very important that I have this tight gesture with the open palm and fingers. Please realize that I want you there for that sentence and a half, because my camera is going to zoom in on your fingernail.'"[10]

As do Chase's dance tapes, *Lies* focuses on a single performer whose movements are confined to a small, carefully lighted cube of space. (Chase later described it as "portrait space.") Also, like the dance tapes, the camerawork focuses frequently on the performer's eyes, fingers, and hand gestures, providing a voyeuristic access to physical details. Finally, as in the earlier work, at the beginning of the tape there are no special effects at all. "Later, when you start to feel the disintegration at the interior of it," Chase says, "there are definite effects—the moral and visual images fluctuate, decay."[11]

The script of *Lies* is a freely structured monologue about emotional prices and debts, and the social clichés and rationalizations they engender. To Chase, the tape is "a study in cost accounting" that reveals "the constant drain of everyday hypocrisies and compromises," particularly in the life of the

Fig. 59. Ruth Maleczech in *Lies*,
1980. Video still.

artist. Maleczech's props include a typewriter, upon which she composes a letter of recommendation for a talented former student which is really intended to keep him out of town, and a telephone. "The problem is *cash*," she tells us, followed by, "No, that's a lie. The problem is cash flow. No, that's a lie. The problem is *flow*." Meanwhile, superimposed numbers roll across the screen together with accounting and billing terms, creating in Chase's words, "a visual dilemma between the interior and exterior of the performance" (fig. 59). *Lies* concludes with a rendition of "Bury Me Not on the Lone Prairie," accompanied by a rhythmic clip-clop with the typewriter. Compared with *Lies*, the live multimedia performance of *Hajj*, which incorporated mirrors and video monitors, was more ambiguous, broadly symbolic, and suggestive. With actual, reflected, and electronic images, *Hajj* presented personal pledges and social infidelities as ironic mazes of truth and illusion. Chase's *Lies*, which she produced and directed, is comparatively informal and conversational and is intended, she says, "to help us recognize ourselves."

While working on *Lies* in 1980, Chase also began collaborating with writer-director Linda Mussman of the Time and Space Theater. Mussman's theatrical texts of the early 1980s integrate foreign languages, abstract poetry, Dadaistic sound poems, word association exercises, and alliterations à la Gertrude Stein. The texts, blocks of *non sequiturs*, are chanted, mimed, sung, delivered as monologue, or blurted in syllables. To keep the emphasis on language, typical Time and Space productions employed few props or costumes, and theatrical effects were confined to subtle lighting. Mussman and Chase decided to redesign for video a composition by Mussman called *Window*, one component of her three-part, multimedia production entitled *Room/Raum*. According to Mussman, *Window* is "about living in a constant state of change. The piece is about memory—not the act of memory, as in Proust, but memory as form."[12] Chase describes it as "a dramatic poem concerned with inner and outer tensions in a woman's life."

In Chase's videotape, *Window* is performed by Claudia Bruce, who first appears in triplicate playing the violin. This simultaneous image of multiplicity and singularity corresponds to the structure of the spoken text, where a series

of similar sounds is converted into different words, as in "to show, to shoe, to issue. . . . " As the tape progresses, Bruce's hand, neck, and facial gestures become a videodance (see fig. 57) in which a new visual meaning emerges for the technique of debeaming. In tapes such as *Sara Rudner* or *Dance Seven*, Chase uses debeamed floods of color to extend the dancer's body in space. In *Window*, debeaming punctuates verbal rhythms and extends the sounds in time: as Bruce slows her articulation of individual words, drawing out single consonants, liquid trails of light stretch the temporal transitions as if the sounds were physically elastic.

As a compelling visual performance, *Window* is perhaps most successful in a middle section of the tape where the speaker's face fills the center of the screen (fig. 60). Here Bruce begins to perform the word "wait," repeating the "t" sound over and over as if mimicking a dripping faucet. The image of the face is segmented vertically into several bands, some colored, some solarized, and one in normal flesh tones. As Bruce continues to speak rhythmically, accelerating her pace gradually, the banded segments begin to move and change color, first slowly and then faster and faster, until image and afterimage register at the same time. Like strobe lighting, which this video technique resembles, the psycho-perceptual effect is visceral and disarming, fulfilling Chase's ambition to create "two ways of seeing, the real and the unreal, the conscious and the subconscious."

Lies and *Window* were the first tapes in a series of 29-minute video theater productions Chase called the "Concepts" series. Seven other productions followed: *Skyfish* (1981); *Electra Tries to Speak* (1982); *Travels in the Combat Zone* (1982); *Three Story Suite* (1983); *Mask* (1983); *Glass Curtain* (1983) and *Thulani* (1984). As a group, the tapes conform to the definition of "performance video" proposed by Marita Sturken in her 1983 article, "Video as a Performance Medium":

> A performance video piece is a work designed specifically for the architectural space defined by a video camera, rather than the theatrical space defined by the stage. Video breaks down the barrier of the proscenium arch, not only bringing viewers into a more intimate relationship with the performers, but altering the very nature of the performance. Performance video differs from simple, straightforward documentation of a perfor-

Fig. 60. Claudia Bruce (above and left) in *Windows*, 1980. Video stills.

mance in that these artists are interested in the issues raised by using the TV camera and monitor as part of the artistic, creative process.[13]

With the exception of *Skyfish*, each of the "Concepts" productions features a New York actress or performer who appears alone, without set or costumes. *Skyfish* has two performers, although the primary character is off-Broadway producer, writer, and painter Lee Nagrin. First presented at the Women's Interart Theater in New York in 1973, *Skyfish* is based on twelve dreams experienced by Nagrin.[14] In her performance she explores the meaning of these inner visions while painting a large abstract mural, a conscious act of creation. The central metaphor, the "skyfish," refers to attempts made at various stages in life to integrate depths and heights, earthly realities and spiritual truths (fig. 61).

Fig. 61. Lee Nagrin in *Skyfish*, 1981. Video still.

As she did in *Lies*, in producing her *Skyfish* videotape Chase tied the more broadly suggestive stage presentation directly to the life of the artist.[15] Celia Weisman describes Chase's interpretation in *Film Library Quarterly*:

> In *Skyfish*, perhaps Chase's most abstract tape, images float, crash, collide, dissolve, reappear and swim across the screen. They fill the frame or gather atop one another to create a computer-age palimpsest. While this visual feast of color and movement continues, the audio track travels from soothing sine-wave cadences to speech, to layered textures of nonverbal sound. Such elaborate technical strategies serve as devices to unravel meaning; they never come across as empty virtuoso display. With *Skyfish*, Chase's surrealism moves spectators with its immediacy and precision to an archetypal world of dream, vision, symbol and transformation.

Skyfish charts a journey into the interior shores of consciousness, according to Weisman, as Nagrin begins to externalize the landscape she finds within herself. A telling phrase is

> chanted repeatedly by the younger artist, Andrea Goodman [the second performer]: "I had no reason to know that this radiant image would collapse and I'd look at it all like old clothes and start over again. How could I imagine?" In this phrase, as with the whole of *Skyfish*, life is revealed as a continual cycle of creative and destructive rhythms—an interweave of light and dark elements. If allowed to unfurl, this interplay of opposites moves the true seeker to a profound gnosis. Here the artist is pictured as a seeker, documenting her individual and universal identity. *Skyfish* depicts this one woman's quest for knowledge of life's mysteries and her own self in such a way that we can see ourselves in Nagrin's search.[16]

Despite Nagrin's powerful physical presence and the myriad of visual effects, however, *Skyfish* remains formally unresolved. Chase sometimes seems to lose control of Nagrin's body as a physical shape moving through the framed video space, and the juxtapositioning of the two performers is awkwardly executed. *Skyfish* represents Chase's first attempt to present two performers in video theater, and she admits to being less than satisfied with this aspect of the tape.

Chase's next production, *Electra Tries to Speak* (1982), changed her artistic perspective. Although *Lies*, *Window*, and *Skyfish* all center upon insightful female characters who explore the issues of language and identity that engage many feminist artists, Chase did not conceive of these productions in specifically feminist terms. Her outlook changed in 1982 when she began working with theater artists Roberta Sklar, Clare Coss, and Sondra Segal, who collaborated on the script for *Electra*. Beginning with *Electra Tries to Speak*, Chase identified a "new dimension to my work, a similar aesthetic... but a new commitment and vocabulary: the feminist voice."[17]

A review of Chase's previous video theater collaborations suggests how and why *Electra* served as a catalyst for her nascent feminism. In producing and directing *Lies*, *Window*, and *Skyfish*, Chase personalized the metaphorical and symbolic content of the texts, relating them more directly to herself and to her experiences as an artist than did the authors themselves. The Lacanian *Electra* script confronts the predetermination of female identity in a patriarchal society by representing the frustrations, insecurities, and rage of a woman struggling to speak with her own voice (fig. 62). Any professional woman can find direct analogues to her own history somewhere in the text, and Chase found a great many. Bluntly confronting the universality of what she once regarded as her own private shortcomings, she felt both outraged and relieved. She already knew that she wanted to "communicate more concretely" in her work; now she began to understand more clearly what she wanted to say.

Chase's colleague Julie Gustafson offers another perspective on the feminist orientation of her recent work:

> I'm a documentarian and I try to be sensitive to nuances of internal states. I think Doris, over the years I've known her, has had a lot going on way deep inside that only occasionally breaks through. She's sometimes hard to get to know on a personal level, although she can always get to *you* on a personal level.... There's a lot of things... she feels

Fig. 62. Sondra Segal in *Electra Tries to Speak*, 1982. Video still.

strongly about and maybe couldn't release before. I think it all has to do with her sense of arriving at a real maturity. . . .

What happened to Doris during the years she was married is important here too. I remember a while ago I was talking to her about my having another child—I have two children—and she was horrified. She said, "You need time. You have to think about this. You have two beautiful children you barely have time for now and you can't neglect your work." She made this impassioned statement about *my* life, but I can see now that it said so much about *her* life.[18]

Chase herself composed a similarly revealing statement for an interview conducted shorted after *Electra Tries to Speak* was completed:

It is worth reiterating the bottom line about women artists in society, in media and in other art forms. Over and above any considerations of theoretical issues, technical questions and funding problems, there is the constant struggle to be allowed to work as an artist at all. A woman's creativity is still—in spite of everything—not taken seriously as her ultimate priority. Making art is scarcely considered to be REAL work anyway. Thus, any artistic achievement by a woman has certainly, at some point, been ridiculed by family and friends, who often do not define this as a relevant sphere of success for a woman. The woman artist has to struggle for the right to devote her time and energy to herself and her work, instead of always caring for others. Once this has been achieved, she has not even started to figure out what she wants to say, let alone tackle the formalist questions.

Video is a particularly fast-paced and grueling art field that can absolutely ravage fragile egos. The support groups, alternative funding and distribution networks, heritage and role models necessary to help women to succeed are just beginning to emerge. Yet video and its new technology offer us a very special opportunity to develop new forms of expression specifically designed for works by and about women.

To quote a line from one of my productions [*Electra*]: "I used to want to be the Muse. Now I want to be the artist. I don't want to be the inspiration. I want to BE IT."[19]

In her post-*Electra* productions, Chase self-consciously confronts the constraints placed upon women artists by a patriarchal culture as well as her own emotional autobiography. Video historian Ann-Sargent Wooster, who has known Chase's work for several years, compares these productions with her earlier work in sculpture. "In formal terms, in sculpture, look at how so many of the forms are about exterior shell and interior space. Then you see what she does with image processing: she takes the dance forms and turns them into forms like her sculpture. What's interesting in both cases is that the interiors are empty. When she does these theater pieces she's doing the interior she's left out all these years."[20]

In her next tapes, *Travels in the Combat Zone* and *Mask*, Chase has produced scripts and directed performances by women of color, whose frustrations and resiliencies project far beyond Chase's own white, middle-class experience. *Travels* is written by Filipino writer and musician Jessica Hagedorn, who moved to the U.S. in the late 1960s. The tape brings together a series of prose poems—survival stories about young black and Asian women who samba

through a combat zone of urban relationships. Hagedorn arranges her language in broad and small percussive patterns, alternating passages of raw, lyrical, and ironic first-person testimony. To underscore the linguistic rhythms, Chase uses digital effects that break down the human image into a series of moving squares. Applied to a close-up of a face, the effect produces a cubist abstraction; using the effect to produce several different images, the screen is filled with a grid of black squares and moving picture postcards, capturing the actress at different moments in time (figs. 63, 64).

Mask, written by Bonnie Greer, reviews the confusions of an outsider emulating the success models of white America. As a young black schoolgirl, the performer tells us, "I drew my self-portrait on white paper. . . . I did not color it in." As a teen-ager, she wanted to be Sandra Dee. "I practiced Sandra's smile, the tilt of her head. *She* was the heroine of my secret self, not Harriet Tubman." As a successful business executive, she "took pride in not knowing the words to gospel songs." Recounting other memories—a romance with a militant black man that concluded with abortion; her grandmother, "a tiny old lady, her face full of wrinkles, smoking in bed"—the actress paints her face with the design of a tribal mask (fig. 65). As her fingers touch her cheeks, she repeats the line, "If I take this off, my skin may come off too, like the flesh of Hiroshima victims when they were touched." At the end of the tape, the performer's painted features fill the screen, her mask no longer a façade but an emblem of power and resolution.[21]

In a later tape, *Thulani* (1984), writer and *Village Voice* Senior Editor Thulani Davis presents more structurally elusive vignettes of black experience, which she threads around characters named Minnie and Snake and a "genius from southeast D.C." Davis tells us, for example, that in trying to talk about a race riot, Minnie looked up and said, "We don't have anywhere to put any more dead." Snake replies, "We never did. We never did." *Thulani* was based on earlier live performances at the Kitchen and the Public Theater in New York, where Davis executed her poetic monologues in collaboration with jazz

Fig. 63. Mary Lum (top) in *Travels in the Combat Zone*, 1982. Digital effects. Video still.

Fig. 64. Maralyn Amaral in *Travels in the Combat Zone*, 1982. Postcard effect. Video still. David Gronbeck photograph.

Fig. 65. Pat Patton in *Mask*, 1983. Video still.

Fig. 66. Thulani Davis in *Thulani*, 1984. Video still. David Gronbeck photograph.

musician and composer Anthony Davis. Redesigned for video just as Chase was completing her "Concepts" series in 1984, Davis's performance in the *Thulani* tape is transformed by a virtuoso display of video texture. A study in black and white, both literally and figuratively, *Thulani* reconstructs Davis's face as a mime's head cut from what appears to be a shaggy fabric, like striated terrycloth (fig. 66). Instead of moving diagonally or at right angles to the framing edge of the monitor, as do most of Chase's transfigured images, the mottled mime's head in *Thulani* jumps across the screen in arclike patterns, echoing the changes in pitch in Davis's voice.[22]

Investigating another genre of female expression, Chase created *Three Story Suite*. In this tape, storyteller Laura Simms performs three folk tales about archetypal women: *Fetnah*, the disturber, is a Persian king's consort who teaches him humility; in *Spirit Basket*, a South African bushman tale, the goddess of

spirit attempts to convince men that "things of the spirit are not empty;" *Hina* is the story of a Polynesian moon goddess who transforms traditional women's work into a cosmic force by wringing fleecy clouds from tapas cloth. Although Simms uses expressive physical and vocal gestures to animate her stories, a storyteller is the ultimate "talking head" as a video performer. Celia Weisman outlines Chase's attack on this visual cliché:

> Chase's special effects subtly reaffirm the magical texture of Simms' words. Images of her face are superimposed upon one another, presented in multiple successions, emptied of appropriate skin tone and filled with black, blue or red expanses of color. Individual arm gestures are highlighted, slowed down, made to echo themselves, eventually becoming pure patterns of light and line. Through such video strategies, Chase gives imagistic support to the corresponding verbal text; for example, at the climax of *Spirit Basket*, when a mortal man fails to follow the goddess's directions, Chase makes Simms' body suggest the base wrongness of his action: her flesh turns invisible and we see her as skeletal and inhuman.[23]

The last tape in the "Concepts" series, *Glass Curtain*, is unique in that the script was authored by Chase herself and confronts a painful personal experience, her mother's affliction with Alzheimer's disease. Chase says of the script:

> I have written all my life, but what I've written has always been very personal, as if one were writing for a psychiatrist. I never thought of publishing any of it because I thought that, while I can take criticism on my sculpture and my video, I couldn't take it about my writing—it's too personal. Also I think it was difficult to talk openly about my feelings because so many women's feelings are considered to be trivial and unimportant—certainly not important enough for a television script. But I finally faced the fact that *I* think these feelings are important and worth listening to. I'd also begun to realize that I wasn't the only one with a personal load. One always thinks one's life is unique. My mother was sick. Well, *everyone's* mother gets sick. Everyone goes through these things and they are *touching*. I think we really need to share these experiences more, even if it's just with the video screen.[24]

Rehearsing *Glass Curtain*, Chase engaged in a new form of collaboration. The dancers and performers in her previous tapes had all been approached to some degree as objective pretexts or vehicles through which she organized her aesthetic visions or conveyed her social ideas. Using her own script to work with actress Jennie Ventriss, however, a psychic rapport began to develop in which, Chase says, "I became Jennie and she became me. Of course this is what a fine actress can do, become the character that is written. But we were also dealing with feelings that she had and I had before we ever met. That's different from empathy; it's like finding a kind of universal mirror and discovering that another person has the same image as yourself."[25]

Glass Curtain explores Chase's love/hate relationship with her mother, her struggles for autonomy, her helpless frustration in the face of the mental and physical disintegration of a parent from whom "the umbilical cord was never cut." The special effects in the tape are minimal, but the text is supported by dramatic framing of the actress's face (fig. 67). The opening close-up, for ex-

Fig. 67. Jennie Ventriss in *Glass Curtain*, 1983. Video still.

ample, displays Ventriss's profile from ear to nose, stretched horizontally across the screen like a mountain landscape. "Ideally I wanted to achieve the closeness between the actor and viewer one feels in some of Bergman's films," Chase explains:

> Some people say that you can't get real intimacy in video because the technology always seems to come between the viewer and the performer. But I think this has a lot to do with the way television is used—the pacing for example. Developing a feeling of intimacy takes time, and you can't be distracted by a car chase or a shooting or even a lot of characters. Intimate television is not red-hot television: People say that nothing happens in *Glass Curtain*, and it's true. No big action happens but a lot of other important things happen. I think pacing has a lot to do with a woman's way of expression, slowing things down, allowing for introspection. I wasn't trying for mindless entertainment.[26]

The next script Chase produced, *Table for One*, was also her own; with it she began a new video theater series called "By Herself." These productions are dedicated to the world view of older women and are made "to give the average older woman dynamic role models and to show that the older actress is still an exciting force in the acting scene."[27] The latter was never in question, however, in the case of the performer for *Table for One*: Geraldine Page. "I met Geraldine when I went to see her in *Agnes of God*," Chase says. "After the performance I talked to her and told her about my work, and it turned out that she had already seen some of my tapes on television. It took a while to get her over to my apartment to look at some of my scripts, even though she lived right around the corner from the Chelsea. But she finally came and read the *Table for One* script and said, 'I'd like to do this,' and we started right away."[28]

Table for One surveys a female diner's thoughts as she eats alone in a fine restaurant. Chase and Page explore the occasion through the device of an inner monologue in which the diner muses about her recent divorce, her new sense of independence, and the social awkwardness of her singularity. Page was attracted to the script, she said, because "I would like all those silly women who think it's so terrible to go have dinner by yourself to go out and

enjoy it. Of course I realize this is all very well for me to say, because since I work in theater and have so many people around me, it would be a pleasure to go have dinner alone. But I do understand why women don't do it. I empathize with them. But I want to say the same thing Doris was saying in the script: You *can* have a personality without being an appendage of someone else. A lot of women still don't realize how important it is to appreciate *yourself*."[29]

To produce *Table for One*, Chase first recorded the audio track, later adding restaurant sounds and music to Page's monologue. "Then, before we went into shooting, Geraldine came to the Chelsea for rehearsal with the audio tape," Chase explains. "Every action was precisely choreographed with the audio and was worked out visually on my story board. Her precision was incredible and so was her imagination about the kinds of movements and actions to bring the script to life. When we did the shooting, she was like a mime reacting to her own prerecorded voice. What an absolute joy to work with that kind of talent."[30] To strengthen viewer empathy with Page's character, Chase "had the camera move in as far as we could on the eyes. I wanted the shots tight enough to show some wrinkles (fig. 68). There are close-ups of the hands as well. Something that fascinated me when I started showing the tape was the number of women who would say, 'Oh look—she has a little touch of arthritis in her hands too.' Details like that are meaningful to people."[31]

Chase used only a few special effects in *Table for One*: ghostly images of a wine glass and female idols drift by to punctuate sections of the monologue, but most of the shots are straight recordings. "The people who actually make decisions about what gets broadcast kept telling me my theater pieces were too arty and to cut out the special effects," Chase explains. "I didn't want this work to be like a lot of what I'd done before, where an idea would become obsessive and I'd break my neck to do it, but it wouldn't get to much of an audience. With the 'By Herself' series, the idea of the project is wagging me. It tells me what I have to do to make it happen, and I think it's such an important idea that I'm willing to go along. Of course I've got a lot of misgivings about getting into marketing, but do I want to end up just talking to myself?"[32]

Besides reducing the special effects, Chase was also repeatedly advised to stop working with single performers and to introduce dialogue into her scripts. In response, she rewrote the second of her "By Herself" productions, *Dear Papa* (1986), to include two performers: Ann Jackson and Roberta Wallach, a mother-daughter team in fact as well as in the script. Although the characters are in dialogue during the last third of the tape, they primarily enact side-by-side monologues that confront the imminent death of a father/grandfather. In the *Dear Papa* script Chase reflects upon her relationship with her own father, a domineering, professorial lawyer and Washington state legislator. Jackson, who plays the father's daughter in the tape, pulls together a montage of conflicting directives issued to a daughter by a male parent. As a child, Jackson tells us, her father taught her how to fish and shoot a rifle, but later, when she wanted to enter a profession, either law or medicine, he advised her to stay out. "I guess he was afraid I wouldn't get married and be respectable," she concludes. "He told me I could do anything. The sky's the limit. But he didn't mean it. He didn't mean it."

Chase makes occasional but very striking use of mattes and gridlike "postcard" effects to integrate the two characters in *Dear Papa* even when they are not addressing each other directly. The rest of the shots are conventional, although her careful positioning of the actresses within a largely empty cube of space, and her attention to framing, sets *Dear Papa* apart from the usual look of television (fig. 69).

Fig. 68. Geraldine Page in *Table for One*, 1985. Video still.

Fig. 69. Roberta Wallach and Ann Jackson in *Dear Papa*, 1986. Video still.

The structure and content of the "By Herself" tapes also distance them from the daytime network dramas they occasionally resemble. According to Ann-Sargent Wooster's analysis:

> Usually what happens when theatrical people get involved with video is that they end up making a movie. They say, " Video—that's like movies. I can set the story on the prairie." What Doris does that's different is that she stays basically in a theatrical environment, except the proscenium stage has shrunk: instead of still-life space, you have portrait space. I think Doris was the first person to be working extensively in this way.... [In Chase's tapes], even compared to the experience of a one-person show in a small theater, the fourth wall is very thin. What she does with these characters is to have them reveal their inner selves. People are supposedly doing this on *Dallas* or in the soap operas, but we all know they are acting—there seems to be a script. Here there seems to be a script, but at the same time it's a performance of an inner monologue that somehow rings true as a genuine thought. I think that's the reason I have to turn away from certain parts. I don't want to see these people naked, but to a large extent, that's the success of the work. You want to tell this woman—"Look, go to your health club, put on your pink jogging suit and work it out"—but on the other hand, you do believe it's the truth.[33]

While they are distanced from conventional television by their framing, pacing, and psychic nakedness, Chase's tapes appear technically to be the work of a broadcast professional. Chase's tapes had been distinguished for their technical finesse since the mid-1970s, but her 1980s work also reflects a widespread enthusiasm for a broadcast-quality look, especially among a second generation of New York video artists. Among this younger contingent is Robin Schanzenbach, a video producer/editor/director, who acted in all these capacities in creating a 1984 documentary, *Doris Chase; Portrait of an Artist*. Broadcast on WNET in New York and nationally on public broadcasting stations, Schanzenbach's 28-minute survey of Chase's life and work has production values that

would have eluded or would not have been a primary concern for the early Portapak artist-documentarians. Attitudes about production values in the 1980s, as Schanzenbach explains, have undergone a number of changes:

> I was involved with a group of artists starting in 1979 who became very vocal and complained to NYSCA and individual arts organizations that the technology available to the broadcast industry was not being made available to artists, and the art institutions of New York weren't making it their business to get that technology for artists. They were turning a deaf ear to us, so finally we started to create our own video equipment collective, basically taking away from other video institutions their economic base. Then we came together and negotiated and they aired their problems to us. At that point an organization called the "Media Alliance" began to develop their "On Line" program, which basically gives artists access to top technology facilities in Manhattan for ten-to-fifty percent of the normal cost. We strongly supported the program and helped develop ideas about how to make it work. It still goes on and it's extremely successful—it allows artists to stay in touch with the latest technology. After we all talked it out we understood that you can't expect arts organizations to have expensive equipment that costs over a quarter of a million dollars for one tiny box. But we did find a way for artists to have access to the tools to create state-of-the-art programs: now the big issue is distribution—getting our programs out to people.[34]

Launched in 1979, the Media Alliance describes itself as "a professional association whose programs and services support the production, exhibition, distribution and appreciation of nonprofit electronic media artworks through New York State."[35] Through Media Alliance's "On Line" program, Chase was able to finance the sophisticated postproduction work on some of her later "Concepts" tapes, as well as *Table for One* and *Dear Papa*, at broadcast-quality commercial video facilities in Manhattan.[36]

The accelerated production of broadcast-ready, 28-minute tapes among New York video artists in the 1980s signals widespread disinterest in the argument that it is "both a contradiction in terms and a confusion of issues to believe that video art belongs on television."[37] Former Media Alliance executive director Robin White confirms that "while there has been no mass exodus from the art galleries and museums into the coliseums of the television industry, a significant number of artists have decided that video by artists should really be seen on television."[38]

Work by these artists should be termed "television art," according to video writer and curator Carl E. Loeffler. Its production, he says, "marks a decided turning point in the history of the video medium as a form of expression in contemporary art." "Television art" differs from "video art," Loeffler explains:

> Video art is presented in a gallery context or a "framed" segment of television. Television art is presented in an "unframed" television context, or a "framed" gallery situation.
> Video art is subject to the criticism applied to painting, sculpture and other creative disciplines. Television art is derived from art disciplines. Television art is derived from art disciplines, but subject to the criticism of the information environment.
> Video art is perceived as an art commodity which increases in value

over time. Television art is perceived as information which only has value for as long as it's useful.

Video art is distributed to an art audience. Television art is distributed to a non-art audience.

Video art applies hardware as an aspect of mystification. Television art applies hardware to become more accessible.

Video art is funded by the art market, patrons, grants. Television art is funded by advertising, investors, distributors.

Video art looks to the art context for meaning in the end. Television art looks to the art context as a means to the end.[39]

If television art has a cause, Loeffler continues, "it is to further inform the public by offering alternative viewpoints. The possibility of informed choice, which has been eroded by homogenized TV, can become an option through television art. This is not to say that a single program or series of television art will effect massive change when seen by a viewing audience. The socio-political process alluded to here is very slow in augmentation and effect and realistically; it may never happen." If change does occur, he predicts it "will not result from a supposed magic quality of the medium alone. Television is a vehicle, not an icon."

The evolution of Chase's video theater productions from 1980 to 1989 conforms with Loeffler's observations, although she has made no self-conscious effort to follow a broad historic trend. Tapes like *Lies* and *Window* (1980) presuppose an art audience: in these compositions, expressive video effects punctuate and amplify disjunctive monologues, abstract sound poetry, and collages of linguistic clichés, generating aestheticized hybrids of performance, choreography, and visual form.

Financial and technical support for these intimate collaborations was generated largely by Chase herself, who distributed her work through organizations such as Women Make Movies, a small, independent New York company dedicated to promoting films and tapes by women artists. Exhibited primarily in museums, universities, and video festivals, *Lies* and *Window* exemplify the kind of production that, in Loeffler's analysis, "looks to the art context for meaning in the end."

In contrast, *Sophie*, produced in 1989 as the final installment of Chase's "By Herself" series, "looks to the art context as a means to the end." A vehicle for famed British actress Joan Plowright, *Sophie* was produced in London at Channel Four, one of the city's major television stations. In addition to Chase as director, production credits include a property manager, designers for make-up, hair, costume, and lighting, a casting director, a production designer, an associate producer, a producer, and a series producer. The station commissioned five new scripts for Chase's consideration: her choice, authored by Julia Kearsley, presents an encounter between a middle-aged woman and her grown son. She has just left her philandering husband, and her son is embarrassed by his mother's new autonomy.

This radical shift in the working milieu—from rehearsals in the Chelsea Hotel and from bartered studio time at public television stations to a full-fledged, mainline production facility and crew—came about not because of lingering EAT artist/technology utopianism, but because, in 1986, Chase found an executive producer and distributor for the "By Herself" series, Giuliana Nicodemi. Nicodemi, who had known Chase's work for several years, is an Italian television distributor and producer based in New York. While Chase was completing *Dear Papa* with Jackson and Wallach in 1986, she began discussions about a

new production with Luise Rainer, winner of the Academy Award for best actress in 1936 and 1937, who has lived in retirement for many years in Switzerland. Nicodemi's first role was to negotiate production rights with RTSI/TV, a prominent Swiss television station, where Chase and Rainer created *A Dancer* in 1987. In this tape, which utilizes short excerpts from Chase's earlier videodances, Rainer plays a former ballerina who has directed a dance troupe after retiring from the stage. Visited unexpectedly by an old lover, she refuses his offer of marriage in order to preserve her professional life.

While the theme of *A Dancer* is consistent with Chase's ambition to provide dynamic role models for older women, the dialogue and visual execution of the Rainer tape lapse into a sentimentality which undercuts this objective.[40] Chase's experience in executing one of her tightly controlled compositions in a mainline European television studio, however, helped lay the groundwork for *Sophie*, a quiet drama about dominance and submission in a middle-class family which aptly fulfills the goals set for the "By Herself" series.

Chase made the initial contacts for the production with Channel Four. "Channel Four liked the concept but wouldn't have gone ahead with it if I hadn't had an executive producer," Chase observes. "My executive producer made me legitimate. As an artist alone, I wasn't legitimate. They could talk contracts with Giuliana. If you are really going to deal with television, all kinds of lawyers, financial advisers, and accountants have to be coordinated, which is a specialty in itself. It took Giuliana a year to work out all the arrangements in London, and it was very frustrating. On the other hand, all the people I worked with in London were terrific professionals. Working with Plowright was a joy. Joan wouldn't have done the tape if she hadn't respected what I was trying to do (fig. 70). We trusted each other as artists, which, in a typical television situation, isn't necessarily the case."[41]

The character Plowright plays is an outwardly prim English mother named Evelyn, who has finally decided that her own interests are not synonymous with those imposed by her social role. Much to the chagrin of her husband and sons, she has set herself up in a bed/sitting room as "Sophie, reader of French tarot cards." While her estranged husband waits outside in the car, her elder son attempts to restore her sense of propriety, which had, in fact, masked alcoholism and despair. Plowright rejects her son's entreaties with humor and resolve, insisting that she "can't be Mummy all her life." Chase's established artistic signature fills the screen in this production only once. Evelyn actually has two sons, the practical, logical, older man who attempts to bring her home, and his intuitive, playful, alcoholic younger brother, turned out of the family home by his father. Too obviously symbolizing right-brain and left-brain as characters, the two sons nevertheless merge visually into an affecting and suffocating image of demand, their two faces replacing each other in rapid succession as they alternately dictate to or plead with their mother. This video effect, almost physically disconcerting, collapses the major thrust of the narrative into an intense 20-second encounter that interrupts the conventional artistic distancing in the rest of the production. The interlude serves a number of objectives in the tape, one of them to suggest the possibility of a television "art."

After completing *Sophie*, Chase concluded that television art may not require the resources of a major television production facility. "This tape actually made me nostalgic for painting," Chase admitted. "It's not that pushing paint around with a brush is so appealing, but that a painting is a world that's completely under the painter's control. Collaborating with an actress like Plowright was wonderful, but there were so many variables in this kind of production, so

Fig. 70. Doris Chase directing Joan Plowright in *Sophie*, 1989. Rosemary Barraclough photograph.

many needs to serve, that it became a constant frustration. I was there to make a product that Giuliana could market—that was understood. But that's not the only reason I was there. I'm going to continue working with older actresses, but I'm thinking about other ways to put things together." Chase also admits that at the end of the 1980s, "there's an allure of the tangible as well as the tube. I have some new ideas I want to try out in sculpture too."[42]

Given the economics of New York City real estate, it is unlikely that studio space for large-scale sculpture could materialize in Manhattan. In the fall of 1989 Chase took an apartment in Seattle with access to a studio and workshop, maintaining her Chelsea residence as headquarters for new video projects. On a social level, this bicoastal pattern had been in effect since the mid-1970s. She had returned often to Seattle to see her mother prior to her death in 1986 and to maintain personal friendships and professional contacts. Her brother and younger son, both of whom live in Seattle, had drawn her back to the city as well.

Like many of her New York peers in the late 1980s, Chase has misgivings about the future of Manhattan's artist community even while she sustains a deep attachment to the city's unique working environment. Her recent professional decisions are symptomatic not only of shifting relationships between U.S. artists and their country's artistic capital but also of a television art milieu in which the broadcast industry, not McLuhanesque media theory, largely determines how artists perceive the future of video art. For Chase, these shifts have brought about a renewed interest in more solitary forms of artmaking as well as in the modernist aesthetic she never really abandoned, even during her most adventuresome multimedia productions. Chase left Seattle in 1972 primarily to accomplish a transition in her personal life. Returning as an established, independent artist not only completes the circle; it also marks the beginning of yet another round.

Notes

EAT and *Circles II*
1. F. T. Marinetti, "Destruction of Syntax-Imagination without Strings-Words in Freedom 1913," in *Futurist Manifestos*, edited by Umbro Apollonio (New York: Viking Press, 1973), p. 96. Marinetti was the founder and leader of the Italian Futurist group.
2. Marshall McLuhan, *Understanding Media: The Extensions of Man* (New York: New American Library, 1966), p. 33.
3. Marinetti, "Destruction of Syntax-Imagination," p. 97.
4. Marshall McLuhan and Quentin Fiore, *The Medium Is the Massage* (New York: Bantam Books, 1967), p. 63.
5. McLuhan, *Understanding Media*, p. 33.
6. Ibid., p. 70.
7. Calvin Tompkins, *The Scene: Reports on Post-Modern Art* (New York: Viking Press, 1976), pp. 88–89. EAT followed in many respects the pioneering efforts of USCO, an informal art and technology group active in the early 1960s.
8. LaMar Harrington, interview with author, July 15, 1987. The 1968–69 *Henry Gallery Annual Report* states that Experiments in Art and Technology meetings began in July 1968 and involved approximately sixty regional artists, scientists, and engineers. The group used the name and worked with the New York EAT organization, according to the report, but had no formal affiliation with the New York foundation.
9. Exhibition flyer, Galleria Numero, Rome, Italy, May 1966. Artist's files.
10. Doris Chase, interview with author, New York City, September 11, 1985. Further references to author's interviews with Chase will be indicated by initials D.C. and date.

11. Ibid.
12. In addition to the Chase-Staton collaboration, the program included an opera spoof entitled *Back and Forth*, interludes of film produced by Richard Brown and Frank Olvey, and the Seattle Opera Orchestra performing on a moving platform. "At the Seattle Opera House: Three Lively Arts," *Seattle Times*, magazine section, January 12, 1969, pp. 18, 29.
13. Raymond Erickson, "Seattle Goes Psychedelic," *New York Times*, May 16, 1969; and Paul Anderson, "Seattle's Hip Opera," *San Francisco Examiner and Chronicle*, August 24, 1969, B–4.
14. Gene Youngblood describes several multimedia productions presented in the late 1960s designed to immerse audiences in a "sensory arena." See his *Expanded Cinema* (New York: E. P. Dutton, 1970), pp. 371–86. The New York EAT organization's first major multimedia event, "9 Evenings: Theater and Engineering," was produced in 1966.
15. Jean Batie, "Forms for Dance," *Craft Horizons* (July/August 1969), pp. 16–19.
16. Ibid.
17. Doris Chase, "Doris Chase writes about her work in film and video," *Independent* (vol. 3, no. 6, 1980), pp. 13–14.
18. D. C., May 26, 1987. See also: Cynthia Goodman, *Digital Visions: Computers and Art* (New York: Harry N. Abrams, 1987), p. 176.
19. Frank Olvey, interview with author, July 6, 1987.
20. Richard Brown, interview with author, July 6, 1987. Brown and Olvey were responsible for the color processing in *Circles I* which was originally generated on black-and-white 70mm film stock.

21. No optical printer was then available at Alpha Cine. Brown and Olvey created these effects by making contact prints and running the print stock over and over again.
22. Amy Greenfield, "Filmdance: Space, Time, and Energy," in *Filmdance 1890s–1983* (New York: Elaine Summers Experimental Intermedia Foundation, 1983), p. 1.
23. There are two versions of *Circles II:* the first (1972), with a score by William O. Smith, runs fourteen minutes. The second (1973), runs eight minutes and is scored by George Kleinsinger.
24. Roger Greenspun, "Film Reviews," *New York Times*, February 18, 1973.
25. Roger Greenspun, "Doris Chase Dance Films, Donnell Library," *Soho Weekly News*, December 18, 1975.

Seattle: Painting and Sculpture
1. Doris Chase, interview with author, September 10, 1986.
2. Ibid.
3. *Thirty-fourth Annual Exhibition of Northwest Artists* (Seattle: Seattle Art Museum, October 6–November 7, 1948). Exhibition flyer. Artist's files.
4. D. C., September 11, 1986. The Zoe Dusanne Gallery was Seattle's first private modern art gallery.
5. Ibid.
6. Ibid.
7. Parker Tyler, "Young Seattle Painters," *Art News* (February 1955), p. 65. The group included Frederick Anderson, Wendell Brazeau, Robert Colescott, Ward Corley, Richard Gilkey, William Ivey, George Johanson, John Matsudaira, Alden Mason, Spencer Moseley, Jack Stangl, and Windsor Utley.
8. Chase's co-exhibitors included Maria Abrams, Margaret Camfferman,

Thelma Lehmann, June Nye, Dorothy Ransom, Dorothy Rising, and Lisel Salzer. Otto Seligmann Gallery flyer, February 6–March 5, 1955. Artist's files.

9. Kenneth Callahan, "Mrs. Chase and Woessner Grow As Painters," *Seattle Times*, December 23, 1956.

10. D. C., September 11, 1985.

11. Ibid.

12. Ibid.

13. Kenneth Callahan, "Pacific Northwest," *Art News* (July 1946). For a history of the "Northwest School" concept, see Martha Kingsbury, "Seattle and Puget Sound," in *Art of the Pacific Northwest* (Washington, D.C.: National Collection of Fine Arts, 1974).

14. D. C., September 10, 1985.

15. Ibid.

16. Marcello Venturoli, "Doris Chase, Paul Rotterdam alla Numero," *Il Paise Sera*, February 2, 1972. Clipping. Artist's files.

17. Undated clipping. Artist's files.

18. Unsigned review, *Mizue*, May 1963. *Mizue* was a monthly Japanese review of the arts.

19. D. C., September 11, 1985. Several photographs of Chase at work on the cement paintings were published in the *Seattle Times*, magazine section, December 2, 1962, pp. 44–48.

20. D. C., September 11, 1985.

21. Ibid.

22. Smolin Gallery press release, February 16, 1965. Artist's files. The Smolin Gallery was located at 19 East 71st St., New York City.

23. Jill Johnson, "Doris Chase," *Art News* (April 1965), p. 20.

24. The prize was awarded for *Landscape*, oil on canvas, 24 × 36, 1964.

25. D. C., September 10, 1986.

26. Ibid.

27. Ibid.

28. "Statement on Painted Oak Laminars." Typescript dated October 8, 1965. Artist's files.

29. D. C., September 10, 1986.

30. D. C., July 14, 1987.

31. D. C., September 10, 1986.

32. Cindy Nemser, "Doris Chase," *Arts* (Summer 1969), p. 59.

33. D. C., September 11, 1985.

34. Elayne Varian, statement in Finch College Museum of Art flyer, February 1970. Artist's files.

35. *Changing Forms* was first exhibited in 1969 at Wave Hill Sculpture Park in Riverdale, N.Y., prior to its permanent installation in Atlanta, Georgia.

36. The cor-ten steel Shadyside Park sculpture was funded by the Anderson Parks Department in Indiana and the National Endowment for the Arts. It is sixteen feet high.

37. Richard Lorber, "Doris Chase," *Arts* (September 1976), p. 10.

38. D. C., February 12, 1986. The Kerry Park sculpture, entitled *Changing Form*, was installed in 1971. In 1989 Chase had the top section welded into place, converting *Changing Form* into a stationary composition.

39. Calvin Tompkins, *The Scene: Reports on Post-Modern Art* (New York: Viking Press, 1976), pp. 93–123.

40. D. C., July 14, 1987.

Sculpture for Children: Seattle to New York

1. Doris Chase, interview with author, September 11, 1985.

2. Blanche Gordon Narodick, "Please Do Touch," *Puget Soundings* (Fall 1972).

3. Doris Chase, undated typescript. Artist's files.

4. D. C., July 14, 1987.

5. Doris Chase, letter to author, July 21, 1987.

6. Louis Chapin, *Christian Science Monitor*, February 10, 1971, p. 8.

7. Georgia Tasker, "Using Art to Teach Children," *Miami Herald*, July 1, 1972, p. 3–BR.

8. D. C., February 12, 1986.

9. Ibid.

10. Ibid.

11. Mary Staton, *New Dimensions in Music Newsletter*, May 1969, pp. 3–4. Publications of the New Dimensions in Music program are collected in the University of Washington Archives, Seattle, Washington.

12. Doris Chase, "Multi-Media. Yours, Mine-Ours." Undated typescript. Artist's files.

13. *Tall Arches* runs six minutes and was completed in 1974. The score is by George Kleinsinger. There are several versions of *Moon Gates* and *Rocking Orange*, including *Moon Gates I* (1973), five minutes; *Moon Gates* (1974), five minutes; *Moon Gates—Three Versions* (1974), fifteen minutes; *Rocking Orange* (1974), three minutes; *Rocking Orange—Three Versions* (1975), twelve minutes.

14. D. C., March 22, 1986.

15. Bob Sitton, program notes for the Second Northwest Film and Video Festival (Portland, Oregon: Northwest Film Study Center, Portland Art Museum, 1974).

16. D. C., February 12, 1986. The first version of *Circles II* (1972) has a score by William O. Smith and runs fourteen minutes. The version scored by Kleinsinger in 1973 runs eight minutes. Kleinsinger also composed a score for *Circles I:* the two versions of this film are the same, except that one is scored by Kleinsinger and the other by Morton Subotnick.

17. Ibid. The operating principle of the Paik/Abe synthesizer is explained by David Ross in *Nam June Paik*, edited by John Hanhardt (New York: Whitney Museum of American Art, 1982), p. 110. "The effect of the synthesizer relied heavily on the fact that a picture signal has a unique characteristic. Unlike audio feedback. . . video feedback occurs when a live camera is focused on its monitor, producing a mandala-like swirl of exploding light patterns that seem to rotate around a central axis. The Paik/Abe synthesizer used this technique in combination with aspects of the video picture controllable by simple voltage regulation—color intensity and hue, for example—to produce highly original (though ultimately predictable) imagery."

18. Ibid.

Video Art and New York: The First Decade

1. Chris Dercon, "A Little Paragraph in a Text That Is Missing," *Vidéo* (Montreal: Centre d'Information Artexte, 1986), p. 220.

2. Ibid., pp. 220–21.

3. David Ross, "Nam June Paik's Videotapes," in *Nam June Paik*, edited by John Hanhardt (New York: Whitney Museum of American Art, 1982), p. 102.

4. David Ross, "A Provisional Overview of Artists Television in the U.S.," in *New Artists Video*, edited by Gregory Battcock (New York: E. P. Dutton, 1978), p. 141. This article was originally published in *Studio International* (May/June 1976), pp. 265–72.

5. Calvin Tompkins, *The Scene: Reports on Post-Modern Art* (New York: Viking Press, 1976), p. 196.

6. Gene Youngblood, *Expanded Cinema* (New York: E. P. Dutton, 1970), pp. 298–306.

7. Ibid., pp. 307–8.

8. David Ross, "A Provisional Overview," p. 144.

9. Interview with Linda Silman," *Videoscope* (vol. 1, no. 2, 1977), p. 10. In 1977 Silman was a TV/Media associate at NYSCA.

10. Ibid., p. 7.

11. Karen Mooney, "The Television Laboratory of WNET/Channel 13: Project in Symbiosis," *Videoscope* (vol. 1, no. 2, 1977), p. 27.

12. Ibid., pp. 28–29.

13. Ibid., p. 29.

14. Roberta Grant, "Ralph Hocking at the Experimental Television Center," *Videoscope* (vol. 1, no. 2, 1977), p. 47. The center continued its residency program throughout the 1980s.

15. David Ross, "A Provisional Overview," p. 145.

16. "Electronic Arts Intermix," *Videoscope* (vol. 1, no. 2, 1977), p. 34. Known initially as the Electronic Kitchen, the organization changed its name in 1974 to the Kitchen Center for Video, Music, and Dance." Today the Kitchen is also a distributor of artists videotapes.

17. Linda Cathcart, *Vasulka* (Buffalo, N.Y.: Albright-Knox Gallery, 1978), p. 32.

18. Doris Chase, interview with author, February 12, 1986.

19. Karen Mooney, "Gerald O'Grady: The Perspective from Buffalo," *Videoscope* (vol. 1, no. 2, 1977), pp. 13–15.

20. "Young Filmmakers: A Statewide Media Resource and Training Center," *Videoscope* (vol. 1, no. 2, 1977), pp. 64–68.

21. "Anthology Film Archives," *Videoscope* (vol. 1, no. 2, 1977), p. 37.

22. "Video and New York State Public Libraries," *Videoscope* (vol. 1, no. 2, 1977), pp. 64–68.

23. For an extensive national survey of major institutions and events that shaped the history of video art in the United States, see Barbara London, "Video: A Selected Chronology, 1963–1983," *Art Journal* (Fall 1985), pp. 249–62. London has directed the video program at New York's Museum of Modern Art since 1974. Other useful overviews include: Marita Sturken, "Video in the United States," *Vidéo* (Montreal: Centre d'Information Artexte, 1986), pp. 55–65; Lucinda Furlong, "Notes Toward a History of Image-Processed Video: Eric Siegel, Stephen Beck, Dan Sandin, Steve Rutt, Bill and Louise Etra," *Afterimage* (Summer 1983), pp. 35–38, and "Notes Toward a History of Image-Processed Video: Steina and Woody Vasulka," *Afterimage* (December 1983), pp. 12–17; Kathy Huffman, ed., *Video: A Retrospective* (Long Beach, Ca.: Long Beach Museum of Art, 1984); Jeff Perone, "The Ins and Outs of Video," *Artforum* (Summer 1976); David Ross, "A Provisional Overview of Artist's Television in the U.S.," *Studio International* (May/June 1976), pp. 265–72; and Gene Youngblood, *Expanded Cinema* (New York: E. P. Dutton, 1970). In 1983 London mounted an exhibition at New York's Museum of Modern Art tracing the history of video art. Lucinda Furlong's review of the show ("Raster Masters," *Afterimage*, March 1984) points out some of the controversies video historians confront.

24. Ann-Sargent Wooster, "Why don't they tell stories like they used to?" *Art Journal* (Fall 1985), p. 204. This special issue of *Art Journal* on video art, edited by Sara Hornbacher, provides a useful critical overview.

25. Marshall McLuhan, *Understanding Media*, p. 24.

26. David Ross, "Nam June Paik's Videotapes," in *Nam June Paik*, John Hanhardt, ed., p. 104.

27. Wim Beeren, "Video and the Visual Arts," *The Luminous Image*, edited by Dorine Mignot (Amsterdam: Stedelijk Museum, 1984), p. 27.

28. Lucinda Furlong, "Tracking Video Art: 'Image Processing' as a Genre," *Art Journal* (Fall 1985), pp. 233–34. This article draws upon Furlong's two earlier studies of image processing in *Afterimage* (see note 23 above). Video critic Amy Taubin points to another category of objections to image processing in "Room Without a View," *Village Voice*, September 8, 1987, p. 49. She observes that "all image processors fetishize the pictorial aspects of video. . . while paying scant heed to the technology's more significant function as a network for the transmission and regulation of information." Controversy about the uncritical use of video as a "neutral" imaging tool is further discussed by Jack Burnham in "Art and Technology: The Panacea That Failed" in *Video Culture*, edited by John Hanhardt (Layton, Utah and Rochester, N.Y.: Gibbs M. Smith, Peregrine Smith Books in association with Visual Studies Workshop Press, 1986), pp. 232–48. "The cybernetic art of the 1960s and 1970s is considered today little more than a trivial fiasco," Burnham writes, in part because "the art world believes that there is or was a nefarious connection between advanced technology and the architects of late capitalism."

29. In 1972 Daniel Sandin, a professor in the Department of Art at the University of Illinois, developed a general-purpose analogue video computer that can be assembled from a kit. According to Gene Youngblood, within the Chicago video community Sandin's image processor "established a tradition of the user-built personal instrument as a necessary prerequisite for the practice of computer video. The practitioner would make a deep commitment to the instrument— building it, living with it and through it, plotting a life's course through it— The practice of computer video became, in Chicago, the foundation of an electronic visualization as something more than art, as a kind of practical philosophy or personal discipline, a way of life, a way of being in the world and a way of creating a world to be in." Image-processed tapes by these Chicago artists are not necessarily abstract. See Gene Youngblood, "Art and Ontology: Electronic Visualization in Chicago," in *The Event Horizon* (Toronto: Walter Phillips Gallery and Coach House Press, 1987), pp. 335–46.

30. See Jack Burnham, note 28 above.

31. Martha Gever, "Pressure Points: Video in the Public Sphere," *Art Journal* (Fall 1985), p. 239. Similar doubts about the artistic status of documentaries on film were raised earlier by film critics and historians.

32. Acconci's *Air Time* (1973); Jonas's *Vertical Roll* (1972) and Campus's *Three Translations* (1973) are representative examples.

33. Lucinda Furlong, "Tracking Video Art: 'Image Processing' as a Genre," *Art Journal* (Fall 1985), p.234.

34. Gregory Battcock, ed., "What is Video Art?," in *New Artists Video*, p. xii.

35. David Antin, "Video: The Distinctive Features of the Medium" in *Video Art* (Philadelphia: Institute of Contemporary Art, 1975), pp. 63–70. Battcock quotes this essay, although it is not reproduced in his *New Artists Video* anthology.

36. Les Levine, "One-Gun Video Art," in *New Artists Video*, Gregory Battcock, ed., p. 89.

37. Gene Youngblood, "The Medium Matures: Video and the Cinematic Experience," in *The Second Link: Viewpoints on Video Art in the Eighties* (Banff: Walter Phillips Gallery, 1983), p. 9.

38. David Ross, "A Provisional Overview," p. 268.

39. Ibid.

40. John Sanborn, quoted in Carl E. Loeffler, essay, "Toward a Television Art: Video as a Popular Art in the Eighties," in *The Second Link*, p. 16.

41. Nam June Paik, quoted in Calvin Tompkins, *The Scene*, p. 224.

Videodance

1. In 1974, in a last attempt to promote the sculpture, Chase commissioned a 4½-minute film about the work, *Sculpture for Children*. The film was shot in a New York City school with children ages six to nine using the forms. Laurie Steig, then a producer at WNET, produced the film.
2. Doris Chase, interview with author, February 12, 1986.
3. "Underground Films," *Filmmakers Newsletter* (Summer 1974), p. 12. The author of this article is not identified.
4. Doris Chase, letter to author, July 12, 1987.
5. D. C., March 22, 1986.
6. Doris Chase, letter to author, July 12, 1987.
7. D. C., March 22, 1986.
8. *Women/Artists/Filmmakers.* Undated, unpaginated pamphlet. Artist's files.
9. D. C., February 12, 1986.
10. Peter Grossman, "Video and Dance: A Delicate Balance between Art and Technology," *Videography* September 1977), p. 18.
11. Ibid., p. 19.
12. Maya Deren, excerpts from a 1954 taped interview, reprinted in *Dance Perspectives 30* (Summer 1967), p. 10.
13. D. C., February 12, 1986.
14. Ibid.
15. Although it is still technically possible to create debeaming effects, Chase found that, as studio television cameras became more expensive and technically sophisticated in the 1980s, engineers were more reluctant to alter the camera's normal operations to allow for a beam lag, in effect ruling out some of the painterly images that had appeared frequently in her videodances of the 1970s.
16. For a summary of Fuller's career, see Margaret H. Harris, *Loie Fuller: Magician of Light* (Richmond: Virginia Museum, 1979).
17. Roger Greenspun, "Doris Chase Dance Films, Donnell Library," *Soho Weekly News*, December 12, 1975.
18. Andy Bobrow, "Videodance," *Filmmakers Newsletter* (April 1977), pp. 46–47.
19. Richard Lorber, "Doris Chase," *Arts* (September 1976), p. 10.
20. Roger Greenspun, "Doris Chase Dance Films," p. 16.
21. The title of this five-minute composition with Takei is *Dance Five*. Other tapes generated from footage shot at Brooklyn College include *Melting Statues* with Kei Takei (1976); *Jacquelin Smith-Lee* (1977); *Jennifer Muller* (1976); and *Cynthia and Squares* (1977).
22. Three sections of the tape were also transferred to film. On film, "Dance for Television" is *Dance Three*; "Dance with Me" is *Dance Four*, "Improvisation" keeps the same title in the film version.
23. Norma Mclain Stoop, "Dancevision, the t.v. beat," *Dancemagazine* (November 1978), p. 31.
24. Andy Bobrow, "Videodance," p. 47.
25. D. C., March 22, 1986.
26. Bobrow, "Videodance." Unedited typescript of preliminary draft. Artist's files.
27. Maya Deren, 1954 taped interview in *Dance Perspectives 30* (Summer 1967) p. 13.
28. Bob Sitton, former director of the Northwest Film Study Center, Portland Art Museum, Portland, Oregon, pointed out to me this contrast between Chase's videotapes and the cinematic movement in *Circles II*.
29. *How Do You Feel?* (1977) runs 8½ minutes.
30. Jack Anderson, "Miss Hammer Adds Other Arts to Dance," *New York Times*, January 27, 1979, L–11. *Op Odyssey* was also reviewed by Deborah Jowitt in the *Village Voice*, July 19, 1976, p. 99, and February 19,

Videodances of the Late 1970s

1. Jonathan Hollander, interview with author, September 20, 1985.
2. Doris Chase, interview with author, February 20, 1986.
3. Hollander interview, September 20, 1985.
4. Ibid.
5. The synthesized arch appears in the film version of *Dance 10* (8 min.) with music by William Bolcom. The tape version of *Dance 10* (10 min.) does not include the animated arch and has music by Timothy Thompson.
6. *Limbo*, a dance by the Alwin Nikolais Company designed especially for chromakey effects, was broadcast in 1968 on New York's WCBS-TV's Repertoire Workshop series. For illustrations and a technical description of the effects, see Youngblood, *Expanded Cinema*, pp. 270–73.
7. Hollander interview, September 20, 1985.
8. Ibid.
9. Ibid.
10. Winifred Meese, "Jonathan and the Rocker," *Film Library Quarterly* (vol. 11, no. 3, 1978), p. 54. *Dance 10* in this article refers to the 10-minute tape version (see note 5 above).
11. Doris Chase and Diane Richards, "Mixed Media," *Art and Cinema* (December 1978), p. 35.
12. For a review of one of Cohen's presentations, see Lise Liepmann, "An Experiment: Film and Kids and Dance," *Sightlines, Young Viewers* (Spring 1978), p. 10.
13. Amy Greenfield, "Ritual/Movement/Dance/Film/Video," in brochure for Pittsburgh, Pennsylvania, exhibition presented by Pittsburgh Film Makers, June 4, 5, 11, 1979. Artist's files.
14. Norma Mclain Stoop, *Dancemagazine* (November 1978), p. 31. In 1978 Chase also made a 10-minute film version of *Variation Two*. Both the 28-minute *Sara Rudner* tape and the film, *Variation Two*, have a score by Joan LaBarbara in which LaBarbara manipulates her own vocal sounds, accompanied by timpani.
15. Program notes for the "Film as Art" program, 21st Annual American Film Festival, New York, May 29, 1979. Film descriptions by Marie Nesthus are followed by statements from the artists. Artist's files.
16. Undated typescript. Artist's files.
17. D. C., March 22, 1986.
18. Ibid.
19. Doris Chase, artist's statement in *Filmdance 1890s–1983* (New York: Elaine Summers Experimental Intermedia Foundation, 1983), p. 23.
20. Doris Chase, "Doris Chase writes about her work in film and video," *Independent* (vol. 3, no. 6, 1980), pp. 13–14.

Video Theater

1. Elaine Summers, interview with author, September 21, 1985.
2. Barbara van Dyke, interview with author, September 23, 1985.
3. Julie Gustafson, interview with author, March 2, 1986.
4. Doris Chase, interview with author, February 12, 1986.
5. Ibid.
6. John Newhouse, interview with Doris Chase, March 16, 1985. Typescript. Artist's files
7. Ruth Maleczech is Breuer's wife and Mabou Mines cofounder, who won a *Village Voice* OBIE in 1983 for her performance in a multimedia version of *Lies*, presented under its original title, *Haji*.
8. Lee Breuer, quoted from Chase's *Lies* tape. Ruth Maleczech's performance is followed by a short postscript, in which Maleczech, Chase, and Breuer comment on their collaboration.

9. Doris Chase and Carla Zackson. Typescript. Artist's files.

10. Newhouse interview with Chase, March 16, 1985.

11. Ibid. Chase also states in this interview that *Lies* was shot in one day at WNYC/TV. As was typical in the dance tapes, the entire composition was performed three times straight through, with the final product drawing upon all three performances.

12. Quoted in Katheryn Kovalcik-White, "Documentation Versus Interpretation in the Video Theater Work of Doris Chase," Masters thesis, New York University, 1987, p. 27.

13. Marita Sturken, "Video As a Performance Medium," *Sightlines* (Spring 1983), p. 20.

14. Kovalcik-White, p. 31

15. Kovalcik-White documents interpretive disparities between Chase and her collaborators in *Lies, Window,* and *Skyfish.* Kovalcik-White concludes (p. 50) that "though Chase's intention was collaboration, the end product remains uniquely hers."

16. Celia Weisman, "Doris Chase: Video and the Dramatic Monologue," *Film Library Quarterly* (vol. 17, nos. 2, 3, 4, 1984), p. 19.

17. Kovalcik-White, p. 40.

18. Julie Gustafson, interview with author, March 12, 1986.

19. Doris Chase and Carla Zackson. Typescript. Artist's files.

20. Ann-Sargent Wooster, interview with author, March 21, 1986.

21. *Mask* (1983) is performed by Pat Patton.

22. There are two versions of *Thulani.* One is 8½ minutes; the other is 26 minutes.

23. Celia Weisman, "Doris Chase," *Film Library Quarterly* (vol. 17, nos. 2, 3, 4, 1984), p. 23.

24. D. C., September 10, 1987.

25. D. C., February 12, 1986.

26. D. C., March 22, 1986.

27. Jennifer Siemers and Lois Shepard, "Setting the Scene by Herself," *Changing Woman* (May/June 1986), p. 9. At the end of 1989, the "By Herself" series included *Table for One* (1985); *Dear Papa* (1986); *A Dancer* (1987); *Still Frame* (1988); and *Sophie* (1989).

28. D. C., September 10, 1985.

29. Geraldine Page, interview with author, September 23, 1985.

30. D. C., September 10, 1985.

31. Ibid.

32. Ibid.

33. Ann-Sargent Wooster, interview with author, March 21, 1986.

34. Robin Schanzenbach, interview with author, March 21, 1986.

35. Media Alliance information brochure, 1987.

36. Applicants for the Media Alliance's "On Line" program are screened by alliance members. Artists must demonstrate before they begin work that they have at least $500 on hand to pay production companies. Through this program Chase did post-production work at Nexus and LRP Video in Manhattan.

37. See Gene Youngblood, "The Medium Matures: Video and the Cinematic Experience," in *The Second Link: Viewpoints on Video Art in the Eighties* (Banff: Walter Phillips Gallery, 1983), p. 9.

38. Robin White, quoted in Carl E. Loeffler's "Television Art in the Eighties," in *Watching Television: A Video Event*, School of Art and Design (Urbana-Champaign: University of Illinois, 1983), p. 11.

39. Loeffler, "Television Art in the Eighties," ibid., pp. 10–13.

40. Chase produced a more complex and visually satisfying tape with essentially the same plot structure as *A Dancer* at the 1988 American Film Institute Directing Workshop for Women, held in Los Angeles. Titled *Still Frame*, this production features Priscilla Pointer in the role of a professional photographer; Robert Symonds plays her lover. *Still Frame* is the first of Chase's tapes in which her direction of more than one performer is fluid, and this fluidity carries over into *Sophie.*

41. D. C., May 18, 1989.

42. Ibid.

Videotapes and Films

Selected List

Selected Videotapes

Videotapes are listed chronologically. All are in color, except *Plexi Radar* 1981), *Plexi Gate* (1981), and *Conversation* (1981). Scripts are by Doris Chase unless otherwise indicated. Asterisk (*) indicates tapes also available on film. Running times for films may vary from videotapes.

Sophie (1989), 26 minutes
Principal performer: Joan Plowright
Script: Julia Kearsley
Distributor: Italtoons

Still Frame (1988), 28 minutes
Principal performers: Priscilla Pointer, Robert Symonds
Script: Doris Chase and Kimberly von Brandenstein
Distributor: American Film Institute

A Dancer (1987), 28 minutes
Principal performer: Luise Rainer
Script: Jule Selbo
Distributor: Italtoons

Dear Papa (1986), 28 minutes
Principal performers: Anne Jackson and Roberta Wallach
Distributor: Italtoons

Table for One (1985), 28 minutes
Principal performer: Geraldine Page
Distributors: Italtoons and Museum of Modern Art Circulating Film Library

Thulani (1984), 26 minutes
Short version: 8½ minutes.
Principal performer: Thulani Davis
Script: Thulani Davis
Score: Anthony Davis
Distributor: Doris Chase Productions

Glass Curtain (1983), 28 minutes
Principal performer: Jennie Ventriss
Distributor: Women Make Movies

Three Story Suite (1983), 28 minutes
Principal performer: Laura Simms
Distributor: Women Make Movies

Mask (1983), 28 minutes
Principal performer: Pat Patton
Script: Bonnie Greer
Distributor: Women Make Movies

Electra Tries to Speak (1982), 26 minutes
Principal performer: Sondra Segal
Script: Clair Coss, Sondra Segal, and Roberta Sklar
Distributor: Women Make Movies

Travels in the Combat Zone (1982), 28 minutes
Principal performers: Mary Lum, Maralyn Amaral
Script: Jessica Hagedorn
Distributor: Women Make Movies

Skyfish (1981), 27 minutes
Principal performer: Lee Nagrin
Script: Lee Nagrin
Distributor: Women Make Movies

Conversation (1981), 5½ minutes
Principal performer: Ruth Maleczech
Script: Lee Breuer
Distributor: Doris Chase Productions
Film version: Film Makers Cooperative

Plexi Gate (1981), 24 minutes
Video sculpture.
Excerpts from this tape were used to create the 7-minute film *Plexi Gate*.
Distributor: Doris Chase Productions

Plexi Radar (1981), 7½ minutes
Video sculpture
Distributor: Doris Chase Productions

Window (1980), 29 minutes
Principal performer: Claudia Bruce
Script: Linda Mussman
Distributor: Women Make Movies

Lies (1980), 28 minutes
Principal performer: Ruth Maleczech
Script: Lee Breuer
Distributor: Women Make Movies

Gay Delanghe (1979), 28 minutes
Videodance
Score: George Wilson and William Gracy, Jr.
Distributor: Video Data Bank

Jazz Dance (1979), 4 minutes
Videodance with Gay Delanghe
Distributor: Museum of Modern Art Circulating Film Library

Nashville Dance (1979), 3½ minutes
Videodance with Gay Delanghe
Distributors: Doris Chase Productions and Video Data Bank.
Film version: Cecille Starr

Moon Redefined (1979), 25 minutes
Video sculpture. Excerpts from this tape were used to create the 5-minute film, *Moon Redefined*.
Distributor: Doris Chase Productions

Cube Redefined (1979), 21 minutes
Video sculpture
Distributor: Doris Chase Productions

Circling (1979), 22 minutes
Video sculpture
Distributor: Doris Chase Productions

Sara Rudner (1978), 28 minutes
Videodance.
Sections of this composition are also exhibited separately. Excerpts from this tape were used to create the films *Variation Two* and *Dance Outline*.
Score: Joan LaBarbara
Distributor: Doris Chase Productions

Dance Frame (1978), 7 minutes
Videodance with Sara Rudner
Score: Joan LaBarbara
Distributor: Doris Chase Productions
Film version: Film Makers Cooperative and Cecille Starr

Jonathan and the Rocker (1977),
 34 minutes
Videodance with Jonathan Hollander.
 Portions of this composition are also
 exhibited separately. Excerpts from
 this tape were used to create the
 films *Dance Ten* and *Circles and
 Jonathan.*
Distributor: Video Data Bank

Op Odyssey (1977), 17½ minutes
Based on *Op Odyssey,* the multimedia
 stage production choreographed by
 Valerie Hammer, with dance sculp-
 ture and videotapes by Doris Chase
Dancers: Jonathan Hollander and
 Esther Chaves
Distributor: Doris Chase Productions

Jacqueline Smith-Lee (1977),
 15 minutes
Videodance
Score: Timothy Thompson
Distributor: Video Data Bank

How Do You Feel? (1977),
 8½ minutes
Composition on body movement and
 self-awareness for children
Dancers: Kei Takei and Lloyd Ritter
Score: George Kleinsinger
Distributor: Doris Chase Productions
Film version: Film Makers Coopera-
 tive

The Emperor's New Clothes (1977),
 10 minutes
Videodance for children
Dancers: Jonathan Hollander and
 Nancy Cohen
Score: George Kleinsinger
Distributor: Doris Chase Productions
Film version: Coronet Films

Rocker (1977), 9 minutes
Video sculpture
Distributor: Doris Chase Productions
Film version: Film Makers Coopera-
 tive

Jennifer Muller (1976), 15 minutes
Videodance
Distributor: Doris Chase Productions

Kei Takei (1976), 28 minutes
Videodance.
Portions of this composition are ex-
 hibited separately. Excerpts from
 this tape were used to create the
 films *Improvisation, Dance Four,*
 and *Dance Three.*
Score: George Kleinsinger
Distributor: Video Data Bank

Dance Five (1976), 5 minutes
Videodance with Kei Takei
Score: Timothy Thompson
Distributor: Doris Chase Productions
Film version: Film Makers Coopera-
 tive

Melting Statues (1976), 20 minutes
Videodance with Kei Takei, Mel Pate,
 and John Parton
Distributor: Doris Chase Productions

Marnee Morris (1975), 18 minutes
Videodance
Score: Genji Ito
Distributor: Video Data Bank

Gus Solomons (1975), 8 minutes
Videodance
Score: George Kleinsinger
Distributor: Video Data Bank

Cynthia Anderson (1975), 12 minutes
Videodance
Score: Laurie Speigel
Distributor: Doris Chase Productions

Philadelphia Quartet (1975),
 5 minutes
Based on a 1972 performance of the
 Philadelphia String Quartet in
 Seattle
Distributors: Doris Chase Productions
 and Film Makers Cooperative

Moving Forms (1974), 27 minutes
Video sculpture
Distributor: Doris Chase Productions

Selected Films

Films are listed chronologically. All
are in color except *Plexi Gate* (1981)
and *Moon Redefined* (1979).

Plexi Gate (1981), 7 minutes
Video sculpture
Distributor: Doris Chase Productions

Moon Redefined (1979), 5 minutes
Video sculpture
Distributor: Film Makers Cooperative

Variation Two (1978), 11 minutes
Videodance on film with Sara Rudner
Score: Joan LaBarbara
Distributor: Museum of Modern Art
 Circulating Film Library

Dance Outline (1978), 4 minutes
Videodance on film with Sara Rudner
Score: Joan LaBarbara
Distributor: Film Makers Cooperative

Dance Ten (1977), 8 minutes
Videodance on film with Jonathan
 Hollander
Score: William Bolcom
Distributor: Museum of Modern Art
 Circulating Film Library

Circles with Jonathan (1977),
 4 minutes
Videodance on film with Jonathan
 Hollander and images from *Circles I*
 (1971)
Score: George Kleinsinger
Distributor: Doris Chase Productions

Improvisation (1977), 5 minutes
Videodance on film with Kei Takei
Distributors: Film Makers Coopera-
 tive and Cecille Starr

Dance Four (1977), 6½ minutes
Videodance on film with Kei Takei
Score: George Kleinsinger, Eric Eigen,
 and Mike Mahaffay
Distributor: Museum of Modern Art
 Circulating Film Library

Dance Three (1977), 8½ minutes
Videodance on film with Kei Takei
Score: George Kleinsinger
Distributor: Film Makers Cooperative

Dance Seven (1975), 7¼ minutes
Videodance on film with Marnee
 Morris
Score: Genji Ito
Distributor: Film Makers Cooperative

Dance Nine (1975), 4 minutes
Videodance on film with Gus
 Solomons
Score: George Kleinsinger
Distributor: Film Makers Cooperative

Dance Eleven (1975), 8 minutes
Videodance on film with Cynthia
 Anderson
Score: Laurie Speigel
Distributor: Film Makers Cooperative

Tall Arches III (1974), 7¼ minutes
Filmdance based on performances of
 the Mary Staton Dancers at the
 Wadsworth Atheneum, 1973
Score: George Kleinsinger
Distributor: Film Makers Cooperative

Moon Gates—Three Versions (1974),
 15 minutes
Filmdance based on performances of
 the Mary Staton Dancers at the
 Wadsworth Atheneum, 1973. Ver-
 sions also exhibited separately as
 Moon Gates (1974), 5 minutes, with
 color effects executed in collabora-
 tion with Frank Olvey and Robert
 Brown; *Moon Gates I* (1973), 5
 minutes, and *Moon Gates II* (1974),
 5 minutes.
Score: George Kleinsinger
Distributor: Film Makers Cooperative

Moon Gates III (1974), 5 minutes
Filmdance based on performances of
 Mary Staton Dancers at the
 Wadsworth Atheneum, 1973
Score: George Kleinsinger
Distributor: Film Makers Cooperative

Rocking Orange—Three Versions
 (1975), 12 minutes
Filmdance based on performances of
 the Mary Staton Dancers at the
 Wadsworth Atheneum, 1973
Score: George Kleinsinger
Distributor: Cecille Starr

Rocking Orange (1974), 3 minutes
Third version of *Rocking Orange in Three Versions*, exhibited separately. Step printing, overlay and solarization effects executed in collaboration with Frank Olvey and Robert Brown.
Score: George Kleinsinger
Distributor: Film Makers Cooperative

Squares (1973), 7 minutes
Computer animation
Score: George Kleinsinger
Distributor: Film Makers Cooperative

Circles II—Variation II (1973), 8 minutes
Variation on *Circles II* (1972)
Score: George Kleinsinger
Distributors: Coronet Films and Film Makers Cooperative

Circles II (1972), 14 minutes
Filmdance based on *Mantra*, Seattle Opera multimedia stage production, 1969
Score: William O. Smith
Distributors: Coronet Films and Film Makers Cooperative

Circles I (1971), 7 minutes
Computer animation
Score: Morton Subotnick. A second version of the same film was scored by George Kleinsinger.
Distributors: Film Makers Cooperative and Cecille Starr.

Films and Tapes on the Work of Doris Chase

Doris Chase: Portrait of an Artist (1984), 28 minutes
Videotape
Producer: Robin Schanzenbach
Distributor: Women Make Movies

Sculpture for Children (1974), 5 minutes
Documentary film
Producer: Laurie Steig
Distributor: Film Makers Cooperative

Sculpture on the Move (1973), 8 minutes
Documentary film
Producer: William Jensen
Distributor: Film Makers Cooperative

Full Circle (1974), 10 minutes
Documentary film
Producer: Elizabeth Wood
Distributors: Coronet Films and Cecille Starr

Index of Chase Film and Videotape Distributors

American Film Institute
2021 North Western Avenue
Los Angeles, California 90027

Cecille Starr
50 West 9th
New York, N.Y. 10025

Coronet Films
108 Willmott Road
Deerfield, Illinois 60015

Doris Chase Productions
222 West 23rd Street
New York, N.Y. 10011

Film Makers Cooperative
175 Lexington Avenue
New York, N.Y. 10016

Italtoons
32 West 40th Street
New York, N.Y. 10018

Museum of Modern Art Circulating Film Library
11 West 53rd Street
New York, N.Y. 10019

Video Data Bank
Art Institute of Chicago
Columbus Drive at Jackson Blvd.
Chicago, Illinois 60603

Women Make Movies
225 Lafayette Street
New York, N.Y. 10012

Work in Public Collections

Selected List

Painting, Drawing, and Sculpture

Art Institute of Chicago
Chicago, Illinois

Frye Art Museum
Seattle, Washington

Hudson River Museum
Yonkers, New York

Milwaukee Art Museum
Milwaukee, Wisconsin

Museum of Fine Arts
Boston, Massachusetts

Museum of Fine Arts
Houston, Texas

Museum of Modern Art
Kobe, Japan

National Collection of Fine Arts
Washington, D.C.

North Carolina Museum of Art
Raleigh, North Carolina

Pennsylvania Academy of Fine Art
Philadelphia, Pennsylvania

Seattle Art Museum
Seattle, Washington

Smithsonian Institution
Washington, D.C.

Tacoma Art Museum
Tacoma, Washington

Vancouver Art Gallery
Vancouver, British Columbia,
Canada

Film

Anthology Film Archives
New York, New York

British Film Institute
London, England

Brooklyn Public Library
Brooklyn, New York

Epcot, Walt Disney World
Orlando, Florida

Jacksonville Public Library
Jacksonville, Florida

King County Public Library
Seattle, Washington

Museum of Modern Art Circulating
Film Library
New York, New York

University of Quebec,
Montreal, Canada

Video

Allegheny Community College
Cumberland, Maryland

Biograph
Bologna, Italy

Boston Public Library
Boston, Massachusetts

Centre Georges Pompidou
Paris, France

Donnell Library Center Art Library
New York, New York

Duke University
Durham, North Carolina

Experimental Television Center
Owego, New York

Hampshire College
Amherst, Massachusetts

Hofstra University
Hempstead, New York

Institute of Contemporary Art
London, England

Jerusalem Agency Society
Jerusalem, Isracl

King County Public Library
Seattle, Washington

Kobe College of Art
Kobe, Japan

Lincoln Center Performing Arts
Library
New York, New York

Long Beach Museum of Art
Long Beach, California

Metropolitan Library
Toronto, Canada

Museum of Modern Art Circulating
Film Library
New York, New York

National Film Library of Australia
Canberra, Australia

New York University
New York, New York

Patchogue-Medford Central Library
Patchogue, New York

Pennsylvania State University
University Park, Pennsylvania

Rutgers University
New Brunswick, New Jersey

Satellite Exchange
Vancouver, British Columbia,
Canada

United States Information Agency
Washington, D.C.

University of Illinois
Chicago, Illinois

University of Quebec
Montreal, Canada

University of Toronto
Toronto, Canada

Video Inn
Vancouver, British Columbia,
Canada

Worchester Public Library
Worchester, Massachusetts

Wright State University
Dayton, Ohio

Selected Bibliography

Unpublished Interviews and Archival Material

Chase, Doris. Scrapbooks, 1948–72. Artist's papers.

———. Notes and statements from artist's files.

———. Study guides for videotape series. Artist's papers.

Chase, Doris, and Carla Zackson. "Women, Video and Technology." Unpublished article for *Heresies*, November 1982. Copy in artist's files.

Henry Gallery Records. University of Washington Archives. Seattle, Washington.

Kovalcik-White, Katherine. Transcript of interview with Doris Chase, November 9, 1983. Copy in artist's files. An abridged version of this interview was published in *Women and Performance*, Spring/Summer 1983.

Newhouse, John. Transcript of taped interview with Doris Chase, New York, March 1985. Copy in artist's files.

Miller, Lynn. "Doris Chase: An Introduction," preliminary draft of interview for *The Hand that Holds the Camera: Interviews with Women Film and Video Directors*, 1988. Copy in artist's files.

Interviews by the Author

Interviews with Doris Chase, 1985–89, New York City and Seattle.

Individual dates are cited in Notes.

Other sources interviewed by the author include: Robert Brown (Seattle, July 6, 1987); Julie Gustafson (New York, March 12, 1986); LaMar Har-
rington (Seattle, July 15, 1987); Jonathan Hollander (New York, September 20, 1985); Frank Olvey (Seattle, July 6, 1987); Geraldine Page (New York, September 23, 1985); Robin Schanzenbach (New York, March 21, 1986); Elaine Summers (New York, September 21, 1985); Barbara van Dyke (New York, September 23, 1985); Ann-Sargent Wooster (New York, March 21, 1986).

Books and Articles

Ancona, Victor. "Doris Chase: Painter, Sculptor/Video Artist." *Videography* (June 1983).

Anderson, Jack. "Miss Hammer Adds Other Arts to Dance." *New York Times*, January 27, 1979.

Anderson, Paul. "Seattle's Hip Opera." *San Francisco Examiner and Chronicle*, August 24, 1969.

Antin, David. "Video: The Distinctive Features of the Medium." In *Video Art* (Philadelphia: Institute of Contemporary Art, 1975).

Art Journal (Fall 1985). Special issue on video art. Sara Hornbacher, guest editor.

Batie, Jean. "Forms for Dance." *Craft Horizons* (July/August 1969).

Battcock, Gregory, ed. *New Artists Video* (New York: E. P. Dutton, 1978).

Beeren, Wim. "Video and the Visual Arts." In *The Luminous Image*, edited by Dorine Mignot (Amsterdam: Stedelijk Museum, 1984).

Bobrow, Andy. "Videodance." *Filmmakers Newsletter* (April 1977).

Braderman, Joan. "Report: The First Festival of Women's Films." *Artforum* (September 1972).

Calhoun, Sally. "In the Atheneum." *Museum News* (April 1974).

Callahan, Kenneth. "Mrs. Chase and Woessner Grow As Painters." *Seattle Times*, December 23, 1956.

Cathcart, Linda. *Vasulka* (Buffalo, N.Y.: Albright-Knox Gallery, 1978).

Chapin, Louis. "School Yard Profile." *Christian Science Monitor*, February 10, 1971.

Chase, Doris. "Doris Chase writes about her work in film and video." *Independent* (vol. 3, no. 6, 1980)

Chase, Doris. "Statement on Filmdance." In *Filmdance 1890s–1983*, edited by Amy Greenfield (New York: Elaine Summers Intermedia Foundation, 1983).

Chase, Doris and Diane Richards. "Mixed Media," *Art and Cinema* (December 1978).

Dance Perspectives 30 (Summer 1967). Special issue on filmdance.

Dercon, Chris. "A Little Paragraph in a Text That Is Missing." *Vidéo* (Montreal: Centre d'Information Artexte, 1986).

Edelman, Rob. "Doris Chase." *Sightlines* (Spring/Summer 1986).

Erickson, Raymond. "Seattle Goes Psychedelic." *New York Times*, May 16, 1969.

The Event Horizon (Toronto: Walter Phillips Gallery and Coach House Press, 1987).

Furlong, Lucinda. "Notes Toward a History of Image-Processed Video." *Afterimage* (Summer 1983, December 1983).

———. "Raster Masters." *Afterimage* (March 1984).

Goodman, Cynthia. *Digital Visions: Computers and Art* (New York: Harry N. Abrams, 1987).

Gordy, William. "Doris Chase." *Craft Horizons* (February 1971).

Greenfield, Amy, ed. *Filmdance 1890s–1983* (New York: Elaine Summers Experimental Intermedia Foundation, 1983).

Greenspun, Roger. "Doris Chase Dance Films, Donnell Library." *Soho Weekly News*, December 18, 1975.

———. "Film Reviews." *New York Times*, February 18, 1973.

Grossman, Peter, "Video and Dance: A Delicate Balance between Art and Technology." *Videography* (September 1977).

Hanhardt, John, ed. *Nam June Paik* (New York: Whitney Museum of American Art, 1982).

———. *Video Culture. A Critical Investigation* (Layton, Utah and Rochester, N.Y.: Gibbs M. Smith, Peregrine Smith Books in association with Visual Studies Workshop Press, 1986).

Harris, Margaret H., *Loie Fuller: Magician of Light* (Richmond: Virginia Museum of Art, 1979).

Huffman, Kathy, ed. *Video: A Retrospective* (Long Beach, Ca.: Long Beach Museum of Art, 1984).

Johnson, Jill. "Doris Chase." *Art News* (April 1965).

Kovalcik-White, Katheryn. *Documentation versus Interpretation in the Video-Theater Work of Doris Chase*. Masters thesis, New York University, December, 1987.

Lee, Rohama. "Dear Papa," *Sightlines* (Spring 1989).

Loeffler, Carl E. "Television Art in the Eighties." In *Watching Television: A Video Event*. School of Art and Design (Urbana-Champaign: University of Illinois, 1983).

Lorber, Richard, "Doris Chase." *Arts* (September 1976).

———. "Towards an Aesthetic of Videodance." *Arts in Society* (Summer/Fall 1976).

Lorber, Richard, and H. B. Kronen. "From Cimabue to Cunningham." *Millennium Film Journal* (Winter 1982).

McLuhan, Marshall. *Understanding Media: The Extension of Man* (New York: Bantam Books, 1967).

McLuhan, Marshall, and Quenton Fiore. *The Medium Is the Massage* (New York: Bantam Books, 1967).

Making their Mark: Women Artists Move into the Mainstream, 1970–1985 (New York: Abbeville Press, 1989).

Margolis, John. "Doris Chase." *Arts* (Summer 1967).

Marinetti, F. T. "Destruction of Syntax-Imagination without Strings-Words in Freedom 1913." In *Futurist Manifestos*, edited by Umbro Apollonio (New York: Viking Press, 1973).

The Media Arts in Transition (Minneapolis: Walker Art Center, 1983).

Meese, Winifred. "Jonathan and the Rocker." *Film Library Quarterly* (vol. 11, no. 3, 1978).

Miller, Lynn. *The Hand That Holds the Camera: Interviews with Women Film and Video Directors* (New York and London: Garland Publishing, 1988).

Narodick, Blanche Gordon. "Please Do Touch." *Puget Soundings* (Fall 1972).

Nemser, Cindy. "Doris Chase." *Arts* (Summer 1969).

Perone, Jeff. "The Ins and Outs of Video." *Artforum* (Summer 1976).

Ross, David. "A Provisional Overview of Artists Television in the U.S." *Studio International* (May/June 1976).

Ross, Janice. "Dance on Video." *Artweek*, March 4, 1978.

Schneider, Ira, and Beryl Korot. *Video Art: An Anthology* (New York: Harcourt, Brace, Jovanovich, 1976).

The Second Link: Viewpoints on Video Art in the Eighties (Banff: Walter Phillips Gallery, 1983).

Siemers, Jennifer, and Lois Shepard. "Setting the Scene by Herself." *Changing Woman* (May/June 1986).

Staton, Mary. *New Dimensions in Music Newsletter* (May 1969). University of Washington Archives, Seattle, Washington.

Stoop, Norma Mclain. "Dancevision, the t.v. beat." *Dancemagazine* (November 1978).

Sturken, Marita. "Video As a Performance Medium." *Sightlines* (Spring 1983).

———. "Video in the United States," *Vidéo* (Montreal: Centre d'information Artexte, 1986).

Tasker, Georgia. "Using Art to Teach Children." *Miami Herald*, July 1, 1972.

Taubin, Amy. "Room Without a View." *Village Voice*, September 8, 1987.

Tich, Pauline. "Interview: Doris Chase." *dfa Bulletin* (February 1981).

Tompkins, Calvin. *The Scene: Reports on Post-Modern Art* (New York: Viking Press, 1976).

Tyler, Parker. "Young Seattle Painters." *Art News* (February 1955).

Video Art (Philadelphia: Institute of Contemporary Art, 1975).

Videoscope (vol. 1, no. 2, 1977).

Walsh, Alida. "Artists as Filmmakers," *Women Artists News* (vol. 8, nos. 5, 6, Summer 1983).

Watching Television: A Video Event. School of Art and Design (Urbana-Champaign: University of Illinois, 1983).

Weisman, Celia. "Doris Chase: Video and the Dramatic Monologue." *Film Library Quarterly* (vol. 17, nos. 2, 3, 4, 1984).

White, Katherine. "Beyond the Guilded Cage." *Women and Performance* (Spring/Summer 1983).

Wooster, Ann-Sargent. "Doris Chase, Laura Foreman, Wendy Chambers, *Soho Weekly News*, June 8, 1981.

Youngblood, Gene. *Expanded Cinema* (New York: E. P. Dutton, 1970).

Index